The Birth of Modern Painting

Gaétan Picon

The Birth of Modern Painting

Preface by Yves Bonnefoy
Afterword by Alain Bonfand

Translated by Michael Edwards

MALLARD PRESS

MALLARD PRESS
An imprint of BDD Promotional Book Company, Inc.
666 Fifth Avenue
New York, N.Y. 10103

Mallard Press and its accompanying design and logo
are trademarks of BDD Promotional Book Company, Inc.

This edition first published in the United States of America
in 1991 by The Mallard Press.

ISBN: 0-7924-5528-2

Printed in Hong Kong

Table of Contents

Yves Bonnefoy

I

Gaétan Picon did not initially set his sights on the study of artistic creation. His natural tastes drew him toward literature, of which he was a most penetrating analyst for many years after the war, until the day came when, recognizing the writer in him, literature let him speak on his own account.

From the outset, however, Gaétan Picon was too rich in perceptions, too sensitive in his experience of the world, not to have a passion for that which painters seek. As the turning point in his life approached, he began to reflect on their works; after reaching it, he never stopped. Was it due to the influence of his friend André Malraux, who had undergone a similar evolution some fifteen or twenty years earlier? Was it due to the kindred tendencies of the writers he admired—Hugo, for example, whose "sun of ink" he so well evoked? At any event, on the threshold of the 1960s, Gaétan Picon became one of the most perceptive witnesses of both painting and the present era. He kept the company of painters, and when for some years his office required him to make purchases for the State, he knew like no other how to separate the wheat from the chaff among the various avant-garde movements. Finally, he accepted a chair at the École des Beaux-Arts, where he was happy to engage young artists in a dialogue that ranged from art and painting to literature and reading. He no doubt preferred these artists to students of literature during the period of his deeper self-examination, which was undertaken for a vast, subjective, first-person work, only to be cut short by his death.

1863 is one result of Gaétan's interest in painting, and its republication is a happy event, for this book may take its place beside the beautiful writings on art that have so enriched our time—from Élie Faure and Focillon to Malraux and Georges Duthuit. Its original appearance may well have inspired some young readers to take up careers of study and research. But today, alas, rereading it brings to mind more than the history of modern painting; it makes us think of its author, whose life now lies complete before our eyes. That is, anyway, what I am tempted to do, for Gaétan was a friend of mine. I admired his extraordinary reserves of intelligence and heart, but not without seeing them troubled by the contradictory desires that came one day to determine his destiny.

Who was Gaétan Picon? What was it that he desired toward the end of his life? What new at-

tachments had he formed in shifting from writers to painters, from speech to silence? We must ask, as well, or perhaps before all, the reason for his recurrent interest in the rediscovery of the self that took place in the painting of the second half of the nineteenth century.

From Hugo and Ingres to Manet, the Impressionists, and Van Gogh, all his references were indeed organized around this "birth," as he referred to it. Curious about everything, aware of everything, he hardly spoke of classical antiquity or the Middle Ages, of Asian or ancient cultures except for some beautiful but brief pages in *Admirable tremblement de terre*. He fleetingly examined some of the masters of the seventeenth century, Poussin for instance, and touched on or even studied some painters of our own, such as Kandinsky and Dubuffet, but only because they all either heralded or continued the decisive events of the 1860s. While Gaétan Picon seemed to me capable of understanding anything, perhaps he was attracted instinctively only to this one brief moment in the history of art. It seems only natural, for the painting that begins with Delacroix and Hugo and then undergoes a metamorphosis with Manet is the contemporary of the novels of the great writers—from Balzac to Zola and Bernanos, visionaries one and all—who were his most constant passions.

But why, we may also ask, was it this moment in literature that had the power to hold his interest? More than simply noting this fact, we should explore it, as much for the light it may shed on the discussion of our topic as the reverse. Who, in fact, can be sure that Gaétan Picon did not see in painting a mirror that finally revealed the preoccupations that had drawn him to these writers of a

changing era? Let us not forget that 1863 was more than a moment of artistic riches. It was a revolution whose consequences have resounded in many other fields of creation besides painting, to the point of changing our ideas of truth and liberty, understood in the broadest sense.

II

What is 1863? What is this modernity that, while being readied in many ways no doubt (by the light of Constable, the intense color of Delacrois), is nonetheless born of something other than the experience of earlier painters? It is, I venture to say, the feeling among those who trace their roots to it that they have the right to be irresponsible. They can begin their work, carry it to term, and decide when that term has been reached according to their individual principles and methods, which they need not even understand; but simply, and above all, because it pleases them that it be thus. Moreover, it is the obscure but strong conviction that this act, without either obligation or sanction, exempt from all intellectual or civic duty and all morality, too, is nevertheless capable of experiencing truth that is, therefore, only deeper—truth situated on the troublesome plane where consciousness, although still short of words, seeks to express itself. This game is truth, governed however by an exigent new duty that has arisen simultaneously with the right to pleasure: the duty to be as consistent and rigorous as possible in the pursuit of that pleasure.

Let us now clarify these points with the aid of two illustrations, the first of which is taken from before the moment of crisis. At the turn of the century, there was a great deal of interest in Dela-

croix, who, as it happens, died in 1863. There is no doubt that the intensity of his color and the freedom with which he employed it, particularly striking in his African watercolors, foreshadowed the daring of Manet and the speculations of Seurat, who twenty years later was fascinated by Delacroix's first retrospective. On account of this liberty, in which we find not just the hallmark of a very distinct taste for pleasure as such, all pleasure, but in particular the immense pleasure of painting, Delacroix may appear modern. But we must not overlook that there is in Delacroix, even in the least of his moments (which are always studies), the aim that his friend and admirer Baudelaire had in mind himself when he asked the "angels dressed in gold, purple and hyacinth" to bear witness that he had done his "duty." This duty was to be a "perfect chemist" and a "holy soul." In writing these lines—which were to have appeared in an epilogue to *Les Fleurs du mal*, as a commentary to his whole work—Baudelaire, I am tempted to believe, was thinking also of the research of Delacroix, who was then finishing his paintings in the Chapel of the Holy Angels at the Church of Saint-Sulpice. And how right he was!

For there was, so Delacroix thought, a higher reality, before which one could have no other goal or thought than to make it appear in the vessel of one's art. And with this idea of an ideal world, he only continued the great and constant thinking of the Middle Ages, the Renaissance, and the seventeenth century, which conceived of the universe that God had created as a harmonious structure, and therefore endowed form and symbol with a degree of reality greater than that of the material world. In the sixteenth and seventeenth centuries, among the painters that Delacroix so cherished—Titian, Rubens, Poussin—this vision, the theory of

the Idea, reigned supreme. Then under the gaze of the scientist it collapsed, but the idea of transcendence nevertheless lived on into the Romantic era, a fragile but intoxicating intuition that was felt to be in part a privilege—like the "giant wings" of the albatross—but even more an intrepid mission. "Finishing demands a heart of steel," writes Delacroix of his work in progress. "I believe it will kill me." Can we discover under these conditions the simple pleasure of painting? Yes, perhaps, but combined with contradiction and anxiety. The beautiful harmony of two tones cannot make us forget that beauty has its place in the absolute relations that exist up above, in Being, that is, in the invisible. And if one realm is too much loved, the other is sacrificed.

The "admirable trembling" of the painter's hand is due not to the passage of time, the onset of age, but to Delacroix's humanity as such, which experiences (in the great event that art remains for him) its new—"modern," in a first sense—inability to live in the absolute. The biblical text was right, beyond the optimism of the classicists: Jacob wishes to see God; the Angel forbids it; and so he must devote himself to combat and searching without end. Manet's attitude is completely other, as is the decision that he makes, it has been said, so much more easily. It is at Auteuil that he admires a sailboat in the sun, on the blue water. "How nice it would be," he thinks, "to paint a naked woman in this open air," and he goes ahead and does it, without asking any further questions. The result is *Le Déjeuner sur l'Herbe.*

The painting is thus the response, without anxiety, or even reflection, of the painter's sensibility to a mere bit of color in the light—yes, it seems, merely that. Manet did not evidence that day (or any other time he painted) the least concern for

the truth of the world, of the place where the things he painted were located, of the laws of good and evil. He simply followed his taste for first glances—perceptions untainted by prior knowledge—after which he worked, in the diverse moments of the work's genesis, solely with immediate, unreasoning, but obligatorily total adherence to the suggestions of an obscure, inner necessity. Nonetheless, the work begun in this way was not a soliloquy dissipating the meaning attached to perception by society or language: This green patch remained grass, this body was identifiable as a body, and this unclothed woman disclosed much about her approach to life. But the obligation to perceive, incorporate, study this meaning had disappeared. Manet had decided that he might, at his own discretion, choose to draw on it or not, use it or not. The result was a sudden silencing of the voice that until then, whether clear or confused, never stopped asserting through the intermediary of things the authority of an order of the world, of an *a priori* truth, of an orthodoxy of thought.

And perhaps we may now see more clearly what resulted from the decision that appeared so facile. On the one hand, it was the sudden appearance of a tension in the relation to the other, for this disturbing silence created, whether it wished to or not, a scandal. Almost four centuries earlier, Titian had painted the *Concert Champêtre*, whose subject—naked women accompanied by young men in a pastoral setting—is related to that of *Déjeuner sur l'Herbe*, and whose meaning hardly intruded either; yet that painting had disturbed no one, neither in its own day nor later. Whoever looks closely at the Venetian painting may well fail to grasp its symbolic intentions; nevertheless, when one hears a certain music resonating in these colors and these forms, the viewer cannot doubt that the painter reveres a certain order of the world and is thereby put at ease. Let us not underestimate, reciprocally, the effort that Manet demands, at the very moment when he himself seems to dispense with any. Can one, just like that, in a flash, give up the idea of the truth of the world for a little bit of pure painting? And will it be necessary, following art's own trajectory, to have a painter's ability to perceive that two tones side by side may be the equivalent, in the mind, of a whole network of meanings and values? It is one thing to like blue next to red when they appear, charged with meaning, in the garment of the Virgin, but quite another to accept them in this sudden, complete silence, where they are now nothing more than their reciprocal relationship, until the painter endows them with his own meaning.

On the other hand, in this overriding relation of the painter to himself, we see developing an awesome commitment, from which he will no doubt often wish to escape. What is in fact happening when what is wanted is only that which I have called pleasure? In a sense, this painting, which forbids study prior to the creation of the work, marks the end of the imaginary, for others' myths must be accepted, whole or in part, in order to elaborate one's own. *Seeing*, in other words, the interest in perception that is nothing but itself, seems to replace *vision*, as Mallarmé was later to believe. But in another sense, this empty appearance can only compel the painter to project upon it a sense that he can draw solely from within himself, from a place where ready-made ideas and comfortable *doxa* no longer reign or give protection. There where the study meets its end, it is the assumption of the self that must begin, on the frontiers of the unconscious. A difficult task, one that can be tackled only by the courageous. Born,

we may say, of the death of God, the new painting, like free verse in poetry, also is the obligation to live henceforth without any support or any refuge.

Such is the desire, the determination of Manet, such is the new path of the spirit that *Déjeuner sur l'Herbe* forges and *Olympia* extends even further. This is not only an intoxicating discovery, a clear direction, the positivity of Being regained after centuries of interpretation and theory always falling short of the presence of the world; it is also an unceasing incitement to venture into the unknown and, therefore, something that can be admired and appreciated, but just as easily feared. Is it this risk that attracts Gaétan Picon? Or, on the contrary, is it what so long prevents him from approaching this moment of "birth"? Or is there perhaps another explanation?

III

An observation must be made, in any case, on the path that leads toward it: Creative irresponsibility did not triumph simultaneously in all domains, and around 1930 there still were in this regard some very real differences between painting and literature.

In painting, from Manet to Cézanne and Van Gogh, then to the Fauves, Cubists, Mondrian, Miró and Giacometti, the majority of artists had maintained and diversified the new poetics, and this new poetics was current also among the great poets, for it was the very principle that Rimbaud contrasted with the "poetic relics" before employing it radically in *Les Illuminations*. Later, Laforgue, in *Moralités légendaires*, Jarry, in *L'Amour absolu*, and Apollinaire, in *Onirocritique*, frayed the path to contemporary writing. "Literally and in all senses": that is how the text would signify, after the fashion of modern painting.

But poetry did not assume this liberty with as clear a conscience as painting. Apollinaire no less than Reverdy, Breton no less than Jouve wished to express their beliefs and values just as much as they wished to produce a text, which is not the least bit surprising, since poetry is made of words and thus of ideas, thought. A resistance had been revealed that was yet more powerful in Valéry and Claudel. As for the novel, it rejected the principle of liberty in almost all its experiments, which were, however, very innovative in their own fashion. Novelists never stopped "studying" what existed outside the work: whether for example, revolution in Malraux, or Southern society in Faulkner, which was then being translated into French. In 1937, when Gaétan Picon completed his studies, the contrast between the two lines of research was truly striking. Even Kafka was quite equivocal. He enjoyed dismantling the old symbolic discourse, but was himself torn apart by nostalgia for knowledge. Joyce, virtually single-handedly, put free invention into practice, whence his prestige, but among such a small readership! And philosophy came to the aid of the resistance, insofar as there flourished a genre that carried on the old aesthetic program in the space of thought, namely, the essay. Indeed, what is an essay if not a study enamored of truth but still open to a new intuitive sensibility or subjectivity, as in the time of Titian, Rembrandt or even Delacroix? The essay is art in the domain of thought, but an art that remains classicist, at least during the period of Paul Valéry and then Sartre.

On the periphery of this debate, there was in addition Academe. While its most advanced minds— I am thinking of Bachelard and Jean Wahl—could appreciate the new sources of creation, it remained nonetheless rather uneasy and restive. Born out of religious orthodoxy by the transformation of the metaphysical Idea into lay reason, it felt a duty toward knowledge and order, and was therefore scarcely ready to assume in all its consequences the vow of irresponsibility—total, at least moment-

arily—that established the modern work. It could thus feel excluded from the world of artists and their ilk, and all the more as it sensed that world's rich resources. Even the hothouse in the rue d'Ulm—the École Normale Supérieure—already had, and would long retain, a provincial air in comparison to this other world, which may be called "Parisian" on account of its propensity for disorderly yet bizarrely fruitful exchanges in the cafés and studios of one of the world's great crossroads. With his neophyte clumsiness, his naïve enthusiasms, and his invasive analyses that nevertheless remained external to the true problem—witness his unfortunate book on Baudelaire—Sartre again furnishes a nice example of this self-assurance mixed with a feeling of inferiority, and nothing is more significant than his fevered interest in Alberto Giacometti, who was a Parisian through and through.

Now, Gaétan Picon, who was so much more perceptive than Sartre insofar as art and poetry were concerned, so much more intelligent in the Baudelairian sense of the word, had an unusual response to Paris: one of impatience, agitation, hostility, which might well signify—despite the welcome he received from "Parisians," publishers, and all kinds of people—that he felt an outsider in the place where his generous spirit paid attention only to the extraordinary work that was being done there. And, reciprocally, his own gifts made him immediately aware of the responsibilities and riches that one may claim for one's own during wonderful years of study. In love with literature, especially modern literature (he adored Baudelaire; at age ten he parodied Ducasse's *Maldoror*; at sixteen he underwent the influence of Malraux's *La Condition humaine*), Gaétan Picon had also tried to understand it; the natural preferences that reflected his inner turbulence were brought to the same penchant for analysis that made him study

and then briefly teach philosophy. In sum, he had internalized a sort of categorical imperative that played, perhaps, the role of a brake in the core of his own nature, an imperative that would appear in *1863*. Poet and professor—few since Michelet have succeeded in combining the two roles.

I know no individual more contradictory than he, more cruelly divided within himself. It is this duality—or rather this multiplicity, this desire to lead "several lives," as he said, citing a draft of Rimbaud's—that gave him an evasive intensity, an authority that nevertheless lacked certainties, and, to hold nothing back, a charm that won over all those who recognized his shyness. One could only be beguiled by the intellect that was wise enough to make room for the most nonchalant subjectivity, by the marvelous lucidity that he nevertheless maintained, with enviable ease, in the wanderings of his imagination. But these twin imperatives weighed on his destiny. Born to the purple of the University, he had a long way to go before he could permit himself to follow his own path. And so he produced works that appealed to Academe: essays, novels, forums where truth sought itself, as in every thinker, rather than immediately found itself, as in every painter. In sum, he had to read, pen in hand, before writing or understanding what it was he wrote. He had to free himself from mental habits that some had already discarded in 1863.

I have in mind, for example, this idea of "pleasure." I brought it up a little while ago, in speaking of the new pleasure sought by Manet in the act of painting, which I contrasted with the fervor that tormented Delacroix. The "pursuit of pleasure," as it is said, was obviously not absent from painting or literature before the modern era, but its status was completely different. On the one hand, this preference had other ambitions than Painting and Literature, even if these ambitions might be harbored in their breasts—thus, Fragonard and Clod-

ion's erotic explorations. And to the extent that the pursuit of pleasure found a place in the work of art, it was therefore in opposition to the work's own purpose, which was study and asceticism. In short, the pleasure of creating had not been recognized in its aptitude to divert and sublimate all other purposes. These other purposes did not disappear but maintained their fierce grip upon the work of art itself. And for a young and feverish being, as Gaétan was then, that could be cause for hesitation, and a reason, though not the best, to prefer the old art, which allowed the beautiful, sensual ardor of the ordinary condition to be more clearly perceived.

How many paths we would have to tread in order to appreciate fully who Gaétan Picon was! What we would encounter, for example, at the point we have now reached is the book that he wrote about Ingres, clearly one of the still classicist creators whose sensuality and need for enjoyment willingly submitted themselves to the study of the Beautiful and the True, and moreover almost emerged triumphant, in *Jupiter and Thetis* and *Angelica and Roger*. Gaétan loved this temperament, loved to relive it in word. But that did not smooth his access to the austerity of modern painting.

However, he did, at the end of his journey, give his attention to modern painting. And it is moving, for the affection that became trust signified primarily the movement of a being in itself, across a whole life, and could even indicate that the author who only adjudged himself a critic discovered at this moment that he could allow himself the liberty of writing the way Manet and the modern poets had decided to paint and write. Chronologically, this appears quite clear. *1863* appeared in 1974, and less than a year later Gaétan Picon confided to Cella Minard, in his *Entretiens* (a series of interviews on Radio France-Culture)—and to several friends as well—that, as an extension to *Un Champ*

de solitude, which already went well beyond the critical domain, he had begun a book that he wanted to be "a circle-book, the book that would encompass everything." "A little like Michel Leiris's *La Règle du jeu*," he added. Clearly it was to have been a work in which he would pass from one moment of his being to another and another without deliberation. And perhaps it would have therefore marked the submission of reflective truth to the instinctive truth out of which Manet had made modern art. Was Gaétan Picon thus on the point of subscribing to this poetics of invention and creation above all else? Of learning painting's lesson? "I think that art criticism allows the transition to personal creation," he also remarked in his *Entretiens*.

IV

It still remains that the reservations he expressed about the new art in the last chapter of *1863* are not only important and thought-provoking but shed light as well on his own pursuits and even his destiny.

He makes note first of all of a certain resistance in others (but how close he comes to joining their ranks!), which, he says, "we should investigate." From this resistance he deduces that modern art is less an advent that once for all erases a way of being than a schism in whose shadow the old faith lives on. "The Refusés have won the war without achieving total surrender," he emphasizes. Noting the unease caused by *Olympia* and revived by Cubism, and the sort of welcome that these works later received—impassioned, but only from those with the right cultural background—he could not forget the medieval crowds that thronged around *The Mystic Lamb* under the spell of a more immediate and more profound emotion, a feeling that this work was their own inheritance. "We who like and understand the new art remain attached to the art

13

of ages past," he added, recalling (not that he accepted it, but because he understood it, especially its anguish) Baudelaire's well-known remark to Manet: "You are only the first in the decrepitude of your art."

Thus, the great events of 1863 did not fail to evoke a certain ambivalence in Gaétan Picon, and the cause of this perplexity is clear, even stated: It was the interest that, as the author of *Un Champ de solitude*, he had in the experience of time as it affects the living of life, the feeling that time is our ultimate reality, our only access to truth. Moreover, if one opens that book, or *Admirable tremblement du temps*, or *Entretiens*, the latter two being works that are roughly contemporaneous with *1863*, one will immediately discover that time is their constant concern, the center of all perspectives. "Time is for me," Gaétan Picon told Cella Minard, "the very space of art. All that I think, all that I feel, all that I love is dominated by the theme of time, not the juxtaposed structures of space." Time is all, since, Gaétan Picon could have said, we are all mortal beings with our choices to make, our responsibilities to assume, our values to choose—and even our own selves to perceive and discover—under its aegis, the one specific sign of our humanity's relation to language. Time is the real itself, and it is for this reason that it also dominates artistic creation. Is this creation a structure composed of partly unconscious elements determined by the sole "pleasure" that being oneself affords? Perhaps, but it is achieved through the abrupt reorganization of elements formerly in disorder, out of which one produces a new being. As a result, it is in this regard still an eminently temporal existential event, which has to do with the meaning of life and is infused with it and will come to possess its full grandeur only in understanding this meaning and deepening it.

When someone, Gaétan Picon said, could no longer adhere to his experience, his "constituted truth," and rebelled against it, that was the origin of the work of art. Thus, may we begin to grasp why this profound thought kept itself at a distance from the art of 1863, which it could not but admire for its daring and rigor. This thought knows, in fact, that revolt, the rejection of the old state that constitutes the artistic event, must, in order to be a real investigation, concern itself with the *totality* of life, its representations and values as much as its perceptions and fantasms. And what, as a result, is the worth of an art that is in contact with the totality of life (Manet is real, he breaks with all the stereotypes) but does not attach its thought to it?

Let us be clear about one thing: The intention is not to challenge the fundamental value of a painting's interest in the relationship between pure colors or the tension between forms, for the work that adheres as closely as possible to the sensory given certainly contains all our sense already. "The Rorschach test proves that we are prisoners of ourselves in our tiniest responses," Gaétan Picon wrote. "The least perception [. . .] whispers our secret like the reeds of the [Midas] story." But precisely for that reason should we not be concerned about a state of creation in which—for want of an authentic expression of the sensory world in the period's thought—our "secret" runs the risk of remaining secret, in a perception that is developed, transmuted, but unquestioned? Should we not be concerned that the work only makes perception speak in a manner that remains inaccessible, and inaccessible firstly to the artist himself at the moment of his great decisions? The work will finally deliver up its meaning—it is the critical operation—but to someone other than its author, and at a moment other than the one in which its author would have been capable, perhaps, of a surfeit of intuition and discovery. What is more, it will come at the cost of a deciphering—of a system of significations, an ideology. Nothing can keep alive the rebellion and hope that there was at the beginning.

. . . The virtue of the old art, Gaétan Picon held, was that through the correspondences, symbols, and signs of medieval thought, perception *spoke*, to the extent that it was part of the work; and as a result, the painter reflected, at the center of a collective reflection, on responsibility and freedom. From color and form one moved to sense.

But today? Did not Manet have to recognize—after the ultimate, desperate effort of Delacroix—that he no longer had this power? And having this knowledge, was he not therefore the one who would have the courage to continue painting in spite of everything—yet also the one who would fail to become alarmed at such a development, and even turn away from it, contrasting with it this "pleasure" that puts an end to a form of expression? I think therefore that, all in all, it is the pleasure in which artistic modernity consists that is the reason for Gaétan Picon's reproaches, if this is the right word to describe what is at first admiration and respect. He is afraid that modern art, unconcerned with the elucidation and exchange that accompany perception in ordinary experience, even today, has engaged itself, since Manet and in dangerous fashion, in the labyrinths of each individual's idiosyncrasies, which would serve only to supply sociology, psychology, or history—all disciplines devoted to an object and not to time as it is lived and presence—with documents and themes. Thus, in effect, would be lost the signs that inscribed the human as such in Being and allowed it to remember its difference and its plans. Considering Kandinsky's "first abstract watercolor," a new stage in what he feared was an irreversible advance, Gaétan Picon notes that art and the physical world had become one, at the expense of the relationship of the person to himself that used to be found on the canvas. A Kandinsky has meaning, but only as an index of a point of view that is no longer that of a particular existence. "From the majority of the significant forms of contemporary art, time, human time has disappeared." Now, if Kandinsky represented a "new start," it was as a consequence of 1863. "The events of 1863 blazed the trail for its most recent avatars. It is understandable that an art moving nearer and nearer to the thing and capturing it as we have not previously perceived it may appear *produced*, not *reproduced*." This means that it erases the distance at the heart of which we find the sign, to which we owe our existence.

V

When he wrote *1863*, Gaétan Picon did not, however, subscribe to the principles that this date recalls. And there is no reason to think that he came to this "birth of modern art" in order to make it his truth and the key to personal creation. Rather we must place under the rubric of his reservations the greatly important study that should be made of his work still too little known.

The aim of his critical investigations would appear clearer, suggesting, as I said earlier, dues paid to analysis and understanding, before receiving one's own permission to "create." Is *L'Usage de la lecture* not a "study," rather than a reflection upon the simple "pleasure" that had held Joyce's attention and was then presiding—the first volume dates from 1960—over the effervescence of what is called "writing"? If so, it is the study of time as it is lived by the individual whose work Gaétan interrogated, lived either in days or as the recovery that art opposes to them. It is the study, consequently, of an interiority that one can approach only with means that resemble it. It requires the involvement of the "critic" at that profound level of his being where poetic creation takes place. Few works of commentary are more intimately written and thought than Gaétan Picon's. We see him not simply "understanding," as other exegetes in this era of all manner of investigations seek to do, but admiring, rejecting, judging, and moreover declar-

ing (in the important preface to the original edition of this great book) that he is not concerned with the preparatory or complementary readings that are the tools of the man of science.

And here he is toning down, if not dispensing with, the supposed opposition of two forces in his life and revealing the degree to which the reservations he expressed in *1863* were an old and profoundly experienced conviction. In fact, Gaétan Picon posed implicitly, in his work as a "reader," the question that is stated more clearly at the end of his reflections on Manet. And one may even think that modern painting did not demand his attention, subsequently, as the image of a right to the creative freedom that he approached little by little, but on the contrary, as the enigma whose measure he ended up taking. As a result, *1863* is less a work of criticism than a moment in his most decidedly personal reflections. Indeed, Gaétan Picon, coming out of the world of thought, seems almost intimidated by these masters of instinctive decision, but he nevertheless tackles them with the aim of making, discreetly but firmly, a judgment on an experiment that seems to him dangerous.

His ultimate work, this "circle-book, the book that would encompass everything"—what would it have been if not the culmination of all his earlier work, that is, a combination of critical reflection and roving imagination that makes the text of *Un Champ de solitude* transform itself from moment to moment like a dream? We see in this long prose poem, which recalls Chateaubriand and André Breton, what may be a literature that strikes a balance between obedience to profound Being and the search for a "common ground": between invention and composition, between *pleasure*, in Manet's sense, and *duty*, in Baudelaire's. And we perceive in it an authority that is all the stronger for having examined the disturbing thoughts that contradict it, and a profound reflection—at the cost of much hesitation and suffering—of the contradictions of an age.

Gaétan Picon

1863

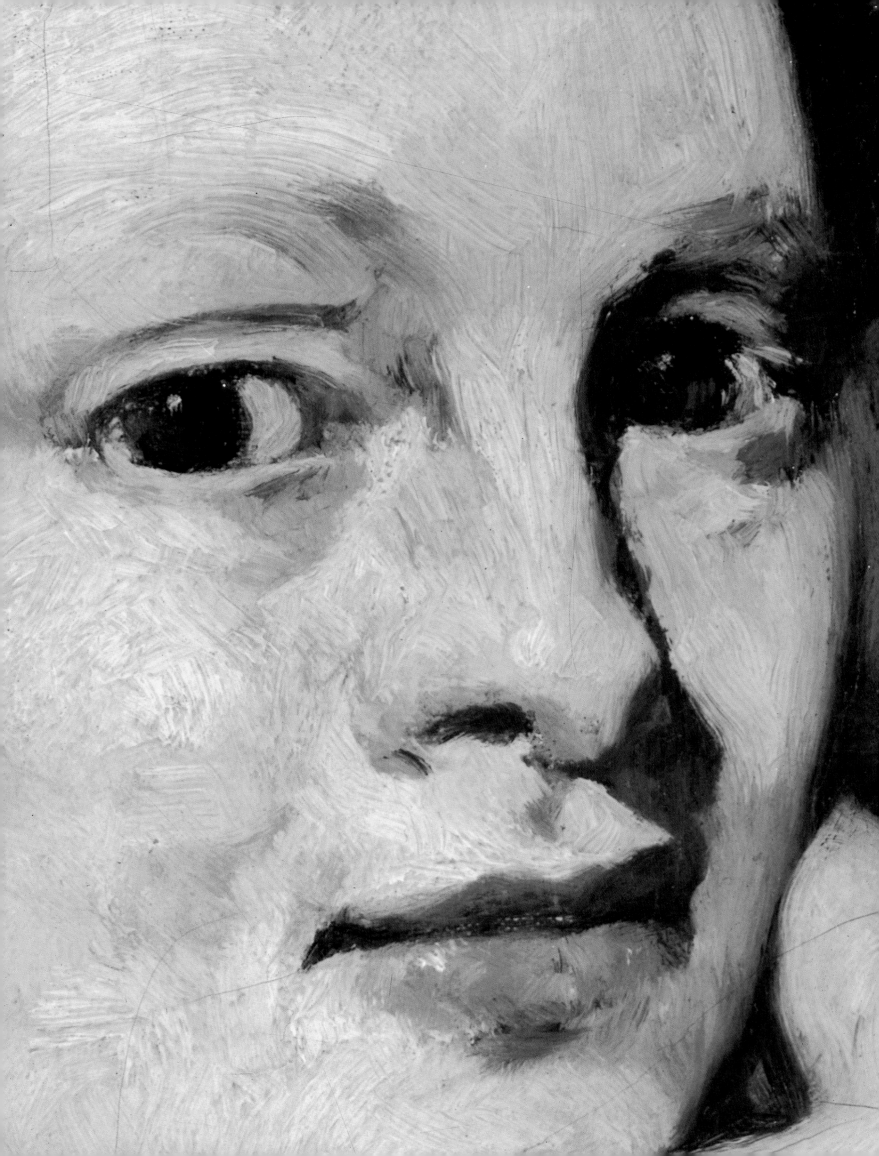

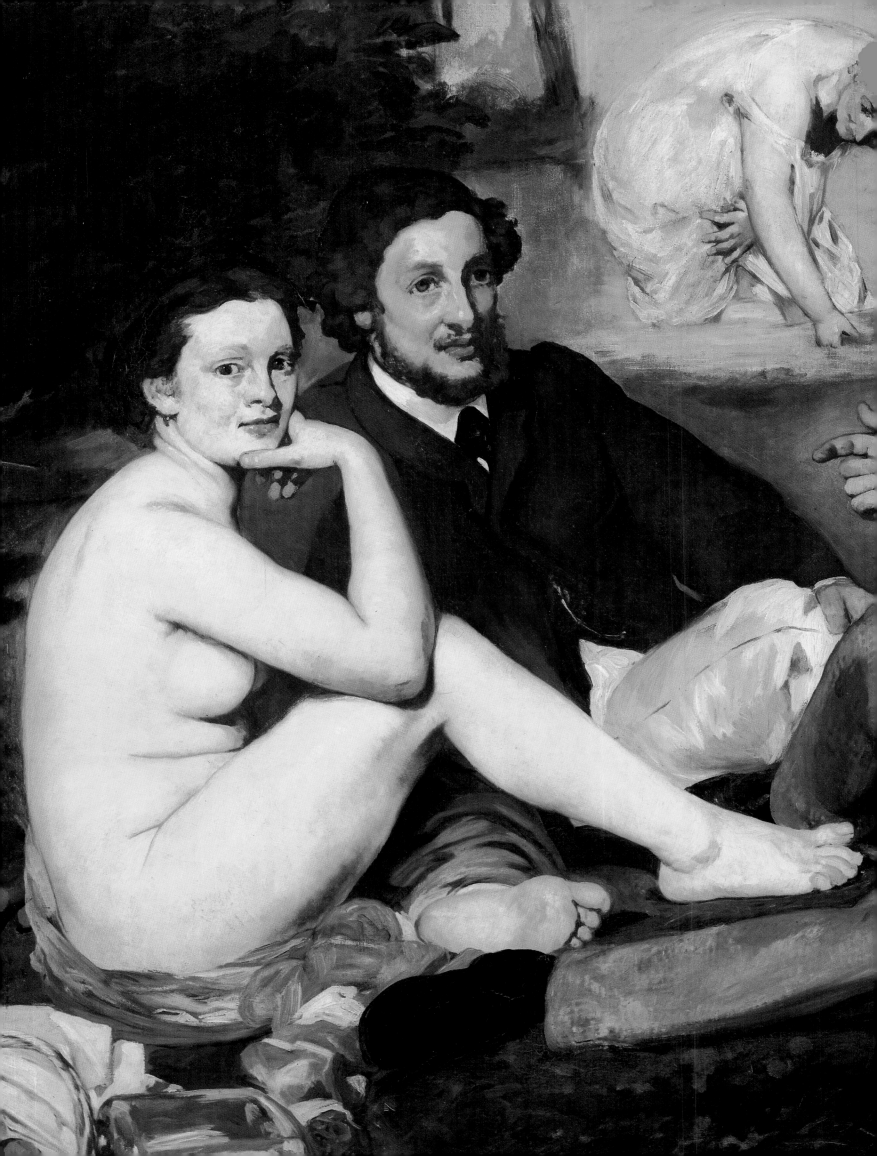

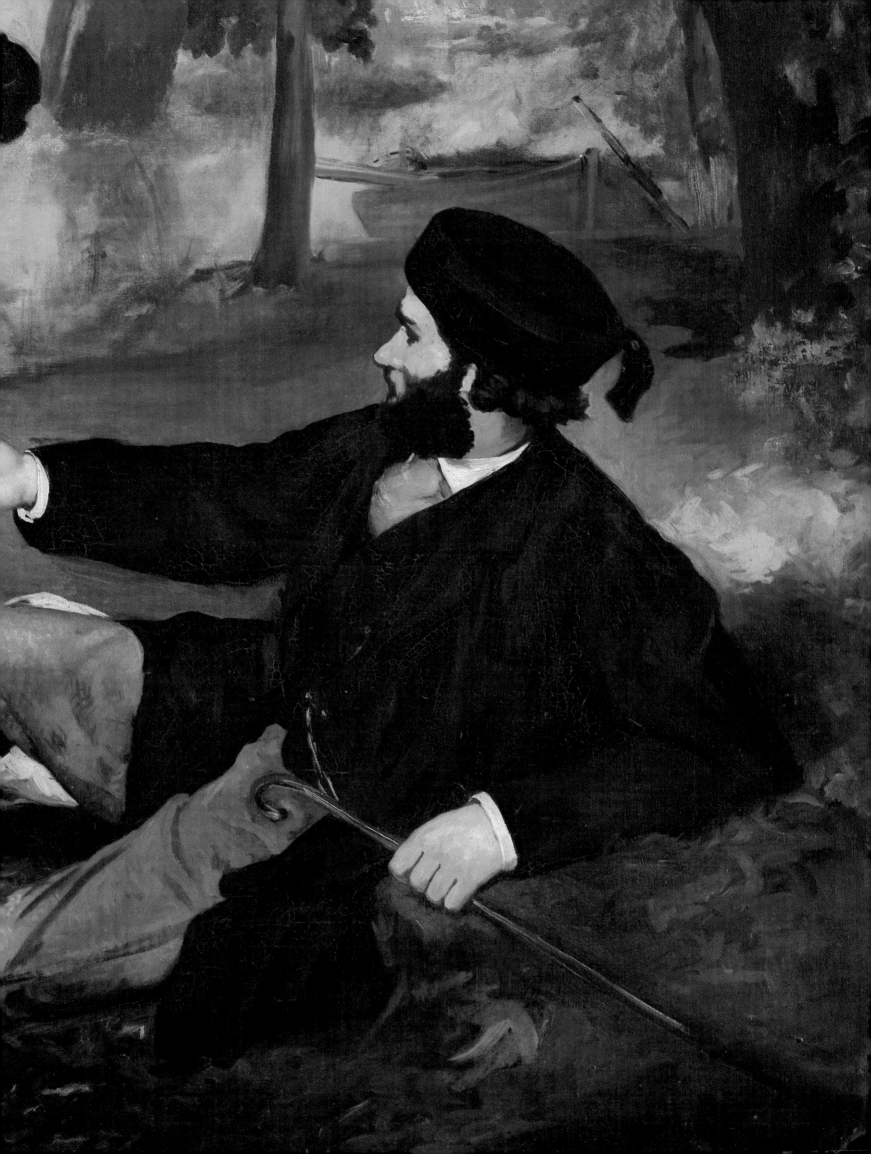

Memory, he put it then so well:

"The eye, a hand . . ." let me but return.

Mallarmé. *Some Medallions and Portraits: Édouard Manet*

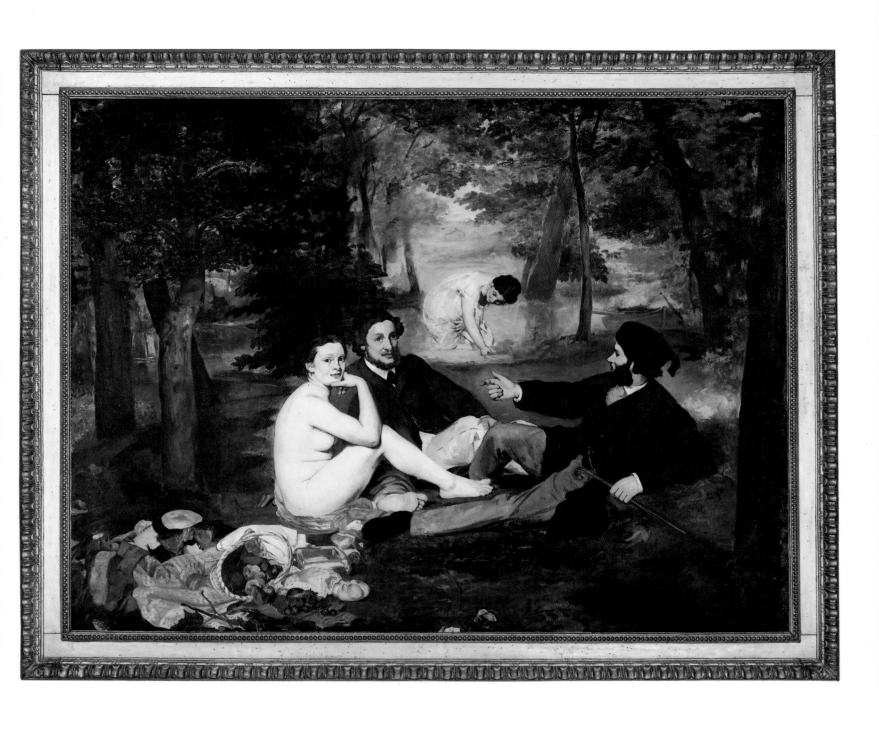

Édouard Manet,
Le Déjeuner sur l'Herbe, 1863
Details pages 19, 20–21

23

When the Salon des Refusés (the Salon of the Rejected) opened in Paris in 1863, history saw to it that events in the world of painting were staged in such a manner that we might recognize all the signs of a break with the past and a new beginning. The great actors of the preceding play were making their exits or speaking their last lines. On August 13, Delacroix died, and the obituary that styled him "Member of the Institute" added the highest professional epitaph: history painter. The 83-year-old Ingres, after puttering for so many years, had just completed his last composition, *The Turkish Bath*. The scandal of the Salon des Refusés attested that a new play had opened, with a company of forces that had been quietly rehearsing for some time. The play had several leading characters, but only one hero: Manet. And *Le Déjeuner sur l'Herbe*—praised or panned—could well serve as its title.

While it is true that this event, anecdotes aside, marked the true beginning of a kind of painting that we still recognize as the source of our own, the event should be viewed in the light of a history that had yet to be made, a history that it did not even know it carried within—as something that had not yet taken place, but would. At the same time, we should try to refrain (no easy task!) from the perspective of hindsight; in other words, we should try to rediscover the shock that has since been softened. The event would best be viewed as something that really was occurring for the first time, although everything now pushes us to situate the liberating break, the commencement, at an earlier or later date.

Let us recall the circumstances. Paris's few private galleries rarely mounted exhibitions, so the official Salon was the artists' one great opportunity. The Institut de France, bastion of academicism, had sole discretion over the choice of judges. The revolution of 1848 had installed a panel of independent artists (Théodore Rousseau among them) and decreed that a salon showing all submitted works would be held annually. But the Institute promptly resumed its powers, and, in 1857, the annual salon was discontinued. The number of protests grew unceasingly: against the two-year wait between Salons; against the composition of the selection committee; against the selection criteria and the high

number of rejections. Of the five thousand works submitted in 1863 by some three thousand artists, only two thousand were accepted. The rejected canvases included the work of such well-known painters as Chintreuil, Harpignies, and Jongkind. Disturbed, the Emperor spoke to Count Walewski, Minister of State for Fine Arts, and Count de Nieuwerkerke, Director-General of Museums. The minister courteously received a visit from Gustave Doré and Édouard Manet, but denied their requests. The excluded artists appealed in vain to Louis Martinet, director of a major gallery on the Boulevard des Italiens. They appeared to be out of luck. Then in a bolt from the blue, an announcement appeared in the April 24 issue of *Le Moniteur*:

> Numerous complaints have reached the Emperor on the subject of the works of art rejected by the jury of the exhibition. H.M., wishing to allow the public to judge the legitimacy of these complaints, has decided that the rejected works of art will be exhibited in a wing of the Palais de l'Industrie. Participation in this exhibition will be voluntary, and the artists who do not wish to take part need only inform the administration, which will see to the prompt return of their works.

During the preceding days the official Salon had received an impromptu visit from the Emperor, who had, with a gloved hand, turned over some of the rejected canvases. Judging them to be no worse than the rest, he had dismissed the protests of the administration, which respectfully noted that a line had to be drawn, that the lower ranks were a social danger. So May 1 witnessed the opening of the official Salon, ruled over by Flandrin's *Napoleon III* and Winterhalter's portrait of the Empress. On view were many mediocre canvases, notably the two battle paintings by Protais that Napoleon III purchased for the sum of twenty thousand francs; Baudry's *The Pearl and the Wave*; Cabanel's *Birth of Venus*; J.-P. Laurens's *Death of Cato of Utica*; and Alfred Stevens's *Ready to Go Out*. But there were also works by Corot (*Study at Ville-d'Avray, Rising Sun*), Courbet (*Fox Hunt*, a female portrait), Millet (*Return of the Flock, Woman Carding Wool, Man with a Hoe*), Rousseau (*Clearing at Fontainebleau, Pond*

beneath the Oaks), Puvis de Chavannes (*Work, Rest*), Daubigny, Guigou, Fromentin (*Hawking in Algeria*) and Gustave Doré (*Episode of the Flood*). Two weeks later the Salon des Refusés opened its "exhibition of works not accepted." It was referred to as the Salon of the Losers and even, sotto voce, the Emperor's Salon. Certain artists dared not exhibit. Only 1,200 out of 1,800 chose to do so, and the catalogue, as a result of the administration's sabotage, listed only 683 titles. At the same time, others had paintings in both salons.

Courbet's case, however, was unique. His representation in the official Salon was automatic, since he was a past medal-winner, but one canvas, *Return from the Conference*, which showed drunken clergymen staggering down a road, was rejected for indecency at both places and, therefore, was exhibited at his own home. Still, Manet was joined by Whistler (*The White Girl*), Chintreuil, Harpignies, Jongkind (*Winter Effect, Canal in Holland, Ruins in the Nivernais*), Fantin-Latour (a portrait and *Féerie*) and Pissarro. With the Emperor's backing, the artists had won the institutional game. The annual salon was reestablished; Count Walewski was replaced by Marshal Vaillant; and the Institute was dispossessed. Henceforth, the committee of judges (all paid) would be composed of three quarters exhibiting artists and one quarter administrators.

When, today, we revisit *Bathing* (the original title of *Déjeuner sur l'Herbe*), we see it as belonging to the museum tradition. It draws its inspiration from Giorgione's *Concert Champêtre* and Raphael's *Judgment of Paris*, which Manet knew from the engraving by Marcantonio Raimondi. The composition remains decorative; we imagine the canvas on a wall, an architectural element in the Italian tradition; the suggestion of perspective remains perceptible. As for the technical peculiarities, what is there that is not already to be found in the work of the Dutch, notably Hals? Or of the Spanish, whose influence is plainly acknowledged by Manet's other works on show (two canvases: *Young Man in the Costume of a Majo, Mademoiselle V. in the Costume of an Espada*; two engravings: the *Little Cavaliers* and *Philip IV* after Velázquez)? How to find a breach here? Whether a museum of modern art should begin with the early Cézannes, the *Demoiselles d'Avignon* or Kandinsky's first abstract watercolors is open to discussion. But who would ever dream of starting with *Déjeuner sur l'Herbe*?

The Jeu de Paume is part of the Louvre. And if we hesitate to identify the breach with Manet, we have even less reason to find it in the other painters who enjoyed the hospitality and honor of the Salon des Refusés, for they scarcely differ from the few great artists that were accepted by the official Salon. If breach there was, is this breach still visible to us? Has it not long since been "co-opted," attenuated, subdued by a tradition from which it escaped only superficially, anecdotally?

One may wonder whether people, at the time itself, were conscious of the rupture. Has not the caprice of history's footnotes—and history's tendency to overdramatize—given the event an appearance disproportionate to its immediate and specific reality? For the first time, admittedly, a group of painters rejected by an official selection committee decided to exhibit separately. But only at the suggestion of the Emperor, whose intercession was prompted by liberalism and a desire to create some mischief for the Institute (a center of opposition), and whose preference for Protais and Baudry over Manet was hardly clairvoyant. Sympathies, "morality," politics all contributed to the event's high profile. And certainly, on an administrative level, the Refusés won a lasting victory. But the relations of art to officialdom and to the State were not a crucial chapter in its history.

Of course, Manet's canvases did cause a scandal. But the general reprobation that prompted Castagnary to write in *L'Artiste*: "Now we know what a bad painting is" and that drew the words "sorry and grotesque exhibition" from the pen of Maxime du Camp (*Revue des deux Mondes*) also struck Courbet and Millet, "official" artists whose talent was unquestioned. All of this confirms that the principal provocation was the subject, which has become for us so minor a matter that it risks being overlooked. Paul de Saint-Victor wrote:

Monsieur Millet plunges deeper down the path on which Monsieur Courbet has lost his way. For him art is limited to the servile copying of ignoble models. Millet lights his lantern and goes off in search of a cretin. He must have searched far and wide before finding this peasant resting on his hoe. Similar specimens are uncommon, even at the Bicêtre asylum.

Manet introduced, as Zola stated, a "new way of painting," and he would not go unnoticed! But while none of his admirers—not even Zola—truly saw his profound

and active innovation, no detractor attributed his faults to the definitive lack of talent that was later charged to Cézanne; he was simply advised to choose other subjects and to undertake further studies. Ernest Cheneau, for example, wrote: "Manet will have talent the day he learns drawing and perspective; he will have taste the day he renounces subjects chosen to provoke a scandal." We find that the same qualified remarks employed by almost all his adversaries were used also by his partisans. Zacharie Astruc is the one who showed the most enlightened enthusiasm: "He is the star, the inspiration, the dominant flavor of this salon. Manet's talent has an aspect of decisiveness—something cutting, spare and energetic—which explains its nature, simultaneously reserved, exalted and, above all, sensitive to intense impressions." Excellent words, no doubt, but no guarantee that their author really knew that he was in the presence of a decisive event. As for the famous article written by Zola in 1867 and aptly titled "A New Way of Painting," the text does not quite live up to the title: "This audacious artist, although the object of ridicule, uses very sound methods [. . .]. In sum, if I were asked what new language Édouard Manet speaks, I would reply: he speaks a language of simplicity and precision." Does Zola express himself in this way in order to reassure? I think not. Simplicity, precision—these were his own values, and he was later to rebuke Manet and his followers for abandoning them. What's more, if Zola believed, or forced himself to believe, in the latent genius of the age, he did not and would never consider that its incarnation had already appeared. He continually called the creators precursors and pioneers; perennially, he awaited what had already arrived.

It is an attitude shared by Baudelaire, with this difference, that his judgment of Manet—in spite of the charm that he found in the pink and black jewel—lagged further behind Zola's. Baudelaire never spoke of Manet as he had of Delacroix, or even of Constantin Guys; he never recognized in him the man whom fate had destined to express "the heroism of modern life." In 1862, Manet had to share Baudelaire's praise with Legros:

Messrs. Manet and Legros combine a definite taste for reality, modern reality—a promising start—with an imagination that is lively and wide-ranging, sensitive and bold, without which, it must be said, the greatest talents are but servants without a master, agents without a government.

Baudelaire lived in anticipation: "It is true that the great tradition is lost, and the new one not yet established" (1846). But he did not see Manet as the one who would put an end to his wait. And if he seemed to have intuited Manet's importance, there was also an element of denial, denial of the art thus heralded. The letter of 1865 is well known: "You are only the first in the decrepitude of your art."

As for the Goncourt brothers, apart from their excessive esteem for Decamps, they were rarely mistaken, during the decisive years between 1862 and 1865, either on mediocrity ("Solid respect is reserved for painters who were not born to be painters: Flandrin, for example") or on talent and genius, giving due praise to Millet and especially to Daumier. But strangely, they found nothing to say of Manet.

And yet, what may be mistaken for an historical accident betokens a truth that was not recognized at first and may be overlooked today. On the Paris painting scene of 1863 something was truly beginning, and whatever tradition we may find in it takes on a whole other meaning. It was the dawn of a new age, one whose final avatars we still experience.

"Painting begins with Manet," Gauguin was to say.

The End of the Imaginary

The traditional figures of the imaginary still dominated French painting in the first half of the century. David did not so much replace mythology with history as he mythologized history. Gros did the same, though he was reproached for painting soldiers rather than heroes. While the figures in *The Raft of the Medusa* (like those of *The Fualdès Story*) were taken from newspaper reports, they were inflated to legendary proportions. History was worthy of the art and style of Antiquity, to which belong *General Bonaparte Visiting the Plague-Stricken at Jaffa*, *Marat Assassinated*, and *The Death of Bara*. Prudhon's portrait of Josephine—and her reverie—is less characteristic of his work than are his Hellenistic dreams, his Psyches and his Venuses, or the famous allegory of *Justice and Vengeance Pursuing Crime*. The exact likeness of the *Two Sisters* defines Chassériau less than does the nudity of his imagined Esther or the frescoes on

such themes as *Peace*, *Silence*, and *Meditation* that he painted for the Cours des Comptes. The pathos-laden gesticulations of the large-scale compositions that today hang in the Grande Galerie of the Louvre have the air of farewells to a grandeur that is slowly fading. And how these figures of the imaginary shine in the last works of Ingres and Delacroix—contemporaries of Manet's earliest ones—before they are extinguished by the light of the rising sun!

In Manet's first canvases, something approaches us for the first time, its brilliance haunted by the absence of what it has just replaced. That something is what we must try to define.

Let us compare Delacroix's frescoes in the Church of Saint-Sulpice (*Jacob Wrestling with the Angel*, *Heliodorus Driven from the Temple*) and Ingres's *Golden Age*, *Jesus among the Doctors*, and *The Turkish Bath* not with *Olympia* or *The Fifer*, but with the most traditional of Manet's paintings: *Le Déjeuner sur l'Herbe*. What a chasm divides them! With Delacroix as with Ingres, an image was formed slowly in the mind, prompted by, say, a reading of the Bible or perhaps a letter from Lady Montague about the hot baths at Andrinopolis, which Ingres read in 1819. Entrusted to the dream, to the work of draftsmanship and sketching, it was patiently reeled in before being landed on the shore of the painting. Of each figure, we are inclined to say that *it reached that point*. The attitude of each seems to result from prior actions, prior trials. The stasis we find in Ingres's work prolongs and preserves the equilibrium of a position chosen with full knowledge of its cause; the violence of Delacroix's movements reveals that the drama has reached its climax. And just as each figure comes out of a past that confers meaning, it belongs also to a space from which it has been extracted and with which the painting communicates. Each sign is the now of a then, the near of a far. In time and in space, there is an elsewhere toward which our mind and our eye are attracted. In *The Turkish Bath*, the distribution of light and shadow accentuates the back and turban of the woman playing the viol in the foreground; then our gaze shifts from her to the depths, where darker groups the size of figurines form, and finally, we move toward the door, which, even if it were locked, would lead us elsewhere. In the Church of Saint-Sulpice, too, the light that falls upon Heliodorus being flogged by the angels and knocked

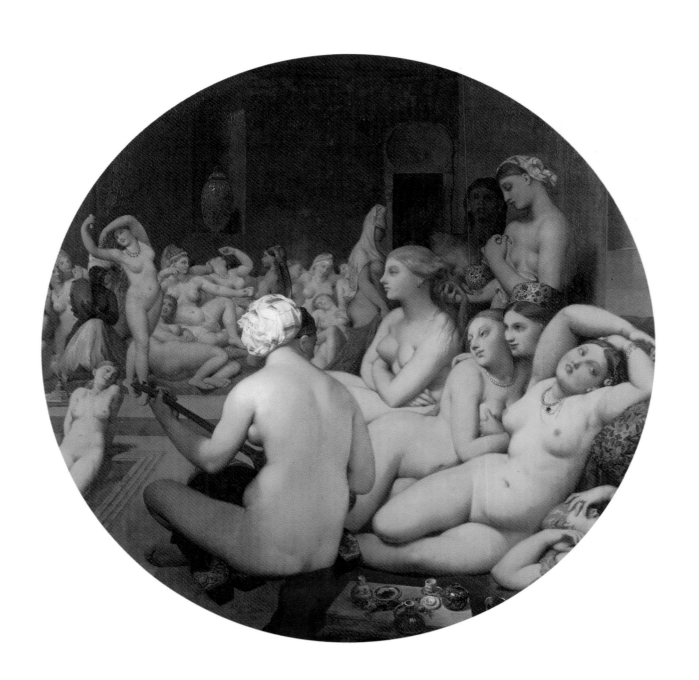

down by the horseman comes from elsewhere, from a space that we cannot see (since our field of vision is reduced to that of the image) but with which the image interacts. The image is tightly framed, closed in on itself, but the very sharpness of the framing confirms that it has been cut off, extracted from the continuum to which it rightfully belongs. Each image is the sign of another, sign of an elsewhere; it is borrowed from the storehouses of a world, an imagination and a body of knowledge that hold everything worthy of representation; the artist has only to choose the most deserving object, the best moment, the best state.

The striking contrast we find in Manet is a kind of absolute presence of the image. Clearly, it is less tightly framed, more open. And yet, it seems to possess a kind of independence. As it comes toward us, it seems to have severed its ties with the spatio-temporal elsewhere. The scene is acted out here, now, right in front of us. The attitude of the figures is no longer the result of an earlier action; it is the truth of the moment, not a history, but a presence. Whereas the figures of Ingres and Delacroix look at one another or gaze off at what is not represented, but exists all the same, the woman in *Déjeuner sur l'Herbe* looks not at her companions, but at the flash that catches her. What is represented refers less to what else is represented (the whole, or one of its parts) than to the act of representation—very much like Velázquez's gaze in *Las Meninas*. And the remaining suggestion of space is less a distance into which we enter than a "void" conferring upon us the appearances in the foreground—the only plane that counts. The scene has not been imagined, but seen. It is not a choice among the images furnished by the imaginary, but an encounter. According to Antonin Proust, the idea of painting a nude outdoors in the daylight came to Manet one Sunday at Auteuil, while he was watching the white skiffs criss-crossing the river and striking their light counterpoint against the dark blue of the water.

The end of the imaginary, the end of all that belongs to collective memory and dreams, the end of models that the individual does not meet, but must reconstitute, reanimate: legends and myths, great deeds and historical figures, ideal representations of beauty, ideal objects of desire . . . The end of the world conceived as a whole, as a totality in space and time waiting in the background of

Jean-Auguste-Dominique Ingres,
The Turkish Bath, 1859

each presented image, the end of the world as a hierarchy in relation to which each image chosen must situate and justify itself . . .

More precisely, what was ending was the possibility of restoring to the imaginary a universalizable authority, the possibility of making it live again for everyone, or at least for most people. We do indeed run into its figures again. But either they have become lifeless bodies and empty clothes, or else they are specters, occasionally fascinating, but reclusive, difficult to communicate with. From 1863 on, the history of painting was to be essentially the history of perception, not imagination. Cubism, abstraction, and action painting are the consequences of a painting of the perceived, even if they depart from it by recombination or invention. Meanwhile, Symbolist and Surrealist painting define themselves as fringe forces, an opposition.

Degas, with his classical temperament, started out painting large-scale historical compositions: *Spartan Girls Challenging the Boys*, *Alexander and Bucephalus*, *Semiramis Founding a City*, *The Daughter of Jephthah*, *The Plight of the City of Orléans*. But even then the museum formed only half his experience, one of the terms of an antinomy ("Ah! Giotto," he wrote in an early notebook, "let me see Paris! Paris, let me see Giotto!"). Following in Manet's footsteps, he would come to see Paris better and better. *The Bellelli Family* (ca. 1860) was still an admirable classical grouping, but it was soon followed by the jockeys caught in the instant preceding the start of a race and by Manet himself, drawn seated on a chair, hat on knees and overcoat dragging on the ground.

Admittedly, such painters as Puvis de Chavannes, Gustave Moreau and, later, Odilon Redon, as well as engravers like Meryon, cannot be overlooked. But they remained on the periphery despite their talent, even their genius. Unlike Manet or Degas, Jongkind or Renoir, Pissarro or Monet, they were not the makers of the new painting. Theirs was an isolation, an "alienation" that had its own fate: the traditional imagination to be found in the spirit and the very techniques of their art appears either somewhat diluted, at a lower temperature, as in Puvis de Chavannes, or marked by a certain febrility, a dreamlike intensification, oblivion, or outright delirium, as in Meryon. Since the imaginary was no longer life, it could be only their fantasy, their madness, or their conceit—a concept that risked

Eugène Delacroix,
Heliodorus Driven from the Temple, 1861, *detail*

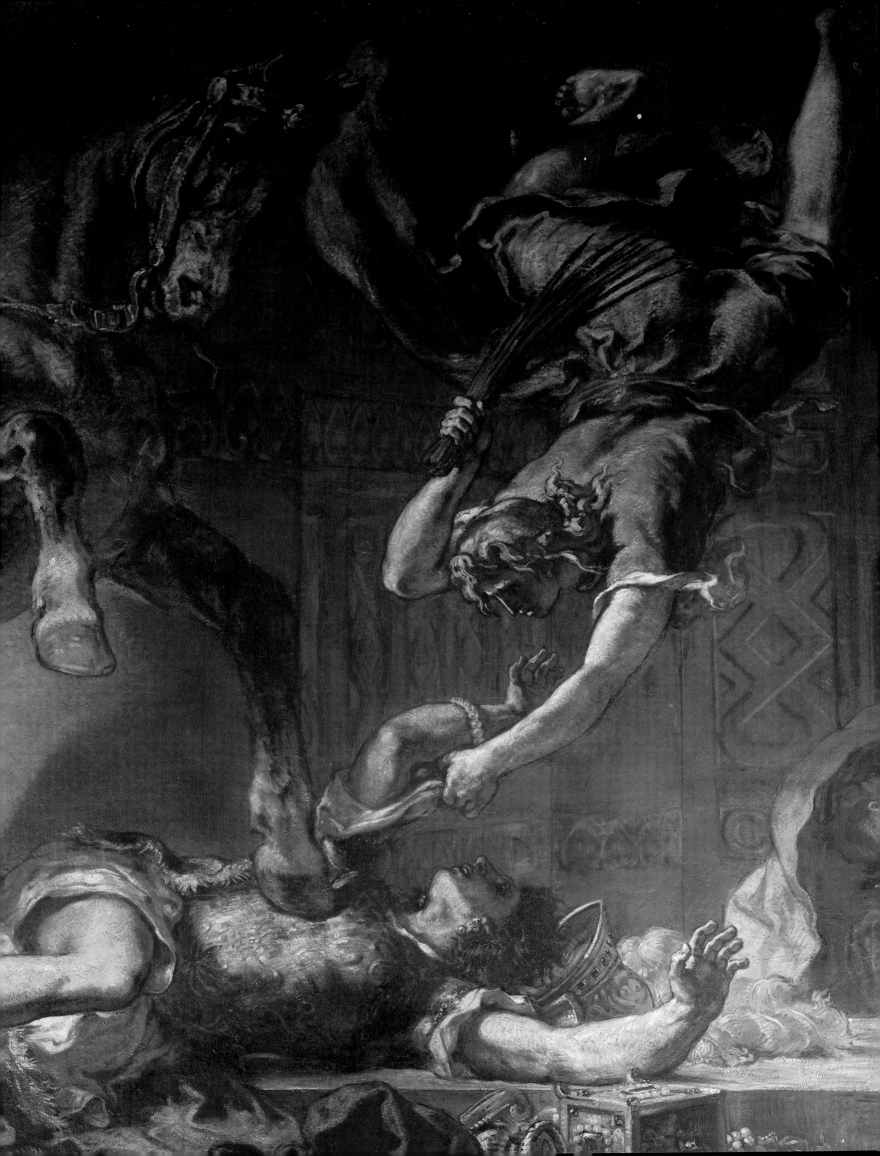

being empty, and did become empty in passing from Puvis de Chavannes to Cabanel or Baudry.

The depth of the schism is demonstrated by the fact that painters as clearly mediocre as Cabanel and Baudry, who exhibited at the official Salon, could have been the heroes of critics for whom Manet was the whipping boy, even though the critics in question lacked neither intelligence nor visual acuity. (For it is Gautier who described *The Pearl and the Wave* by Baudry as "the strange in the exquisite, the rare in the beautiful," while Paul de Saint-Victor reserved his accolades for Cabanel's *Venus*.) With few exceptions, no one realized that the traditional imaginary had become impossible. Habits persisted, each retina received its consecutive images. Very few noticed the bloodless pallor of the art that was concerned with themes and schemes of composition, an art whose last glimpse of sun was let in by Ingres and Delacroix (or even Proudhon and Chassériau). What was withering had so many roots that it could not die instantly, any more than what was aborning could be received in one fell swoop.

Taking place was a change of life, not the refutation of a doctrine or the mere substitution of one truth for another. What had once been fertile was no longer. Today's sterility served only to underscore yesterday's fertility. Baudry, Cabanel, and Gérome practiced the lessons of Ingres: the primacy of draftsmanship; the repudiation of brushwork; the belief that the model is nature corrected by the drawing of Antiquity, that the painting should be fully conceived before being executed, etc. All this was consistent with the subjects they treated, but these subjects spread death around them; whereas for Ingres they had still been alive . . . But the young painters who rejected these subjects as so many cadavers and denounced the nullity of official art perceived the genius of the masters from whom they kept their distance much more clearly than did the official artists. They could see as alive what had been living, and they culled those aspects that they might use to advantage from among the sources of inspiration that were now inaccessible. Degas, for example, started out copying Ingres's drawings. And we should not forget that Ingres's painting, foreshadowing a *modernity* that would reveal itself only later, appeared *flat, Chinese, primitive* to more than one critic of the day. But Ingres's overall lesson ran counter to the explorations of the

Édouard Manet,
Le Déjeuner sur l'Herbe, 1863, *detail*

37

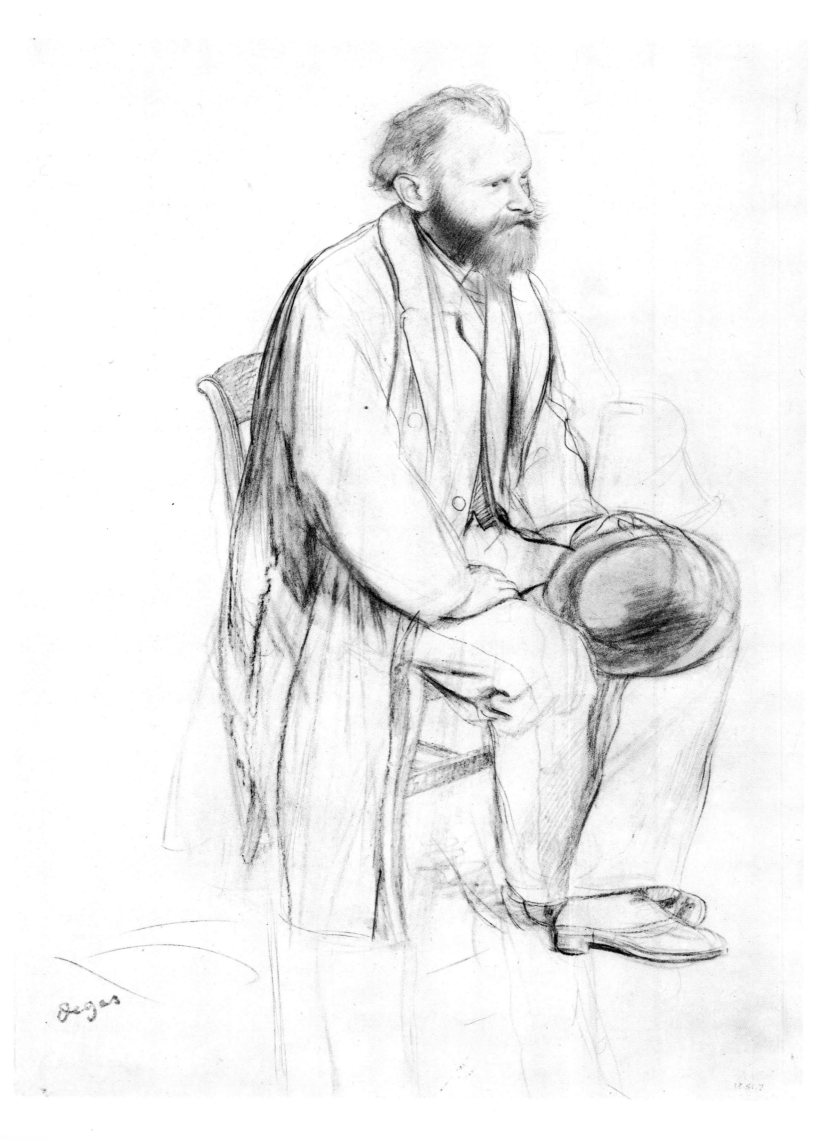

young painters. However, even if they could not share his spirit, they admired and remembered the art of Delacroix.

In 1864 Fantin-Latour, who some years later would paint an homage to Manet (*Studio in the Batignolles Quarter*), painted an *Homage to Delacroix*. Often, at night, Bazille and Monet watched the master at work through the windows of 6 Place Furstenberg. Seeing him at a ball, Odilon Redon dared not speak to him, but followed him through the nocturnal streets without approaching. It was admiration for Delacroix that brought together Cézanne and Choquet, a customs clerk and collector. And their admiration was more than nostalgia for the irretrievable—to what would never ever (as Baudelaire said) be found again. It was discovery of the two elements whose dialectic would govern the new art: on the one hand, a more precise analysis of color sensation, an accommodation to a closer reality; and on the other, not only the freedom of the brushwork, but the invitation to reveal oneself. The canvas would henceforth bear the mark of actions as important as the object they were directed toward. It is Delacroix who wrote in his *Journal* of "this air, these reflections that form a whole out of objects of the most disparate colors." It is he who praised the rough draft and the sketch that gave "freer rein to the imagination." It is he who, in extolling Titian's brushwork ("this broadness of handling that breaks with the aridity of his precursors and is the perfection of painting"), saw in it a means of communication, which need preoccupy itself with naturalism no more than do the incisions of the engraver or the lines of the draftsman.

However, Delacroix would recognize his heirs neither in the academic painters who maintained appearances without preserving life nor in the painters of the Salon des Refusés who preserved the life while rejecting the appearances. He considered that Titian's brushwork had "nothing in common with the monstrous abuse of technique and the lax style of the painters who mark the decadence of the arts." And one suspects that Delacroix inspired Janicot to write the following lines in the *Gazette de France*:

M. Manet has all the qualities necessary to be unanimously rejected by every jury in the world. His sharp colors pierce the eyes like a hacksaw; his figures are stamped out with a coarseness unsoftened by compromise. He has all the bitterness of green fruits that will never ripen.

Edgar Degas,
Édouard Manet with a Hat, 1865–1870

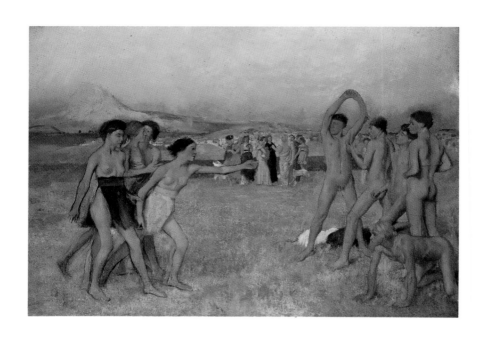

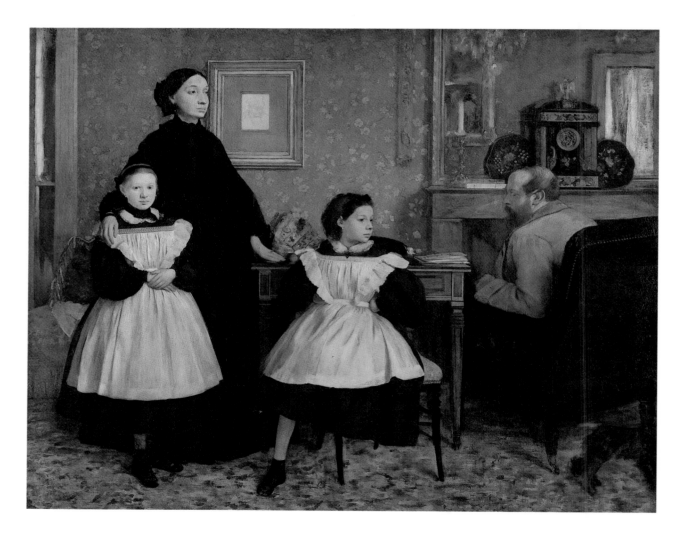

Edgar Degas, *Spartan Girls Challenging the Boys*, 1860
The Bellelli Family, ca. 1860
Gentlemen's Race: Before the Start, 1862, *detail*

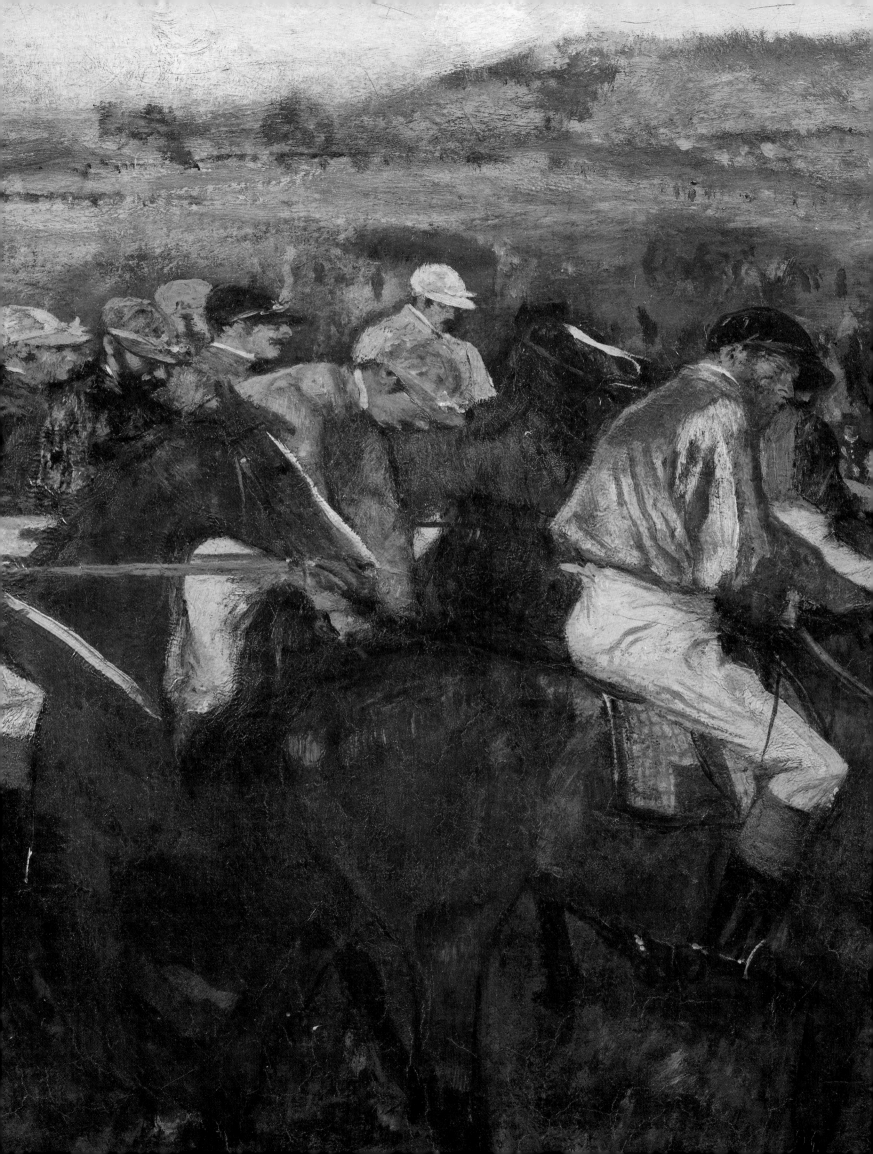

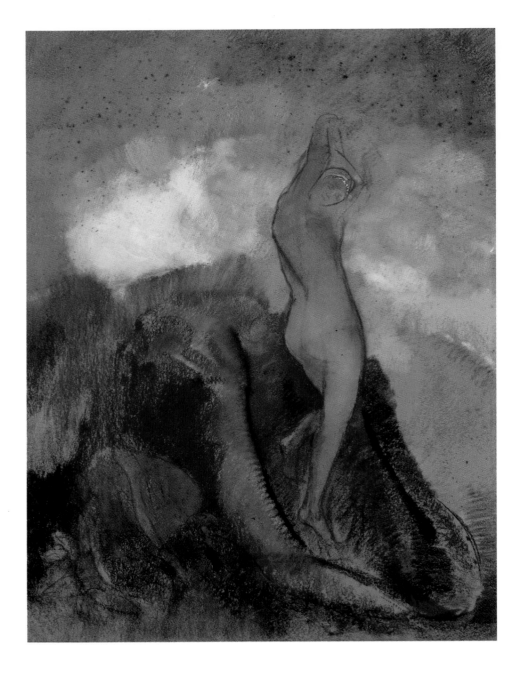

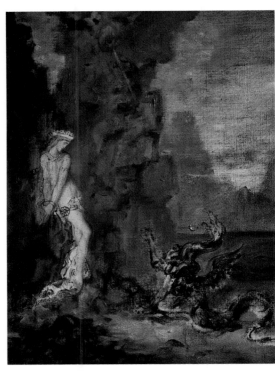

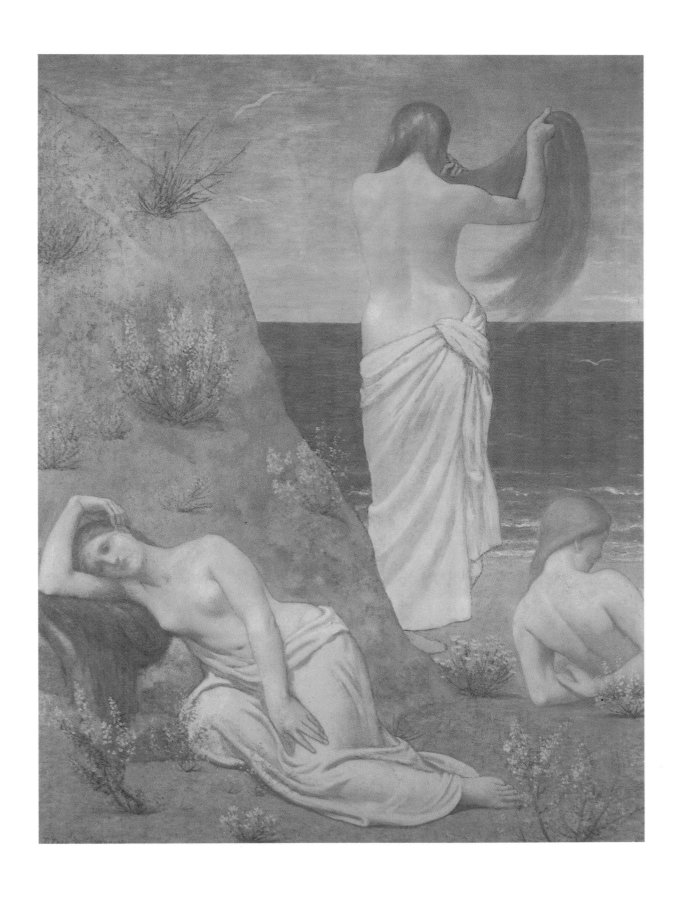

Charles Meryon, *Ministry of the Navy*, 1866
Odilon Redon, *Birth of Venus*, ca. 1910
Gustave Moreau, *Andromeda*, undated
Pierre Puvis de Chavannes, *Girls by the Seashore*, ca. 1879

43

As for Ingres (who is said to have liked Manet's early portraits nonetheless), he constantly complained of Paris being "abandoned to the most violent anarchy of the arts." While the mediocrity of some did not escape them, the genius, or rather the *program* of the others did.

The new tradition was in the making, but they did not see it. The stage appeared empty to them. Indeed it was empty—of the art they had served! Why was it becoming empty and at that very moment? Why was the imaginary that had still been alive for them now disappearing? Delacroix, in a journal entry dating from 1857, gave a variety of convergent reasons:

> The general absence of taste, the gradually increasing wealth among the middle class, the increasingly imperious authority of sterile critics who specialize in encouraging mediocrity and discouraging the great talents, the inclination of minds toward the practical sciences, the increasing powers of reason that scare off the imagination.

The traditional imaginary disappeared from painting because it disappeared from the mind and from society (where it survived only in an artificial, hypocritical, denatured state). Its program had to make way for another. Because it failed to grasp the meaning of this new program—and wished to linger in the old one—any talent directed toward the past fizzled out; whereas, a talent that was perhaps no greater received added momentum from choosing the right direction. Gérome carried out the questionable *Cockfight* and abandoned some beautiful sketches; Friand's lugubrious *All Saints' Day* contained a bouquet of chrysanthemums that made Vuillard jealous.

The world inhabited by classical painting was haunted by invisible presences, which did not always belong to an historical past, but were part of a spiritual past, in the sense that, for a long time, ever since the origin of Western culture, they constituted the knowledge or intuition of the mind. The mind thought and art created while looking backwards . . . Toward the middle of the nineteenth century, the new Orpheus was forbidden to look back. Man no longer lived while looking back, for he was forging a new history—domination of the world—and its significations had not yet developed. But this was not simply a matter of

moving from a world of nostalgia to a world of the present. *Worship of the past* does not define the situation that existed in the past, but rather the moment when one can neither resuscitate a dying past nor rally to new values. This was the situation in which Ingres and Delacroix found themselves, but not Poussin or Racine, nor certainly Raphael! Ingres and Delacroix clung by one last thread to the imaginary—and that is why their record of it, simultaneously weakened and exasperated, took on this crepuscular brilliance or fever. The romantic imagination had been a past, but the classical imagination was a present.

It was a present—although the mind constantly looked back—in the sense that its relation to the past was lived as proximity and communion, not conceived as distance or separation. Orpheus and Eurydice were not strangers to Poussin's trees as Corot's nymphs were to his. And between the mythological and historical scenes of the seventeenth century, the *Arcadian Shepherds* and the battles of Louis XIV, there was not the abyss that separates the visions of Gustave Moreau from the things seen by Manet—or a Fuseli nightmare from David's *Marat*. If classicism lived the past in the present, it is because, for classicism, the past was less the past in the temporal sense, less the earlier event, than the model, the referent of a myth, a sense that was revealed or intuited from the beginning and of which each thing was a sign. In classical art, as in the life of the world that corresponded to it, each form had a signifying function, and the signified was not invented—or discovered—but recalled. The signified was not necessarily the past in the historical sense, but *what was already there*. Moreover, we are not progressing from an art of the past to an art of the present. Rather we are proceeding (despite a romantic interlude, which is prolonged by both academic art and the deviation of a few great peripheral works) from one present to another, from a present of celebration and representation to a present without division, without a hidden text, a present that is sign only of itself, a present simply present.

None has put it better than Baudelaire: "The life of the past *represented* a great deal" (1846). The emphasis is his. It is true that he added: "It was made above all for the pleasure of the eyes"—which weakens the phrase. For the pleasure of the eyes existed as much for the nineteenth-century crowds that filled

Eugène Delacroix,
Jacob Wrestling with the Angel, 1861,
detail following pages

45

the Jardin des Tuileries to listen to music as for the crowd that surrounded the Doges and ambassadors of Venice. And even for modern painting there would be nothing but this "pleasure of the eyes!" The sole (actually, incommensurable) difference is that classical painting presented something that was already represented. The image was split; it was the sign of an image that was itself a sign. I mean that the image painted by Carpaccio was the sign of a figure that functioned already as a sign. It was not simply a sixteenth-century ambassador visiting Venice, but the hero of a timeworn ceremony festooned with insignia that the painter had only to paint. What was image on the canvas and what had been its model in nature were plates added to a text, while in modern painting—from 1863, if a chronological marker is required—the image was no longer the illustration of a text. It no longer had a text. The sole text was that of its visuality. Mythological scenes with several levels of implications demanding erudite interpretation; still lifes whose every element represented one of the five senses; battles in which Louis XIV played the role of Alexander; dramatic or psychological allegories, right up to Le Brun's physiognomic drawings in which humanity is linked to animality and the human eye is a dog's or a falcon's—no image was without a sense external to it and prior to it. And each of these senses was a word in a text accounting both for the intelligibility and composition of the world and for the history of a culture.

It is the world both closed and divided that Goethe evoked in *Torquato Tasso*. At the court of Ferrara, the garden of Belriguardo is adorned with busts of epic poets (on the right Virgil, on the left Ariosto). Tasso, who is, however, suffocating from this perfection and searching for the "unnameable," celebrates it:

> Here is my fatherland, here among you the place
> Where my soul finds its home. Here for my eager mind
> Each sign is charged with sense. . . .

Art and Civilization

Therefore, since the date of which we speak, it has become impossible to paint a naked woman as a Venus, impossible to paint some figure of contemporary

history as Le Brun painted Louis XIV—wearing Alexander's helmet—or even a bourgeois notable the way Le Brun represented Chancellor Séguier. Why is Meissonier's *Battle of Solférino*, which was, however, admired at the Salon of 1864, not the equal of Pharsalus? Why is it not even the equal of Eylau? Napoleon III was wary of seeing himself adorned with the traits of his predecessor, whom Gros and David celebrated and whom Stendhal presented as the successor to Alexander and Caesar in the opening lines of *The Charterhouse of Parma*. Despite the adventures into which he had let himself be drawn, he had even ceased considering conquest and military glory as the goal of history. He was truly the expression of the bourgeoisie, whose genius lies not in the epic. Napoleon I was the last historical figure who lent himself to epic treatment, either literary or pictorial. A genius, he was the last of the geniuses. It was felt that the opportunity would never return, that with him history as action and legend was over, that after him there began a completely different age—both progressive and anonymous—and, whether a bourgeois or worker society, its aims were the same: production and consumption. (On St. Helena, when he pondered what he could have become after a victory at Waterloo, he could imagine himself only as a bourgeois sovereign visiting the countries of Europe like so many peaceful estates.)

All repetition, Marx has said, transforms drama into comedy. It is a judgment that is little true of the classical world in which, after a fashion, everything was repetition, little true of the world of the 18th of Brumaire, the date of Napoleon I's seizure of power. But it had become true for a history that was henceforth to be progressive, in which repetition could have only a negative meaning, and it was true of December 2, 1851, the date Napoleon III seized power. Historic action would no longer be the new manifestation of ancient glory and primitive virtue. For the first time, its goal would be the oversight of things put at the disposition of man. And if the socialist regimes have tried obstinately to produce artistic portrayals of their leaders, it is clear that they have succeeded no better than bourgeois society, and for the same reason: Their finality is bourgeois, in the sense that it is not epic, even if they are guilty, like the bourgeoisie, of double-dealing and bad faith. Lenin's heroic portrait contradicts Lenin himself, who was a simple man. Those of Stalin and Mao contradict the truth that they theoreti-

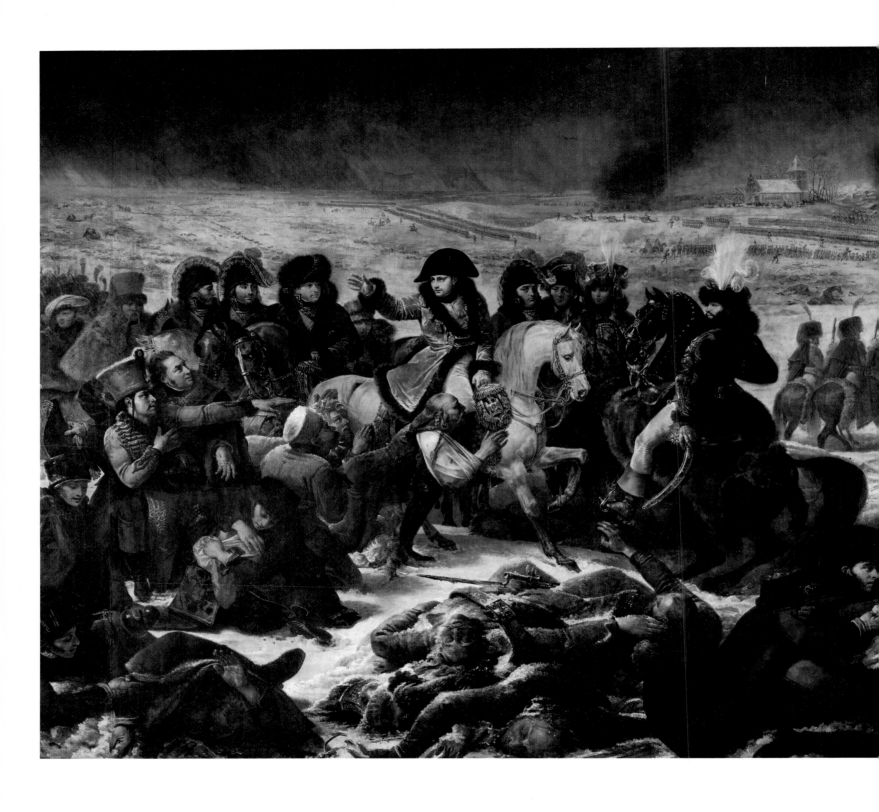

Antoine Gros,
Napoleon on the Battlefield of Eylau, 1808
Ernest Meissonier,
Napoleon III at the Battle of Solferino, 1863

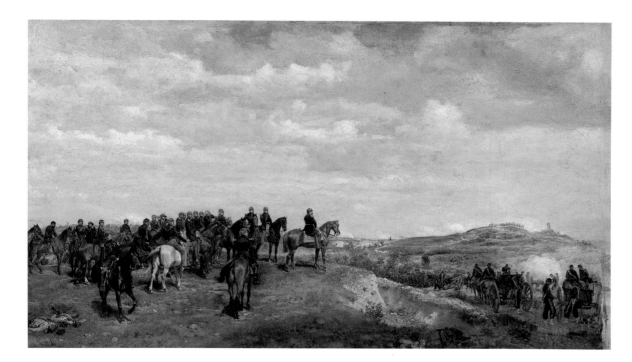

cally served, according to which the "cult of personality" is conscious or "objective" treason.

The expression "bourgeois society" has cropped up, so the time has inevitably come to address the relationship between the new painting and its society. To regard the new painting as an indictment of bourgeois society is no more satisfactory than to regard it as an endorsement. It is, however, impossible to deny the links between them; that would require believing that the left hand does not know what the right hand is doing. The result is a vexing problem that we should not dismiss too quickly. Henceforth, there would exist two paintings, and the bourgeoisie would not have a single face.

There is an art that bourgeois society secretes naturally, that it recognizes as its own. And this is in the first place (to refrain from calling it sycophantic) euphoric art, anaesthetizing art, which presents life as unproblematic, lacking great drama: light comedy; children's literature; popular music; the genre painting that illustrates life's small pleasures . . . But bourgeois society is not always frivolous, nor is its intention always to go unnoticed. The more doubts it has about its own legitimacy, the more it wishes to be serious and noble. Academic art allowed it to see itself as it would have liked to be but did not know how to be: heir to a tradition of classical beauty and mythological culture, instrument of a history worthy of the epic. Baudry, Cabanel, and Gérôme conferred diplomas upon it; Meissonier, Vernet, and Flandrin guaranteed that its glory was not unworthy of the past. Bourgeois society established museums, frequented antiques dealers, piled up collections so as to believe in its antiquity, all while providing artificial respiration for the harmonious art of the imaginary. On the other hand, wary of bad purchases, it demanded art that was well made—that is, made according to the rules, which confirmed that the painter had learned his craft (at the École des Beaux-Arts)—and carefully executed, finished in the tiniest details, and thereby justified the purchase price. It was bourgeois society that reproached Whistler for asking 200 guineas for a landscape done in a few hours. And this reproach gave the painter (who later said of paintings contrasted with his own that they were perhaps finished, but not yet begun) the opportunity to retort that such a sum paid for the science acquired over a lifetime.

Jean-Auguste-Dominique Ingres,
Louis-François Bertin, 1832

52

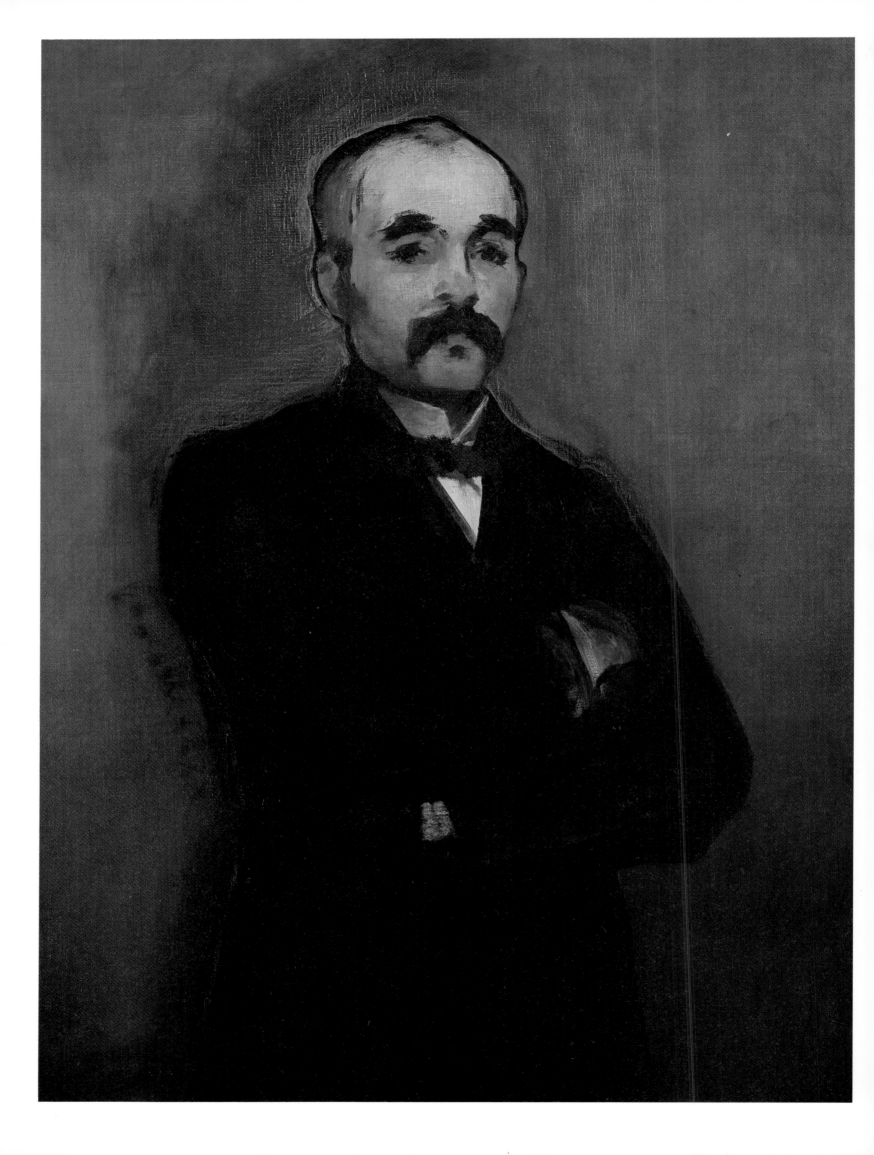

Breaking with this modestly or sublimely idealistic art, the new painting cannot be suspected of complicity with the bourgeois order, despite all the Marxist and "Marcusian" insinuations! Should we instead see it as a denunciation of the bourgeois order, as we are invited to by analysts who employ the same sociology but look favorably upon this painting? It is no more a denunciation than the contrary. And, to begin with, is it the bourgeois structure of society that is at issue, or simply its status as ruling class, regardless of its structure? Idealized art, euphoric art is the official art of any class aspiring to stay in power; witness Stalin's Russia and Mao's China, not just the France of Napoleon III. No doubt academic art responded to a particular complex—that of a bourgeoisie fretting over its own legitimacy—but it expressed the sickness of that bourgeoisie, not its health. For if there is a bourgeois lie, there is also a bourgeois truth, a bourgeois genius; and perhaps the new painting had some connection to it.

For it was precisely this genius that broke with idealization, the heroic, the past, the imaginary. It was the genius of a lucid energy engaged in the conquest and rational exploitation of the earth and aware of being a turning point in history, the first step in a decisive progress. The Second Empire undertook military operations whose success was uneven, but which official art celebrated evenhandedly. However, it was not glory to which bourgeois society aspired, not a hero that it honored; rather it was profitability, an anonymous mastery. *1814* and *Napoleon III at the Battle of Solférino* were as foreign to the bourgeois genius (if not to the bourgeois lie) as *The Execution of the Emperor Maximilian*, which demystified heroic history and the legend of the Prince. From *Monsieur Bertin* to Manet's portraits of Rochefort and Clemenceau, these images without indulgence, without symbolic or mythological attributes, represented, like seventeenth-century Dutch portraits, a bourgeois rejection of grandeur. Between the new art and society, there was this essential difference: The art rejected its heritage of bad faith, but it still remained the genius of *that* society. The new art shared with its society this relationship to things that—excluding the sublime, the past, the imaginary—unceasingly consolidated its hold on the world. And without doubt, the history of art, dating from the installation of bourgeois power, has often been one of a misunderstood, disparaged solitude. But the conflict was with the public, the masses whose initial emergence

Édouard Manet,
Georges Clemenceau, 1879

55

this marked, rather than with the values of the new society. Baudelaire, Flaubert, and so many others were absolutely right to recognize the bourgeois as their enemy. But the bourgeois was for them the eternal Philistine, from whom everything separated them, and not at all the representative of a class to which they belonged, of a power from which they (more or less) benefited. The salon of Princess Mathilde excluded the Philistine but included the bourgeois.

Temporal proximity creates the temptation to place all contemporaneous movements under the same heading. For 1863 was also the year of the general elections that ensured the success of the opposition (at long last allied) in Paris, its surrounding areas, and all the big cities. Also, 1863 was the year a workers' party was founded in France, although no workers' candidate participated in the elections. In 1862, a delegation was sent to the World's Fair in London. During 1864, the *Manifeste des 60* appeared in Paris, and Karl Marx's "General Rules" of the International Working Men's Association, in London. But it must be admitted that the opposition was scarcely less bourgeois than the government, demanding from the regime the bourgeois right of liberty.

Should one search beyond the bourgeois opposition for a more radical social critique that would have more in common with a certain kind of painting? It is no easier to find in the political order than in the artistic order. On the one hand, the French worker opposition did not view itself as outside the bourgeois world. The *Manifeste des 60* called for the union of social classes against the imperial dictatorship: "The political significance of the worker candidates will be to strengthen the action of the liberal opposition by complementing it. The latter has demanded the necessary liberties; the workers will demand the necessary economic reforms." Admittedly, the author of the "General Rules" of the International did not appear to view things this way: "The economic emancipation of the working classes is, therefore, the great end to which every political movement ought to be subordinate *as a means*." But these three crucial words were omitted from the French translation, the Republicans seeing in it a maneuver aimed at diverting the workers from the struggle against the Empire.

Would "social" painting go further than the worker movement itself? With Daumier, it denounced the actions of the police and the regime—or a perhaps

irremediable poverty, lived in hopeless suffering and unfocused anger. And Millet, who showed the ancestral peasant, not the victim of a specific social condition, did so rather serenely. (Besides, it was almost never the worker— victim of capitalism—who was represented; it was the peasant, the tradesman, the clerk.) Courbet, the sole social revolutionary—who would pay for his participation in the Paris Commune with his death in exile—was amused by his friend Proudhon's commentary on his *Stone Breakers*, saying that he painted quite simply what he saw. (Likewise Géricault scoffed at those who saw a "patriotic" or "subversive brush" in *The Raft of the Medusa*.) And even if we ascribe to this painting a politically revolutionary meaning that it lacked, then given this meaning, the new painting could not exemplify a pictorial revolution that, pursuing its own internal logic, almost nullified the significance of the subjects chosen.

The motto *nothing but the truth*, the reduction of everything to a question of work, was an essential spiritual link—one of common civilization—between the bourgeoisie, the proletariat, and painting. When compared to the odalisques of Ingres, Manet's stylish ladies, Daumier's women of the people, and Millet's and Courbet's peasants stand shoulder to shoulder; the working class's only desire was to enjoy the goods and the gods of its masters. But if at the outset the "victorious bourgeoisie" and the innovative painting shared the same vision of the world, their distinct domains and means of expression implied and created a soon-to-be irreducible opposition.

This vision of the world was at bottom an empty frame; it was left blank. The new painting was attached to bourgeois society by a tolerance that involved no commitment. This society of laissez-faire and laissez-voir subjugated action and perception to no transcendent value, no value external to reality. The sole law was that each should work on something that labor could fashion. Man was created in order to transform a natural resource into a product of his labor. But it goes without saying that the work of painting, which was also relative to *what was there*, resulted in a manufactured product so different that it could not be assimilated, and finally became the enemy. The profitable, the utilitarian, the quantitative reality of social labor was opposed by the useless and qualitative

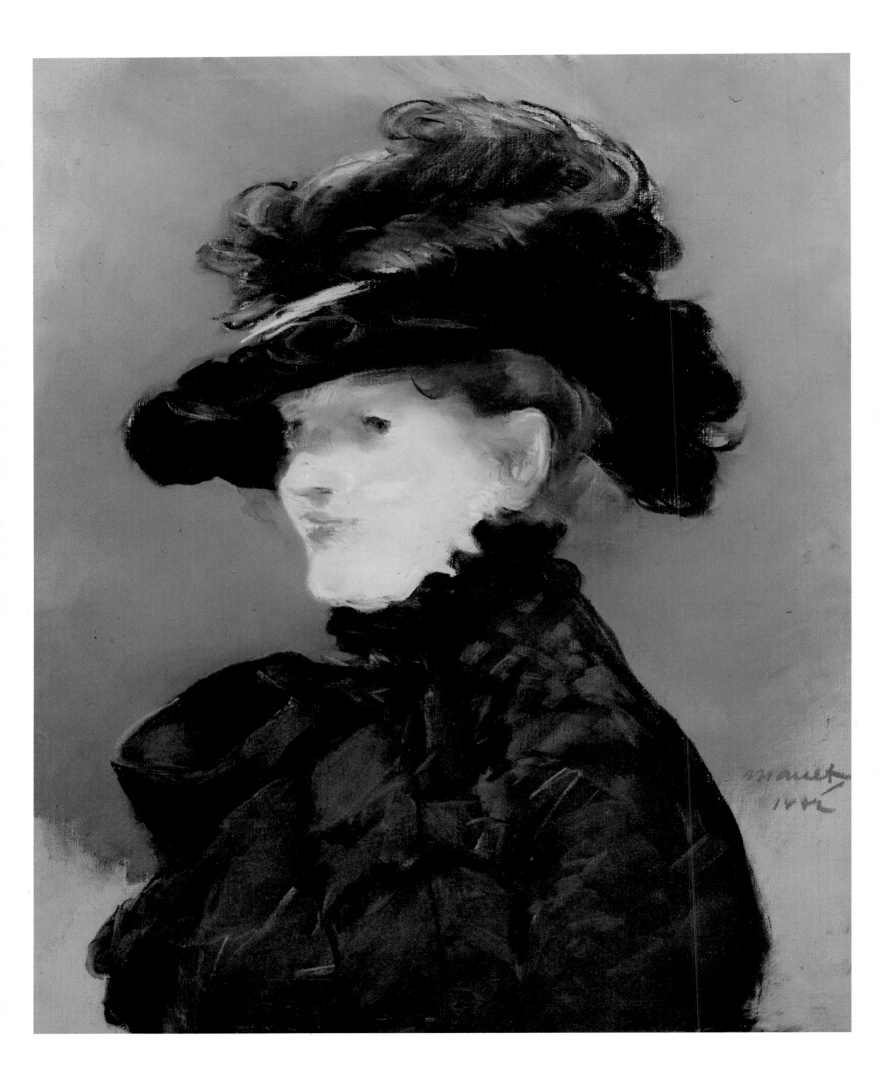

Édouard Manet, *Méry Laurent in a Black Hat*, 1882
Honoré Daumier, *The Burden*, ca. 1855–1856
Jean-François Millet, *Woodcutter*, undated

59

reality of artistic labor. Even when the reality of Manet, Monet, and Renoir was that of bourgeois contentment, it brought out what life brushed by without a second thought, those little things in life that were so easily overlooked. It made Sunday recreation the law of the workweek. It inverted God's commandment. The play of light on the waters of La Grenouillère, the iridescence of the smoke in the Gare Saint-Lazare, the sparkle of a little red wine at the bottom of a glass held all the meaning of life and denounced other meaning as nonsense. The society that allowed the artist to look where he wished, for want of anything better to prescribe, expected from this observation at most the frivolous adornment of its serious existence. It would even allow art to define itself as useless: Ruskin's thesis was a concession to the bourgeois vision. For the artist, the claim of uselessness was a defeat.

But everything changed when art laid exclusive claim to the truly useful and aspired to sovereignty. Liberal society could not defend itself by gagging the artist, but it could refuse to listen, or rather it could choose to reveal its innate deafness. In this sense, the energy of painting functioned in the world of work as an indictment infinitely more profound than any political revolt. After being content with pleading in behalf of the right to useless existence, painting declared itself autonomous labor in its own right, an absolute value. And it would go even further. For to base its dignity on the autonomy of a craft was to bow once again to the bourgeois order of the division of labor, and labor could not be an absolute value. So painting would try to summon by its pure presence what was missing from the civilization of labor, and even from the painting of what was seen: the plenitude of being. "Listen, between you and me: if there is no God, there exists all the same, somewhere, something resembling Him, whose presence we feel at such moments." What Van Gogh (who wrote these lines to Theo) or Gauguin saw in the moment, the object, or the dream, the single gesture of the painter would soon have the illusion of creating.

Within a single moment or state of mind, it is inevitable that many ties unite the diversity of human activity, but these relations, when they can be grasped, often appear as complementarity or opposition. What we have said of the relations between painting and bourgeois society can serve as a key to other

Auguste Renoir, *La Grenouillère*, 1869, *detail page 60*
Claude Monet, *Gare Saint-Lazare*, 1877, *detail page 61*

comparisons. The moment when the new painting suddenly arose was the moment when the scientific mind began to prevail over the religious or philosophical spirit.

The disappearance of perspective from painting has been compared to a new scientific spirit for which Renaissance geometric models ceased to have value. The new painting, it has been asserted, resembled science, in what Zola called its "analytic" aspect as well as in its development of "a critique of perception." The study and the sketch were seen as the equivalent of scientific observations from which Impressionism thought it was deducing the laws of color perception. But the laws of Impressionist perception (the laws of Seurat, Cézanne or the Cubists) are the norms of an historical language that might well become common but can in no way be applied universally in space and time like the laws of science. Moreover, the scientific critique of perception resulted in a formulation that excluded any appeal to the perceived. It challenged the perceived, wishing to dispense with it. Unlike traditional perception, painting called on another, more sensory perception. And the statement that the new painting moved from perception to sensation was true only if sensation was not defined in scientific terms. The painter's business was not to discover the genetic underpinnings of the perceived, but to create the symbol of an original, fictional sensation of the world, the myth of pure sensation contained in each instance of sensation.

It is also worth noting the connections, oppositions, and divergences between painting and the other arts. One may wonder in particular why the spirit of innovation chose to reveal itself through painting and to abandon sculpture and architecture to routine, banality, and eclecticism. One may wonder finally why it was in Paris, in Paris alone, that the new wind was blowing.

In the Salon of 1863, Courbet showed a sculpture, *Young Fisherman in Franche-Comté*, that inspired Cham to create a caricature in which we see, in the gallery, a pair of solid citizens exclaiming: "Not even sculpture is safe any more, now that Monsieur Courbet has put his two cents in!" But at issue here was a change of subject, with sculpture responding to the realist program, and not a change of style. We may find the germ of this stylistic change in Carpeaux, who exhibited *Ugolino and His Children* (as well as a bust of Princess Mathilde) in

the same Salon. The innovation of a work like the *Ugolino* may be measured by the resistance it encountered. Its execution in marble was rejected by the State and had to wait for a private commission in 1867. And a year later Rodin, whose first pieces were corrected by Carpeaux, began the series of male portraits that preceded his series of female busts. In 1864 *Man with a Broken Nose* had been submitted to the Salon and turned down. It was a common excitation, in one case at the service of grace, in the other at the service of force. This turbulence, this bristling with which they animate the surfaces; an accentuation, a stressing of the details; mobility; the looseness of forms—assuredly, there was in all that an analogy with concurrent investigations in painting. However, Carpeaux's subjects remained academic, and Rodin, whose models were taken from Antiquity and Michelangelo, was infinitely closer to Delacroix than to Manet.

Any modernity to be found in sculpture would be due to painters—Daumier and especially Degas. In any case, the stylistic contributions of Carpeaux and Rodin would barely be appreciated. As a whole, sculpture, in opposition to the party of change, was the party of order.

This "confusion," as a chronicler of the time called it, did not go unnoticed. Zola, in an 1868 article, offered an historical explanation of the backwardness of sculpture: It had been so closely bound to the nude that it was very difficult to liberate it, to "reconcile it with modern times," to make it the "daughter of our civilization." Sculpting contemporary man in his black suit, his kid gloves, and his patent leather boots was more difficult than painting him. And Zola's promise that "naturalist sculptors will be the masters of tomorrow" seems to lack conviction. Some years earlier Baudelaire had given a very different reason for sculpture's inferiority. In *Salon of 1846*, "Why Sculpture Is Boring," he wrote,

> Stark and concrete like nature, [sculpture] is at once vague and elusive, because it shows too many faces at the same time. It is in vain that the sculptor endeavors to adopt a single point of view. The viewer who walks around the figure can choose a hundred different points of view, except for the right one [. . .]. A painting is only what it wishes; there is no way of looking at it other than by its own light. The painting has only a single point of view. It is exclusive and tyrannical. The expression of the painter is necessarily much stronger.

Risky judgments, no doubt! It nevertheless remains that painting, a *cosa mentale*, is particularly obedient to the mind's projects. A painting is not only what it wishes but it is also easier for painting to be what it wishes than it is for sculpture.

And, of course, architecture is still harder to change. Thanks to industrial development, the mid-nineteenth century is everywhere an age of builders, but it is still subservient to the classical models. Architecture provides the best opportunity to grasp the schism between the program that the bourgeoisie lucidly pursued and its alibis, its illusions, its lies. The bourgeoisie asked its architecture, buildings, and decorative arts to dress up the reality of new materials and industrial machinery with a gratuitous and brilliant finery. The opposition between art and technology gave a clear conscience both to those who exploited technology for purely practical ends and to those who exalted art without having a technological understanding of the world. Haussmann's transformation of Paris testified to the classical taste for the straight line, the symmetrical, the "beautiful contour"—but it was a taste adulterated by the ostentation of parvenus. In Paris, an increasingly eclectic mix of classical references and decorative splendor was the fashion of the day. It may be seen in Lefuel's additions to the Louvre and especially in Charles Garnier's Opera. (The Opera's foundation stone was laid in 1862, and its plans were exhibited at the Salon of 1863.) Reprising his polychrome restoration of the temple frescoes of Aegina, Garnier combined gold, bronze, marble, stone, and elements borrowed from Antiquity (caryatids, rostral columns, mosaics) with elements from the Renaissance and the seventeenth century (bossage, dogtooth moldings, pediments, consoles, mantelpieces).

No doubt an architecture of metallic structures without decoration, in which the empty spaces let light enter (and which one might consider analogous in spirit to the new painting) was beginning to challenge traditional architecture: les Halles, the central marketplace by Baltard; the interior of the Gare du Nord (1863); Labrouste's public reading room at the Bibliothèque Nationale (1868). Also, the role of Viollet-le-Duc must be emphasized. He replaced the idea of artistic beauty with that of functional adaptation (achieved more successfully, he thought, by Gothic than by Greco-Roman architecture); denounced the confusion

following pages
Auguste Rodin, *Man with a Broken Nose*, 1864
Gustave Courbet, *Young Fisherman of Franche-Comté*, plaster original, 1862
Jean-Baptiste Carpeaux, *Ugolino and His Children*, 1860
Honoré Daumier, *Ratapoil*, ca. 1850

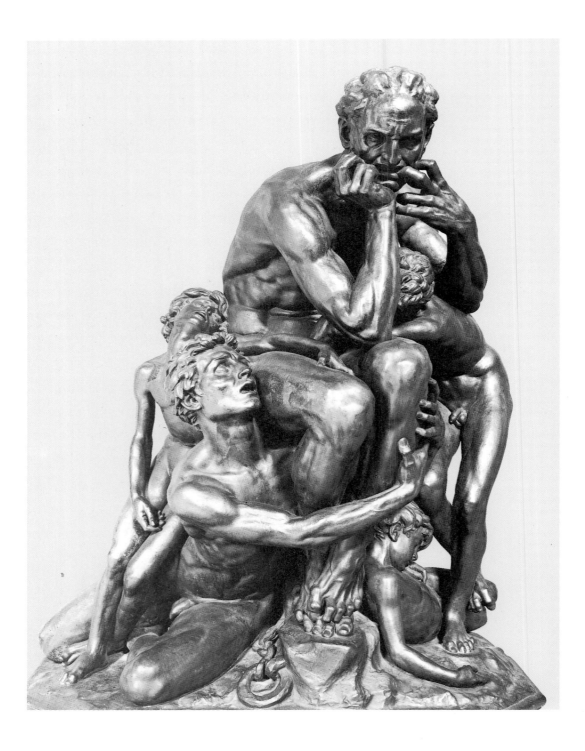

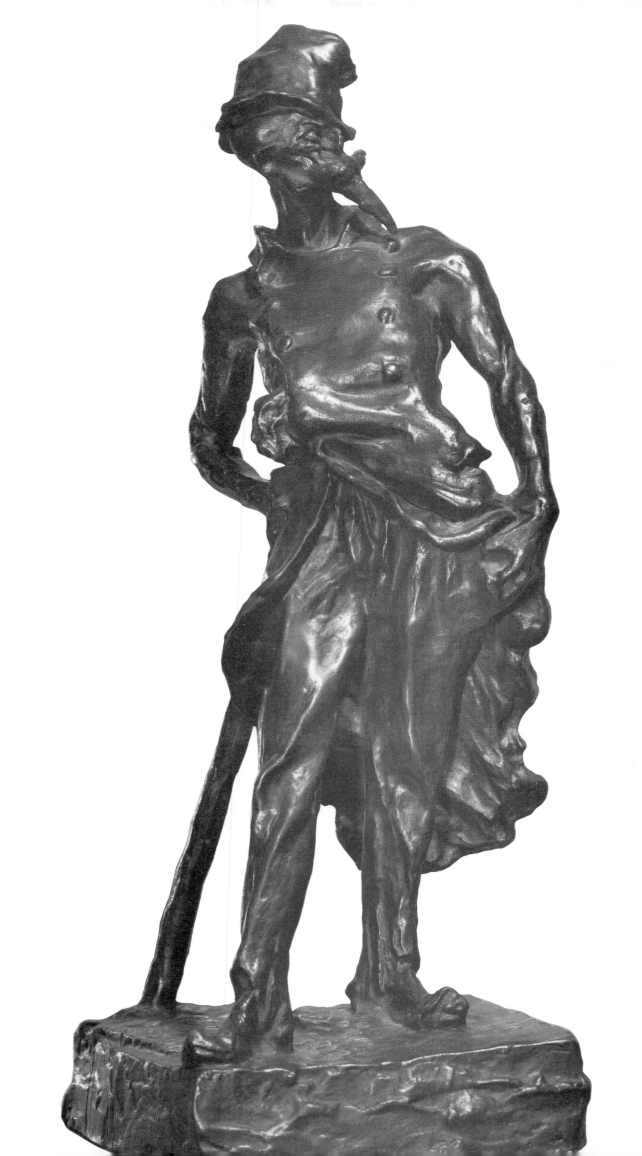

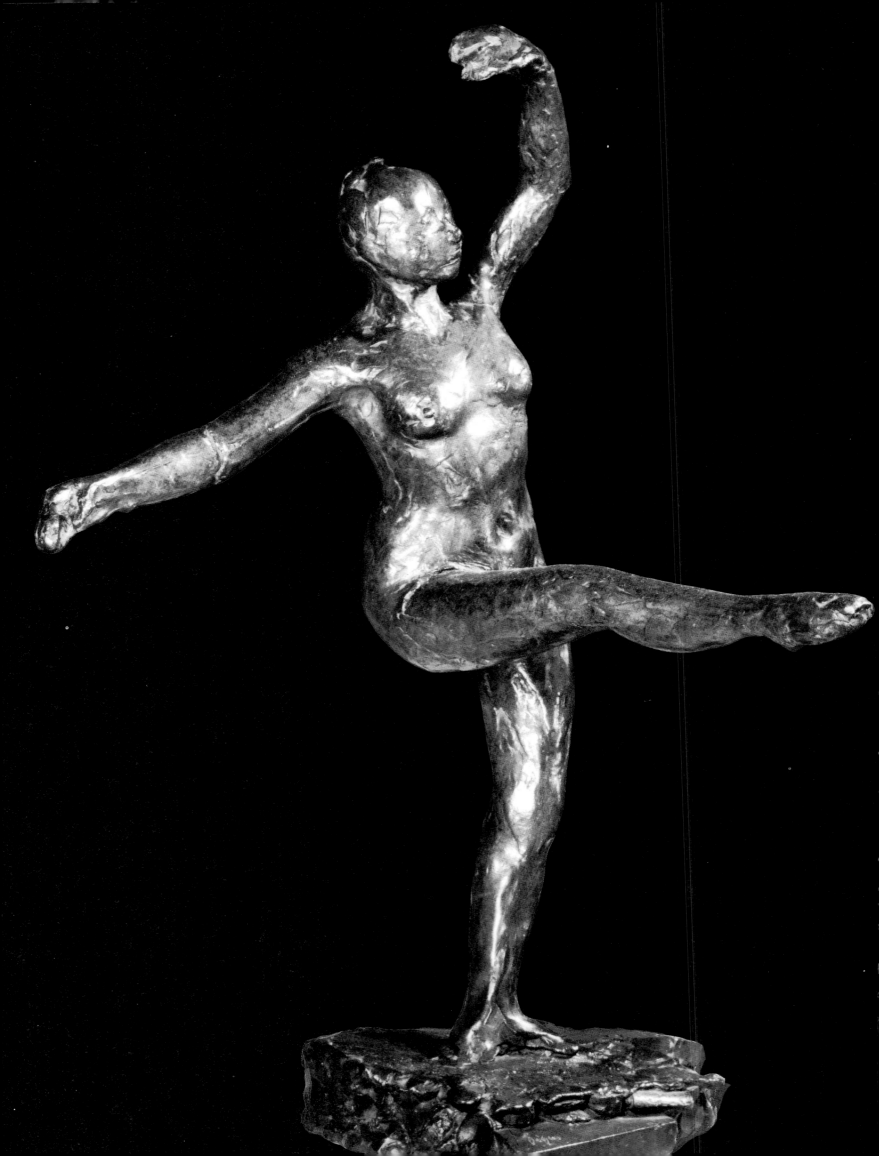

of architecture and decoration; overcame the opposition between art and technology; and justified the utilization of industrial materials. Thus, more than anyone else, he opened the way to the future. In his article "Style" in the *Dictionnaire raisonné de l'architecture française* (1854–1869), he declared that "beauty and style do not reside in form alone, but in the harmony between form and objective or result." The Salon des Refusés was not the only scandal of 1863, for there was also a Viollet-le-Duc affair. At the Ecole des Beaux-Arts, which was subjugated to the Institute and entirely submissive to tradition, Viollet-le-Duc's appointment as professor of art history and aesthetics (by order of the Emperor and in conjunction with a host of reforms) had a distinctly revolutionary cast. After a campaign led by Ingres was mounted against him and the students refused to let him speak, Viollet-le-Duc resigned and was replaced by Taine. Meanwhile, the Emperor abandoned his reforms—a retreat infinitely more consequential than it would have been in painting! After all, while painting needs little besides thought in order to exist, architecture requires public commissions, powerful private organizations, and rich clients. The market remained in the hands of traditional architecture, with a sharing of responsibility in special circumstances. For example, while the interior metal structures of the Palais de l'Industrie were the work of an engineer, an architect (Viel) had charge of camouflaging the exterior. In any case, grand architecture was still distinguished from merely utilitarian construction.

We have yet to account for the venue. Why was Paris the exclusive scene of this artistic revolution led by painting?

> This art—French painting after Manet, the superficial, open-air painting that succeeds the profound painting of the great age and dazzlingly heralds the end of painting—could be at home only in the Paris of Baudelaire, in the overwrought, decadent atmosphere of the cosmopolitan capital. . . .

This passage from *The Decline of the West* has always made me dream, both because it presents what was as something that has taken the place of what could have been, and—contradictorily—because it sees as natural, explicable, what nevertheless remains in part a matter of chance, a "roll of the dice" . . .

Edgar Degas, *Dancer,*
Fourth Position in Front on Left Leg,
Second Study, 1882–1890

Spengler may well have regretted that the profundity of the Faustian Germanic soul did not triumph over this superficial, light, insubstantial painting. He recognizes, however, its decisive attitude and acknowledges the formal tentativeness of Hans von Marées and Arnold Böcklin. He thinks, nevertheless, that Leibl succeeded where Courbet had failed, the metaphysical browns and greens of the old masters becoming once again the complete expression of an interior event; that Menzel had revived a fragment of the Prussian Rococo; Marées, a fragment of Rubens; Leibl, a little of Rembrandt's portraits. But my point is precisely that life cannot be restored. The guillotine of French painting fell forever on what had preceded it. Apart from French painting, what was there? One is tempted to reply: nothing, except for what paved the way, what was consonant with it.

What paved the way was the English school of landscape painting. It was from the London of 1795, for example, that Chateaubriand wrote a letter in which he recommended drawing the landscape "from the nude." In general, English painting was closer to Dutch landscape than to French art with its hierarchy of genres on whose summit history painting reigned uncontested. At the beginning of the century, tourist travel to archeological or picturesque sites had given rise to the fashion for watercolor, which would provide the art of the instantaneous with a crucial instrument. So it was not happenstance that made Constable the first great painter to be exclusively a landscapist. In 1821 his *Hay Wain* was shown in Paris, and Delacroix (an admirer of the watercolors of Constable's friend Bonington as well) hailed him as "the father of our French landscape school." Constable's paintings are perhaps the first where the object takes the place of style; where dignity, majesty and plenitude arise from everyday things; where the evidence of order does not depend on composition. The simplicity of what exists suffices, and a sort of primeval breath infuses the visible with life. In the marvelous (but unexhibited) sketches as in the large canvases that exerted immediate influence (bright, thick paint; little streaks of pure white added with the palette knife; and structure created with a brushstroke that is already almost Cézannian), we perceive and feel the "breezes, dews, bloom and freshness" of which he spoke. Turner's influence, clearly excepting the effect of the 1837 album

Hector Lefuel, Cour du Manège at the Louvre
Charles Garnier, Grand Staircase of the Paris Opera

Jacques-Ignace Hittorff,
Gare du Nord, Paris: Perspective View of the Hall, 1862–1863
John Constable,
The Hay Wagon, 1821,
detail following pages

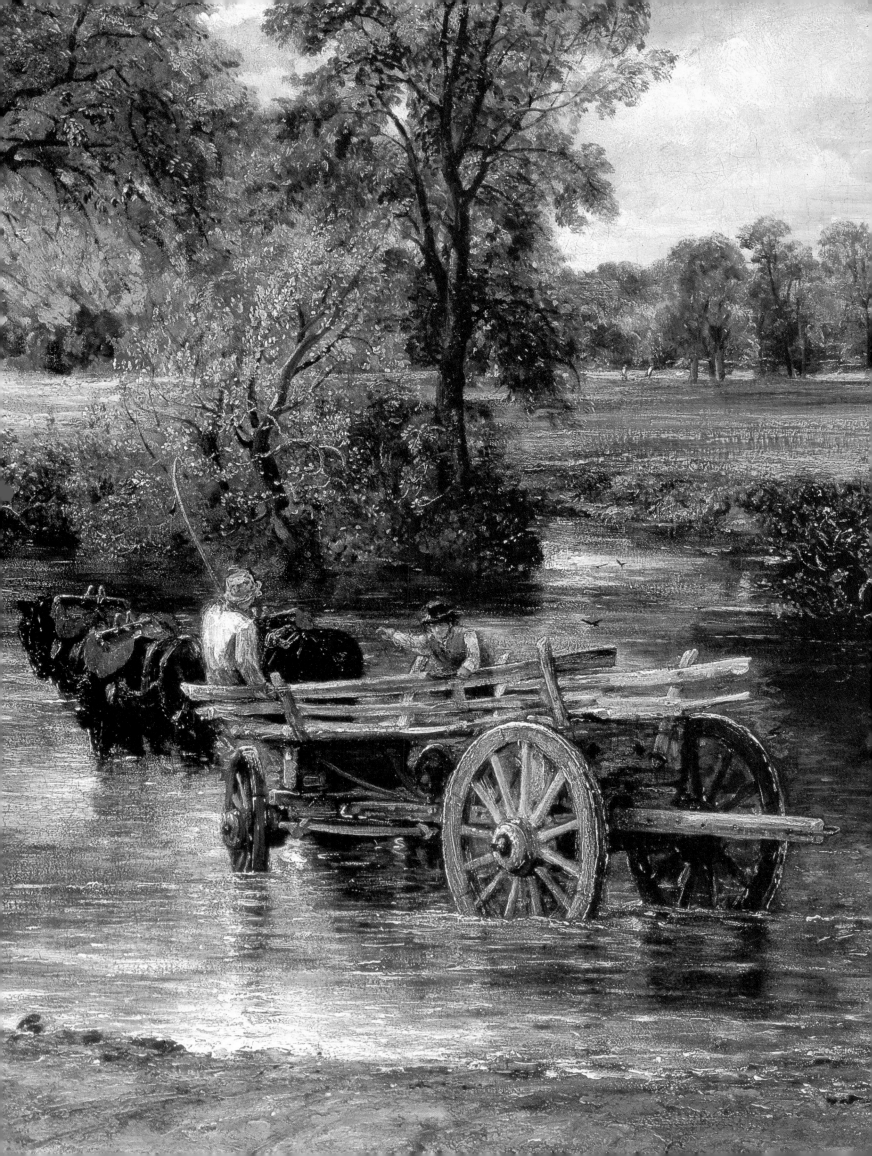

of engravings on Hugo's drawing style, would be felt only later. Only with the advent of Impressionism, or perhaps even the Neo-Impressionism of Sisley and Pissarro, could Turner be recognized as the lyric precursor of the transmutation of appearances that the French were systematically to perform. Undoubtedly, the fabulous inferno, in which forms melt and are recast, was sparked by the sun of Turner's gaze refracted through the lens of the visible.

Why did England leave the privilege of exploiting such discoveries to France? Clearly, the answer must be sought in the concentration in Paris of all the French artists who mattered, as well as many foreign artists. But there was also the tendency of the French genius to transform, for better or worse, spontaneous, individual discoveries into a well-planned, common program, the perennial penchant for doctrine or school. That talent (or genius) without "logistical" support is virtually stifled has been proven also by the example of the Macchiaioli. For in Florence between 1855 and 1860, there developed the one movement comparable to the French: the canvases of Signorini, Lega, and especially Fattori. Built out of big blocks of violently juxtaposed color, they manifested a surprising modernity, foreshadowing, beyond Impressionism, a kind of Fauvism. But the provincial conditions that rendered the appearance of this phenomenon so unforeseeable (mediocrity of the earlier local art, ignorance of European art, etc.) made further development of the invention impossible.

Doubtless, the concentration of artists and the faculty of theoretical reasoning furnish an inadequate explanation of the French privilege. There was also a vocation for modernity. It was not by chance that the guillotine, which settled questions so often in France, fell thusly. The proof of it is that there was a similar movement in England, but which took an opposite course. While there are certain parallels between the Pre-Raphaelites and the modernity of French painting, the contrasts go much deeper than the analogies. Those who signed the initials P.R.B. (Pre-Raphaelite Brotherhood) next to their names (Millais, Dante Gabriel Rossetti, Hunt . . .) also rejected the school and the academy, but only to learn the lessons of primitive painting. They too spoke of the natural, but they did not reject all cultural mediation. Instead, they sought in another history, in a medieval, religious fantasy, a haven from the contemporary world, which they

Richard Parkes Bonington,
View of the Coast of Normandy, ca. 1823–1824
Joseph Mallord William Turner,
The Fighting Téméraire," 1838, *detail following pages*

accused of offending the natural. They also used bright colors and even painted out-of-doors before Impressionism and more forthrightly than the painters of 1863. But they were not serving an art of sensation and gesture. The meticulous detail of their representations sought to restore the object to its primeval, essential reality, and resulted in a dreamlike symbolism rather than the recreation of sensations. It was painting that told a story full of detail, had a meaning, and came to a conclusion. As such, it presented the most coherent, cogent challenge that the new painting encountered. And these stained-glass angels and knights were the dream of the world's most industrialized nation, a way of compensating for the darkness wrought by coal and steel. The French found it natural, not just to take sides, but to side with the new world, in which things were what they became in the act of seeing and working, without longing for a transcendent meaning. They found it natural to be "resolutely modern," to move forward with eyes open, never looking back.

Painting and the Real

But what exactly was taking place? While certain subjects disappeared, it was not true (at least, not yet) that the subject was giving way to the pure act of painting. Despite Malraux's dictum regarding this portrait of Clemenceau, it was not true that modern painting began at the moment when Clemenceau became nothing and Manet became everything. It is more accurate to say that it began at the moment when this face was not the face of Clemenceau, but simply a face—here and now.

And of course, it was not an absolute beginning. There were, in particular, Hals's faces, which were nothing but their presence, their immediate visuality. But the same phenomenon took on a new sense and tended to become a law, albeit with exceptions. It was not a reign beginning, but a movement taking shape. However, dualistic painting, in which image was the sign of a text, an illustration, had not come to an end; it would doubtless never come to an end.

We may follow in Manet himself the stops and starts of a movement that, on the whole, but only on the whole, is a movement toward sensory immanence. On

Giovanni Fattori,
Ox-Drawn Cart, undated

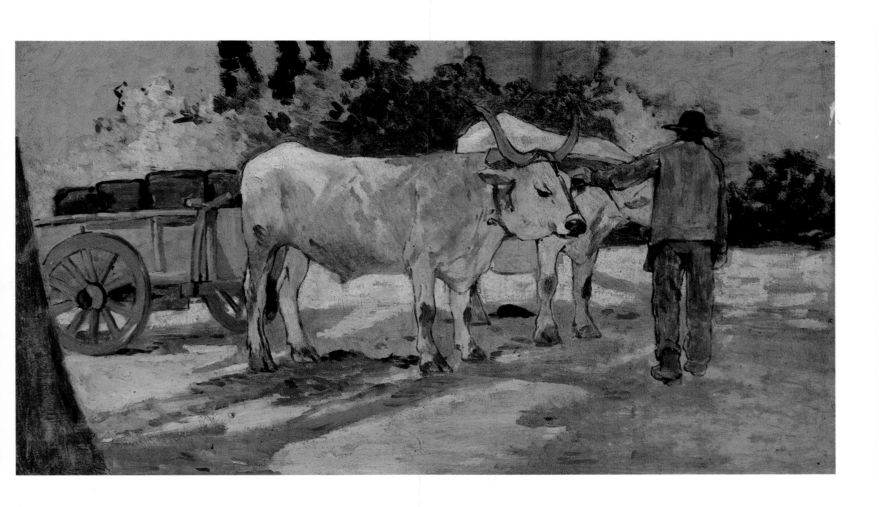

the subject of *Olympia*, Zola is right to stress that there is no response to the question: *What does it mean?* beyond the appearance itself. The correct response, however, is not: nothing but some patches of color and some lines. Rather it is: nothing but a naked woman, a black cat, a maid, a bouquet of flowers, which are only what we see of them here and now. And the apparitions of the *Bar at the Folies-Bergère* and *The Balcony* simply look at us, asking only that someone look back. But in *Bathing* there remains a duality, a lingering reference to the imaginary. In these, Manet's early years, the immanence of the *Racecourse*, the portraits, and the still lifes contrasts with the mythological, historical, or dramatic meanings of *Christ with Angels*, *The Combat of the Kearsage*, and *The Dead Toreador*. And, as Georges Bataille has noted, one of the late masterpieces, *Stéphane Mallarmé*, expresses a meaning that is lacking in the portraits of Clemenceau and Victorine Meurent, since the model, eyes gleaming with total concentration, is the symbol of the very act that represents him.

Elsewhere, the classical dualism is in keeping with the purpose of the work. And that is especially the case whenever the painting is an act of accusation or demystification. Like David's *Distribution of the Eagles* and Goya's *Third of May*, *The Execution of the Emperor Maximilian* has a meaning, although a critical one, which depicts history as an essentially insignificant series of failures, recantations, and trivialities. As for *The Stone Breakers* and *Massacre in the Rue Transnonain*, their meaning, objective or intentional, is complete and direct. The works of social criticism do not replace the images of euphoria with images of appearances, but with images of a reality that create the context of a thought or, at the least, of an emotion. But for all the importance of the social criticism to be found in Daumier, Courbet, and Millet, it is clear that this element of their work has little to do with the new art. An art of accusation did not replace the art of an assertive imaginary. What was beginning, despite the holdovers and the digressions, was an art that no longer relied on a text outside itself. Moreover, the imagery of the era was of happiness rather than misery, an imagery tending in the direction of material immanence. Happiness without idealization, without euphoric trickery, true happiness . . . Paradises abounded, and they were no longer lost or artificial. Instead, they were paradises for the eye, which everyone

Sir John Everett Millais,
Autumn Leaves, 1856

Édouard Manet,
Bar at the Folies-Bergère, 1881–1882, *detail*
The Balcony, 1868, *detail*

85

could experience. Immediate paradises, in which meaning lay not in the content of a sign, but at the very heart of the perceived.

When Courbet spoke of "real allegory," he gave his work an altogether classical aim, suggesting a hierarchy according to which *The Painter's Studio*, *Bonjour M. Courbet*, or *Pierre-Joseph Proudhon and His Children* occupy a position above *The Trout* and *Covert of Roe Deer*. The typical representation, which burdened appearance with what nothing there and then could bear, remained his concern when he complained in 1848, as he painted Baudelaire's portrait: "I don't know how to finish [. . .] Every day his face changes."

The same concern was shared by Millet, who started with mythological paintings (1845's *Offering to Pan*) and remained bound to the museum as much by his seventeenth-century chiaroscuro, with its brilliant yellow-blue dominants, as by a will to human expressivity, which he only rarely sacrificed to landscape. In 1863, Millet confided to the journal *L'Exposition*: "I want the beings I represent to seem predestined for their condition; I want it to be unimaginable that the thought of being other than they are could enter their heads. . . . It is not the things represented that make the beautiful so much as the need that one had to represent them." One cannot state any more clearly what Poussin and Ingres had always thought and said: The painting does not receive its justification from the presence, but from that of which the presence is a sign.

Between 1825 and 1828, Corot's Italian landscapes anticipated the painting of sensory immanence in striking fashion. The settings are those of the traditional imaginary and traditional humanism. Together with the shadows, the illustrious memories have been driven out; history withdraws from the pure space of the visible. But when painting, with Manet's crucial impetus, takes this path, Corot hesitates. The girls of *Recollection of Mortefontaine* are certainly not mythological figures, but neither are they elements, among others, of a visual instant. They are not here and now, in front of us, so much as they are the representatives of young love, akin to Nerval's *Sylvie*. And the "sun of the soul" that he wishes to paint is less Monet's than Lorrain's: The sun of suns disappeared . . .

The representational tradition is clearly present in works that in other respects are linked more or less directly to modernity. The work of Puvis de

Édouard Manet,
Stéphane Mallarmé, 1876

86

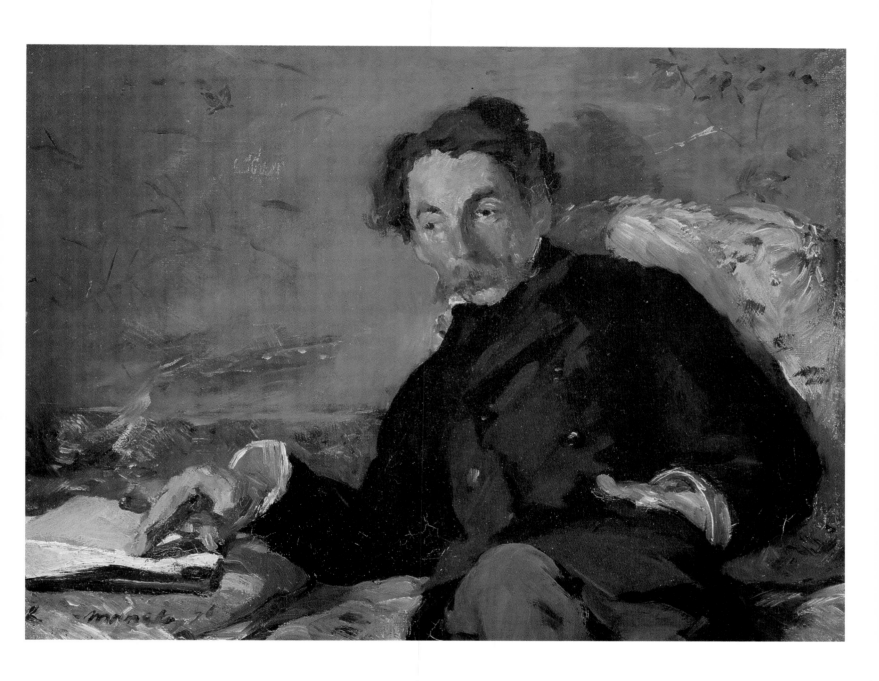

Chavannes, the English Pre-Raphaelites, and soon Gauguin will, like Poussin, portray paradise lost. But for all that, the fundamental spirit of modernity remains firmly committed to the absence of all meaning beyond the visible. And although it persists, representation in the works that matter is very different from what it was in the past.

The purpose, we have seen, is to exclude myth and history (Manet was to tell Antonin Proust that for him "history painter" was the worst insult.) and also to exclude stories and aneceotes. Yet, while the art of the contemporaneous, of the *here* and *now*, finds it natural to dismiss images that always seem to conjure up a model of perfection situated *in illo tempore*, even when they are scenes or figures from current events, it can still be an art of the newspaper item, of the present imperfect. The drawings of Constantin Guys are merely anecdotes, and there is anecdote in the work of Manet and Degas. By its choice of the present, the new painting has ties to newspaper and fashion illustration, as well as political caricature. But this is all peripheral, not essential to the new painting.

Or else, if the process was reversed, the result remained the same, as was the case with Daumier, who strove to be a witness. At first only a caricaturist, he took up painting in 1848 and was particularly active between 1860 and 1863, during his leave from *Le Charivari*. In 1849, he painted mythological and religious subjects. Later, he switched to modern ones, but he always had a subject. Here on canvas rather than newsprint, we see the satirical portrait of contemporary society, the illustration of a human comedy no less inspired than Balzac's, but even fiercer, a vengeful massacre. But it is not enough to say that horror or anger turns these figures into masks surging forth in a dreamlike blaze. If all this differs from the anecdote, it is not only poetically, but also artistically, and in accordance with the laws that were then being discovered. Far from being drawn in the illusionistic space of perspective, all these identifiable characters, bearing at least the name of their social category—judge, lawyer, clown, chess player, third-class passenger, worker, street singer—are caught in the snarled thickets of the painting, in the tangle of brushstrokes that closes off all exits. They cannot escape or breathe the outside air. The painting fills the canvas to the edge, animating the whole surface with its slanting rain, its gusts, its curlicues. Like an

X ray, the painting devours its forms, leaving only an outline, a flexible skeleton. As a result, Daumier's human comedy can place itself wholly under the banner of this wonderful self-portrait (now in Washington, D.C.) in which we see the painter before his easel. In the (still classical?) ocher and blue shadow, in the white, yellow, and green highlights that emphasize the shoulder, the hair and the lower part of the coat, the colors of the palette explode.

In any case, in the salons of 1863, anecdotes and comedies of manners were generally in the same camp as the mythological and historical paintings—the wrong camp. Alfred Stevens's *Ready to Go Out* appealed to the same audience as Flandrin's *Napoleon III*, Gérome's *Louis XIV Dining with Molière* and Émile Loiseau's *Hercules Spinning Yarn at the Feet of Omphalos*. It was not so much that the anecdote—notwithstanding Fernand Desnoyers's often insightful commentary in *La Peinture en 1863*—destroyed the internal unity of the true work by its external diversity (Millet had only one subject, Desnoyers noted). For the new painting aimed not at the unity of a personal world, but at a different totality and unity—the external unity of a space that might contain anything or anyone. The anecdote, however, implies a reading, a title, perhaps a supplementary subtitle, that differs from *Olympia* or *Concert in the Tuileries*—the straightforward designation of what is seen—in that it summarizes a story. To cite some of the works reproduced during 1863 by *Le Magasin pittoresque* and *L'Illustration*, for example: *Girl at the Well, The Enemy is Dead (Return from the Hunt in the Pyrenees), The Childhood of Charles V, Erasmus Reading*. Everything invites us to move outside space and into narrative time. The image is the pretext for a text. The anecdotal paintings of Manet, Courbet, Millet, and Daumier work in reverse, leading us toward space, toward a sensory text that is self-sufficient.

The "technical" history of modern painting begins, perhaps, with the portraits of Hals and Goya, but its thematic history begins with landscape, when it is treated directly and for its own sake. We know that classical tradition admitted landscape only when it was integrated into a composition—as setting and idealization. This was especially so in France. David painted a single landscape (the Luxembourg Gardens seen from his prison window); Ingres (besides, of course, his Roman drawings), the three little Italian paintings; Delacroix, the

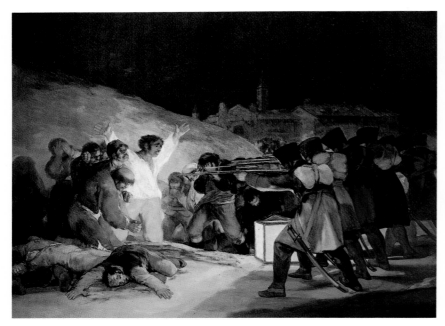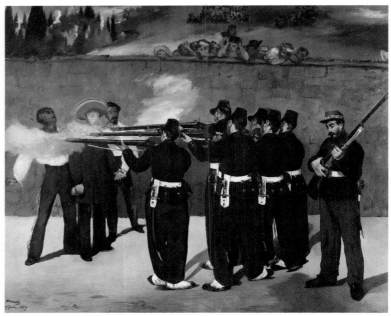

Francisco de Goya, *Shootings of the Third of May*, 1814
Édouard Manet, *The Execution of the Emperor Maximilian*, 1867
Gustave Courbet, *Pierre-Joseph Proudhon and His Children*, 1865
Honoré Daumier, *Massacre in the rue Transnonain*, 1834

Dieppe *Seascape* of 1852 (the remainder consisted of watercolors and the backgrounds of large-scale paintings). There was admittedly a "Romantic" landscape—that of Georges Michel and, later, Paul Huet—seen through the lens of Dutch landscape and especially through the emotion of the painter interpreting nature's "fury" or "majesty" (Huet painted *Breakers on the Promontory at Granville* in 1853).

But, Corot aside, credit for a more direct approach is due to the Barbizon School. In particular, to Théodore Rousseau, the first painter to travel through France, visiting the Auvergne, Normandy, the Jura, the farmlands of Vendée, Creuse, the Pyrenees, Gascony, and the Basque country, although he retained his predilection for the Fontainebleau forest. In his canvases, where the hatchings of the drawing established, as he described it, the painting's "churning substratum," and where the brushstroke sometimes outlined a spontaneous structure, Rousseau demonstrated a delicate and powerful attention to detail. Without doubt, his palette retained a classical tonality, and in his work, as in Dupré's, we feel that nature, beyond supplying a motive to paint, was a living refuge, a compensation for the political disappointments of 1848. Daubigny, for his part, is more modern, more exclusively a painter, and closer to Impressionism. He was the first to abandon tonality for light, to work only out-of-doors (in 1857, he outfitted the studio-boat in which he traveled down the Oise valley), and the first to earn the title of "leader of the school of the impression." But, whatever their differences, there was indeed a Barbizon School. As precursors of the young painters who gathered at Le Havre in about 1862 (Monet, Boudin, Jongkind), the group of painters who assembled at Barbizon in 1848 gave painting a decisive direction, one that was followed in other regions of France, by Paul Guigou and especially Ravier. Van Gogh declared in 1889: "I shall never forget those beautiful Barbizon canvases; to do better than that seems to me very unlikely, and, what's more, unnecessary."

At the moment when it is decided that a landscape is sufficient unto itself, that it need not seek justification as the setting of a scene, that it is neither a work of the imagination nor an image from memory—the moment when painters dare to paint directly, in the open air, beyond the studio and academic convention—time is replaced by space, and text, by image. The representation of human figures in

Camille Corot,
Ischia, View from the Slopes of Mount Epomeo, 1828
Recollection of Mortefontaine, 1864

92

Honoré Daumier, *The Emigrants*, 1868–1870. *Detail pages 96–97*
The Painter at His Easel, ca. 1870

94

Jacques-Louis David, *View of the Luxembourg Gardens*, 1794
Eugène Delacroix, *The Sea from the Heights above Dieppe*, ca. 1852
Jean-Auguste-Dominique Ingres, *Raphael's House in Rome*, ca. 1807
Georges Michel, *The Environs of Montmartre*, undated
Paul Huet, *Breakers on the Promontory at Granville*, 1853. *Detail page opposite*

Théodore Rousseau, *Landscape with a Stormy Sky*, undated. *Detail page 100*
Charles-François Daubigny, *Sunset on the Oise*, 1865. *Detail page 102*

Manet, who has better claim to being a painter of contemporary mores and "modern life" than Constantin Guys, reinstalls us in time. But time here is treated as a landscape; it is an aspect of space. Landscape, figure—these are interchangeable terms. Not that the subject or even its meaning disappears. Rather there is but one subject, the visible, which assigns a meaning to each of its manifestations. The visible is both the meaning of existence and the subject of painting.

To be precise, what disappears is not the identity or the reality of a given image, or its power over us. It is not immaterial that there is in front of us a nude woman or a stand of trees or the waters of a river or a vase filled with peonies. In a sense, our reaction takes this "subject" into account. What disappears is all signification, all connotation that is not conveyed through the visible, the invisible domain of the image. For example, it is of no importance that this woman is Olympia, and not Venus, or that these are the waters of the Oise, and not the Ilissos, notwithstanding the possible expectation created by a title. What is changed is the relationship between the thing preserved (always with its effective identity) and the visible order to which it belongs. It is this change that makes us think the subject has disappeared. The object has lost its primacy; it is no longer the hypostasis of the visible. It is the visible as such that holds and transmits power. In this bouquet of peonies burns "that which is absent from all bouquets": The sun of which these petals are the rays.

And yet, despite this equality of all things within the visible, we are aware of the differences among the images, and even of a sort of hierarchy, a system of exclusion. Rejecting the invisible sphere of the image, this painting corresponds necessarily to a certain order of preferences. It includes a hierarchy founded on the capacity of things to manifest the presence of the sensory, and to be reduced to it. In this sense, Olympia's imperfect body is more effective than that of a Venus or even an Ingres odalisque; its very imperfection is proof that it has been seen and not imagined. A still life is less ambiguous than a portrait, which always risks signifying more than the visible, but a bunch of asparagus is all the same a less complete, less striking manifestation than these spectacles in which the power of the visible has been summoned in its multiplicity: a racecourse, a ball at the opera, a concert in the Tuileries, later a bar at the Folies-Bergère, the Moulin de la Galette, the waters of La Grenouillère . . . At the same time as it took

delight in itself and its own means, painting took delight in its own image; its gesture was attuned to the object of its gaze; it continued to be delectation, but delectation only of the perceived. Far from acccusatory, the new painting was a hymn to the world, and it was that well before it expressed through deformations any discord with the reality of this world. Light playing on colored shadow, water, foliage, or a beach; lovely gardens, filled with playing children, where the charming dresses of the season go by; terraces where beautiful women discard their clothes: Pleasure found in the means of expression cannot be separated from the joy of living, of existing in contact with what gives rise to those means of expression. The world resembles painting. And the more it resembles painting, the worthier it is of being painted, the more it sustains our joy.

All seeing is joy when it is only seeing. The mind is the source of trouble. On May 30, 1863, replying to Alfred Sensier about the recent criticisms of *Man with a Hoe*, Millet wrote from Barbizon that if he saw the drama ("the man destined to earn his living with the sweat of his brow"), he saw also the "infinite splendors" in which the man was "enveloped." *Spring* is on the horizon of *Man with a Hoe*. The drama is not what is seen, but what is thought in light of what is seen. Whence the distance, the striking difference in coloration that marks this painting off from the contemporary literature to which the term "realism" is also applied. In large measure, the realistic novel derived from the will to reclaim its property from painting, the property that painting established so energetically within its limits. And Sainte-Beuve was right to examine *Un Été dans le Sahara*, which had just been published by Fromentin, from the point of view of literary and pictorial description's comparative powers. But description is only one element of a novel that wishes also to convey its opinion of society and mankind, which is none too high. In Flaubert's melancholy, Maupassant's bitterness, and Zola's "nausea," the descriptive moment is the instant of a pleasure that is soon stifled. It is the instant of harmony to which the painting bears witness but that literature cannot make its law.

"Realism," like all words, is no doubt the wrong word. But a better one is hard to come by, and it serves to make ourselves understood. If an art of distortion and exclusion of the real loomed on the horizon, it was at the end of a long dialectic. No doubt, the real would be destroyed upon impact, but the original plan was

Françoise-Auguste Ravier,
Pool of the Levaz, Morestel, undated

indeed to approach the real, to bring together the real and the eye. The new painting challenged traditional painting the way the truth of an appearance truly captured challenges the illusion of an artificial grouping. For traditional illusionism (in the preface to *Pierre et Jean*, Maupassant was to apply the term *illusionism* to every work of art) does not reproduce the illusion of the real, but a conventional model of the real. The new painting, for its part, forgot the museum. (Right at the dawning of the age of the museum . . . But, as Zola saw, a museum does not collect models for the painter so much as it collects evidence of the diversity of expression for the spectator or historian. The moment painting aspired to be nature, the museum erected its monument to culture, as if that culture had already attained perfection.) The new painting shunned the shadows of the studio in which the models, chosen for their conformity to Greek statuary or for their expressivity, posed in a light that was not nature's. (When the world failed to conform to the ancient canon, it was appropriate to rectify it. Therein lay the conflict between Monet and Gleyre, his teacher at the École des Beaux-Arts, who was faithful to Ingres's approach: "Not bad, but too much like the model. You have a stocky fellow; you paint him stocky. He has enormous feet: you render them as they are. It's all too ugly. When you draw a line, you must think of the Ancients. Nature makes a fine element for study, but it is of no intrinsic interest. Style, that's all there is.") The new painting substituted abrupt contrasts without gradation for modelings by shadow, and the intensity of flat colors for the relief of forms spaced out in the perspective cube. It renounced polish—that degree of finish that could only be a mental reconstruction—in favor of an incompleteness that was faithful to the act of perception. It is clear that in so doing, it sought only to come closer to what it believed to be true sensation. Thus Constable spoke of *warmth*; Baudelaire, of Corot's *naïveté*; Zola, of Manet's "window open onto nature"; and Mallarmé, discussing Manet too, of "the immediate freshness of the encounter." It was a matter of regaining sight, as it is recovered by the convalescent or the blind man who has had cataract surgery. Nothing was more common than such metaphors. Ruskin: "The whole technical power of painting depends on our recovery of what may be called the *innocence of the eye*; that is to say, of a sort of childish perception of these flat stains of colour, merely as such, without consciousness of what they signify,—as a blind

Édouard Manet,
Vase of Peonies on a Stand, 1864
Concert in the Tuileries, 1862, *detail following pages*

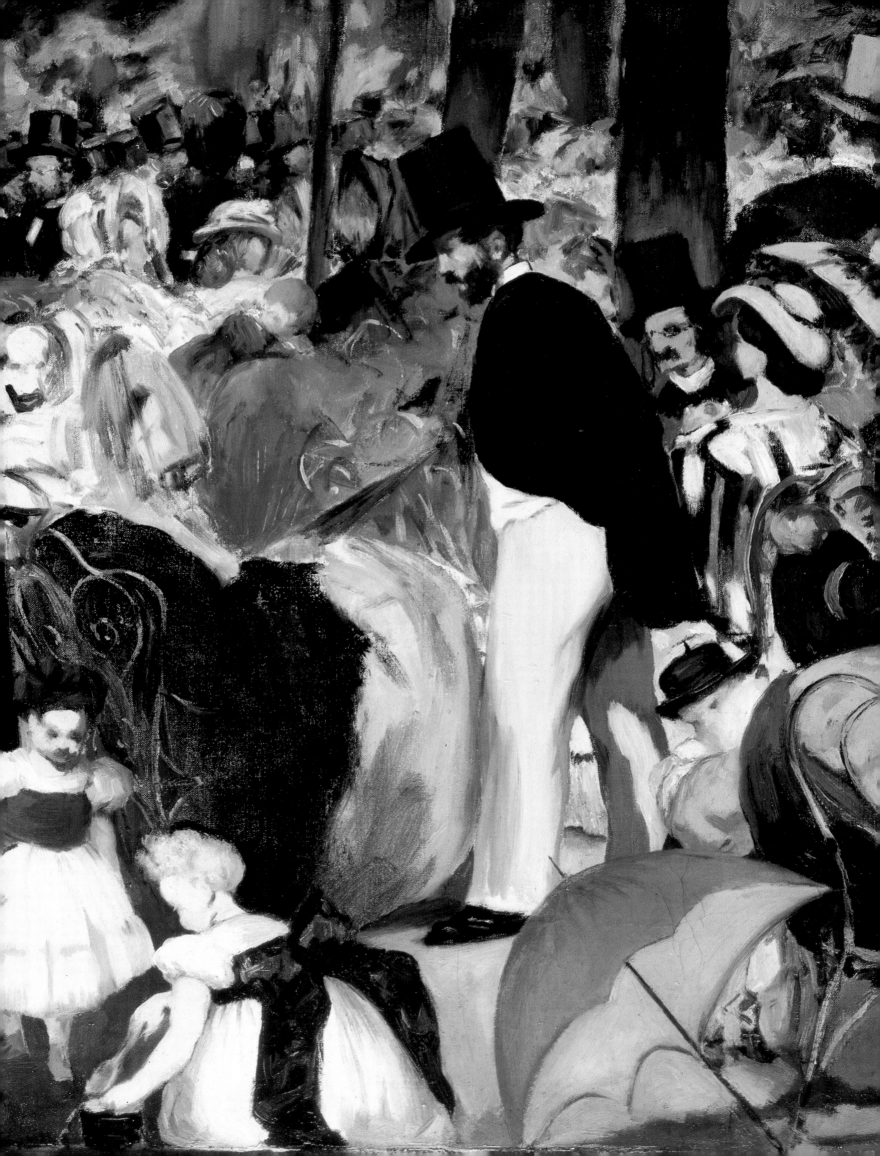

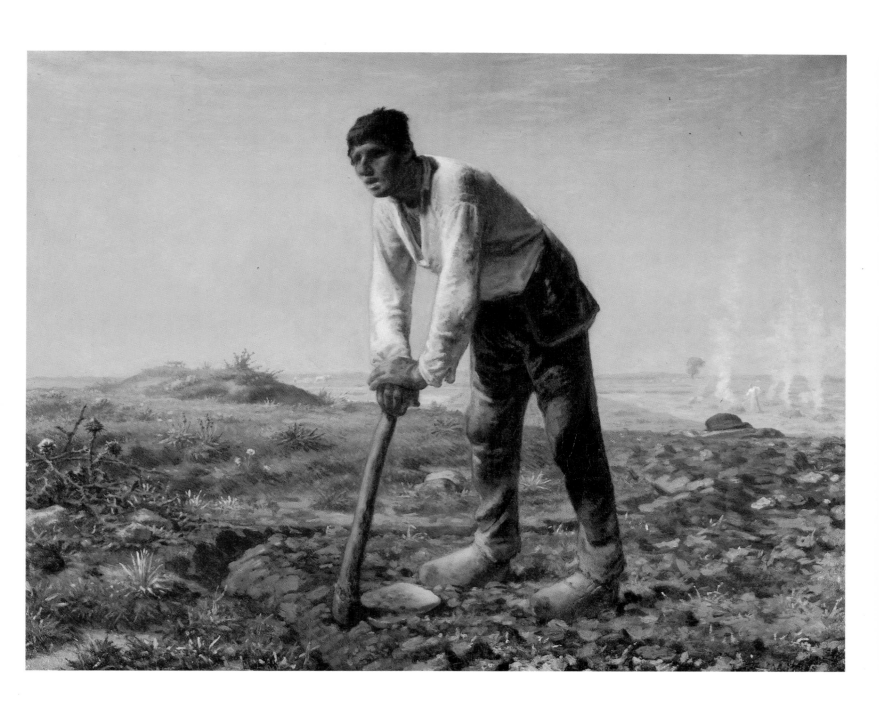

Jean-François Millet,
Spring, 1868–1873
Man with a Hoe, 1860–1862

111

man would see them if suddenly gifted with sight." And Monet would say: "that he would have wished to be born blind and suddenly to gain the sense of sight in order to begin painting without knowing what the objects were that he was seeing in front of him."

Is it a matter of clearing a path to a new perception—truly "unheard of"—or of rediscovering a lost freshness? Here, the men of the present, such as Manet, rebel against those whose hope is always combined with a certain nostalgia, those for whom revelation has already taken place (as the classical tradition holds) but not been maintained. In Baudelaire's eyes, art should return via modernity to a former state, even if only a state of memory: "There they are, happily returned and rediscovered, sensations." But it is the immediate that is rediscovered: we leave behind a languishing present to step into a reinvigorated one. It is thus that the mental, imaginary vision of the Pre-Raphaelites, Puvis de Chavannes, Gustave Moreau, and especially Gauguin joins up with the immanent vision of Manet, Degas and Monet, albeit by a different route. By the mind they return, or rather they believe they return, to the primeval sensory world.

In any case, it is not painting as painting that is being sought for the moment. It finds itself in the world. And Georges Bataille is right (contra Malraux) to say that with Manet, "it is the majesty of anybody, and even of anything [. . .] that belongs, without further justification, to what is and what reveals the force of painting." And Georges Duthuit is also right to make clear, in his essay *Le Feu des signes*, that the question is not "the insignificance of things," but "their total significance."

Was it photography, appearing at the same time, that so quickly diverted the new painting from its realist calling? There certainly was a feeling that coexistence was dangerous. A painting by Lafaye represented the dramatic parley at the Institute: *Painting Is Dead!* And in 1862 Ingres signed the manifesto that declared: *Photography is not an art!* But let us recall that Delacroix and Degas both had a passion for photography. At the outset, these pursuits shared a common goal, and their development was intertwined. Photography imitated history painting when painting still believed in history. Jouvin photographed the parade of troops in the Place de la Concorde for the Emperor's birthday on August 15, 1862, and the crowd waiting for the imperial procession in the

Stereoscopic photos by Hippolyte Jouvin,
Bridge and Place de la Concorde, Emperor's Birthday, August 15, 1862;
Industrial Holiday of January 25, 1863.
Return to the Tuileries,
Emperor's Carriage, the Cent-Gardes.

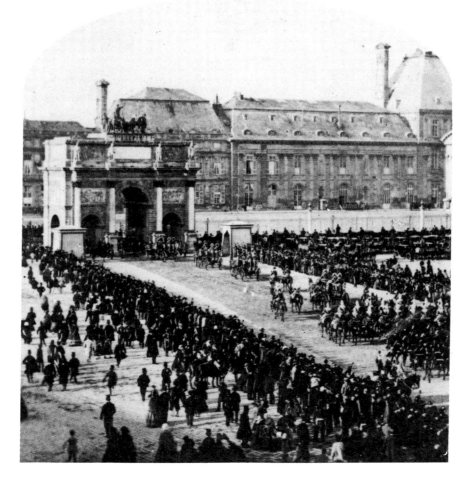

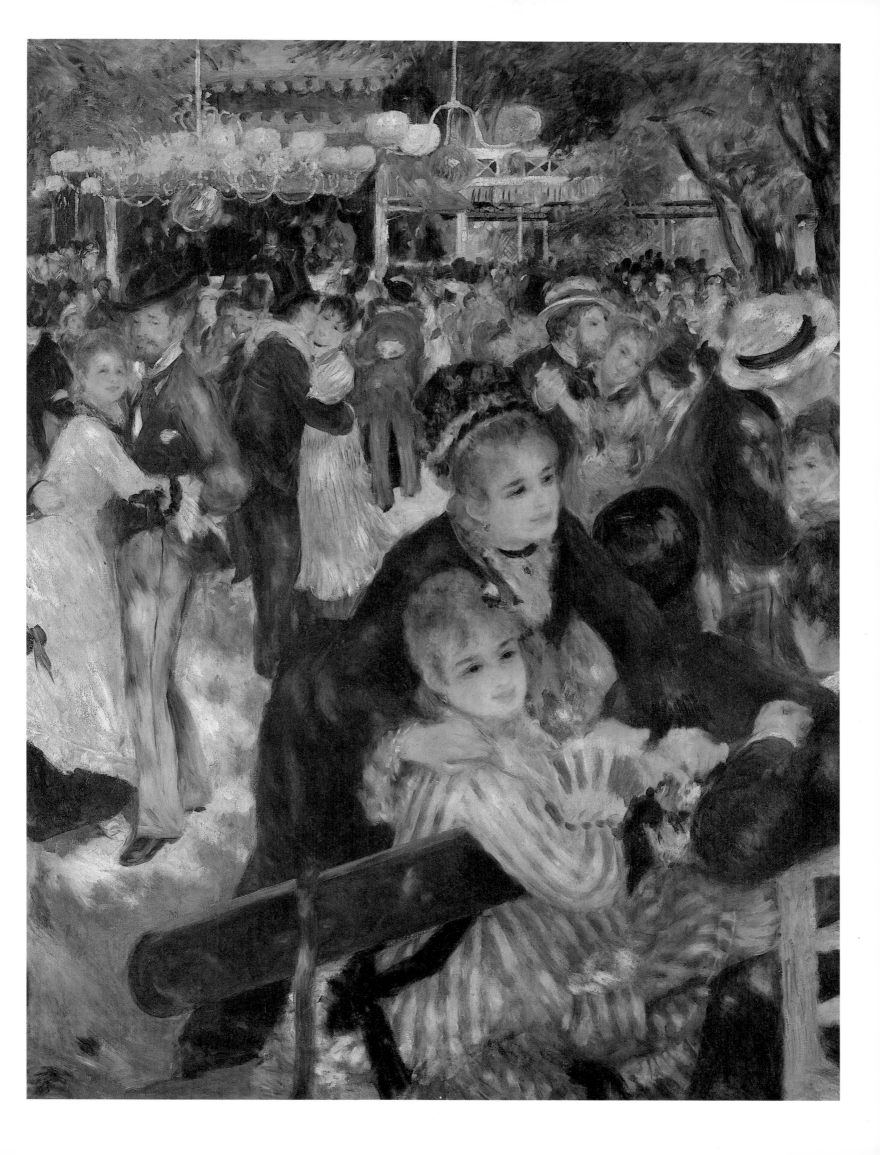

Tuileries on January 25, 1863, at the same time as the capture of Sebastopol and the splendors of the Emperor's voyage to Constantinople were being painted. The photographer posed and composed, just like the traditional painter, when a lengthy exposure was required. Soon the snapshot and the portable camera would appear with Impressionism, sharing with it new angles and unusual framings.

But later their paths were neither parallel nor divergent; rather, there occurred a division of turf. Photography excused painting from portraiture and in particular lifelike portraiture. It assumed the documentary function, the role of day-to-day historian. And as photography could add nothing to what was there, whereas painting necessarily had an intention, whether harmonious or discordant, with respect to its chosen object, it was better to photograph the Second Empire's military parades than to paint them. Painting, in that case, could only be painfully bombastic or accusatory (and there are better things to do than accuse). On the other hand, when photography represented the *Fair at Montmartre*, it fell short of painting; and in the beginning it fell short of painting's enchanting colored world. Black-and-white photography provoked more and more colorful painting, and if its instantaneity did not, as Ingres and the signers of the 1862 manifesto believed, give rise to a painting of premeditated composition and line, then it called forth a compensatory pictorial analysis that would continually accentuate and clarify what was initially global and blurred, and would even seek to anchor the scattered colors to linear structures. The painter would work on the instantaneous in completely different fashion from the photographer; his operation was not development and retouching; the hand worked upon the eye.

The New Representation

Nevertheless, the painting that shed all artifice in order to come closer to the natural seemed obscure, complicated, and hard to follow. It contained the world, but viewers had a hard time recognizing it.

Zola explained the difficulty of adjusting by saying that we are used to seeing only through pictorial convention. And, indeed, any new presentation, even when it more closely approximates the real, is received as confused, disconcerting. Balzac made the same reproach against *The Charterhouse of Parma*; Sainte-

Anonymous stereoscopic photo
Fair at Montmartre, ca. 1862, *page 114*
Auguste Renoir, *Le Moulin de la Galette,*
Montmartre, 1876, *detail page 115*

Beuve, against *Salammbô*; and virtually every critic, against Baudelaire, Monet, and Cézanne. But the pictorial convention in question here is all the more forceful for its conformity to our normal perception of things. If Renaissance perspective was a cultural choice, it was the expression of a culture that wished to capture the normal as closely as possible and succeeded in doing so. And in this sense, if the aim of art is seen as the representation of the perceived image, one may speak of the Renaissance as an advance. We normally perceive in accordance with the lines and vanishing points of perspective; we perceive images, not painted images. Now classical painting, smooth and pristine, gives us the illusion of objects as they exist outside painting: raisins that fool birds. And as long as painting authorized the identification of the image with a real object, there would be at least the germ of a mental bias toward perspective.

Pierre Francastel expresses this very well in connection with Renoir's *La Grenouillère* (1869): "The anchor points of the composition are blurred by scattered dabs of color that reproduce the quivering of the light, but, reduced to its general lines, the painting still suggests the old cubic space of the Renaissance, and we still peer through Alberti's famous open window [. . .]." He suggests the term "Impressionist grid":

> One might say that canvases composed in this way are constituted by the superimposition of two images that coincide at certain points, following the procedure of color printing that superimposes with masks several series of exposures according to a certain number of fixed reference points.

Perhaps only an informal art will escape unscathed from perspective's grasp. In any case, if we still follow its law, we do so against the express advice of painting from Manet on.

Not that a decision was being made to put an end to perspective. Simply, the aim of painting in full light, from life and in the moment, replaced a spatial depth in which objects were ordered with a flat surface that presented itself immediately and globally not as the illusion of an external model, but as the internal evidence of the colors, lines, and brushstrokes whose interrelations were established without the eye's having to leave the surface of the painting. As if space emptied itself and the objects it hid poured forth, the waves of the colors

Édouard Manet,
Races at Longchamp, 1864,
detail following pages

117

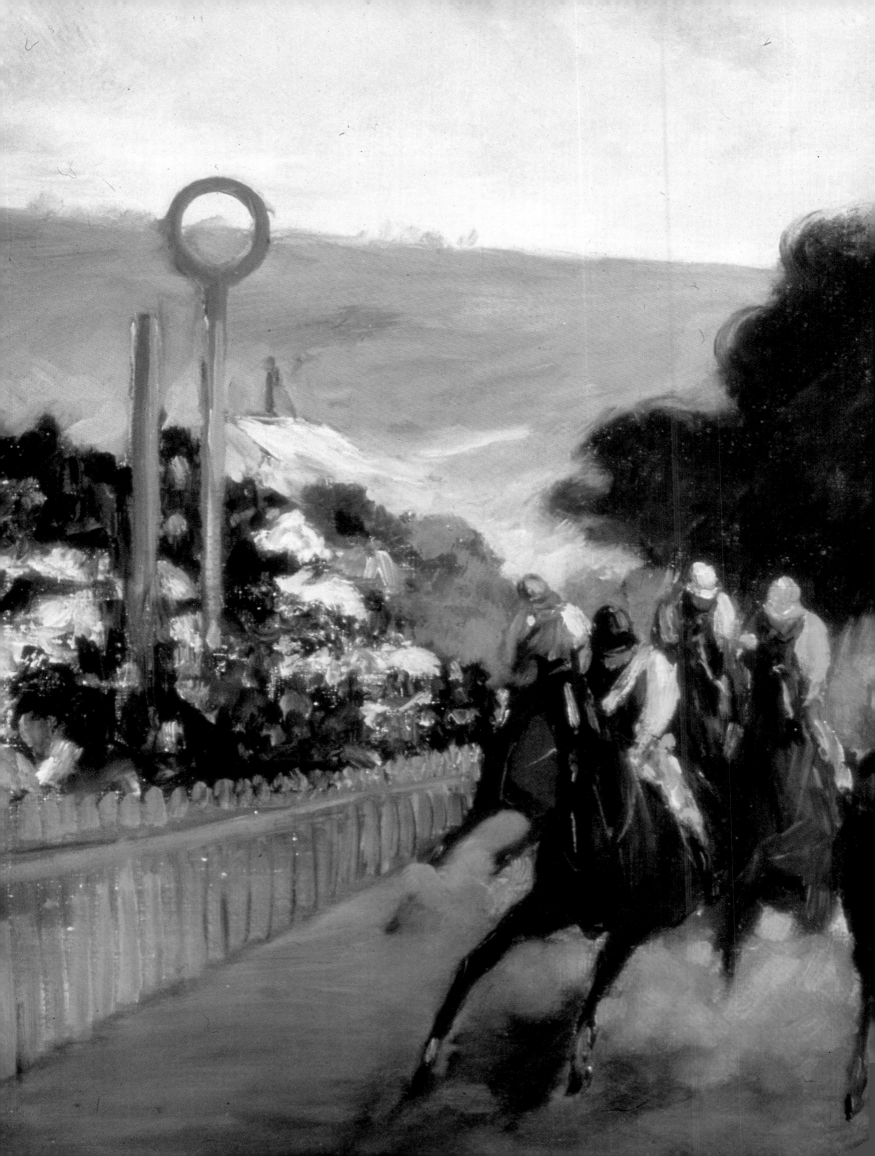

Édouard Manet,
Bar at the Folies-Bergère, 1881–1882
Édouard Manet,
The Balcony, 1868

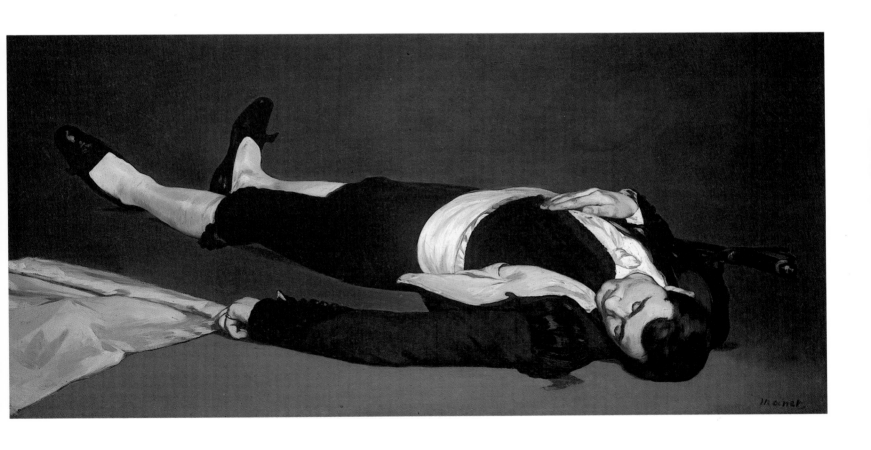

Édouard Manet,
The Fifer, 1866
The Dead Toreador, 1864

123

rose and broke across the surface, laying over the canvas a brilliant, seamless cloth. Color overflowed line, indicated contour, enlivened shadow. By comparison, perspective appeared a discoloration of the world, a world gradually lost from view, while, on this flat surface, the world was completely on view.

It is the tangle and promiscuity of colors in *Concert in the Tuileries* and *Races at Longchamp*, in which the blacks do not separate the forms, but articulate a continuity that will not recede into the background. It is the reversible space of the *Bar at the Folies-Bergère*, the ambiguity of the mirror that makes the barmaid emanate from her own reflection. The fading echoes of perspectival depth become the uniform intensities of a flattened depth, its force spread everywhere, yet collected in each point.

The purpose was certainly not to eliminate the background, which, in Manet's eyes, remained essential: "If the background is opaque, dead, then the painting is nothing!" Rather the point was to harness the power of the background to the surface. In canvases as different in subject, format, and date as *Boating*, *Asparagus* and *The Balcony*, the background, whether it be called sky, cloth, or interior shadow, appears like a reservoir from which flow the messengers of the visible. The background is reversed, not annulled. Far from being the place toward which we move and that slowly withdraws the objects from our view, it is what comes toward us. In *The Balcony*, we do not move from the green of the wrought iron to the lamp; we illuminate this green with the lamplight. The background is not the remote distance; it is the emergence, the respiration of the depths.

But it is not always the overflowing and rising color that achieves the reversal through which background becomes propulsive force. The abstraction of the ground (analogous to a gilded background) containing color alone and against which stands a prominently outlined form, as in *The Fifer* (1866), *The Dead Toreador* (1864) and even *Olympia*, opens a path all the more promising because we can no longer suspect space of containing anything, we can no longer read any perspective into it. Ingres exhibits this modernity when, in a sketch now in the Louvre, he places the body of Angelica against a high, pure red rectangle—a lesson Degas would remember.

For the master of the new linear representation was clearly Degas. In his work, space is never an empty, limitless stage on which the image unfolds, with room to breathe yet imprisoned. Pure colors block the background, prevent it from

Édouard Manet, *Asparagus*, 1880
Edgar Degas, *Landscape*, 1890-1893, *following pages*

124

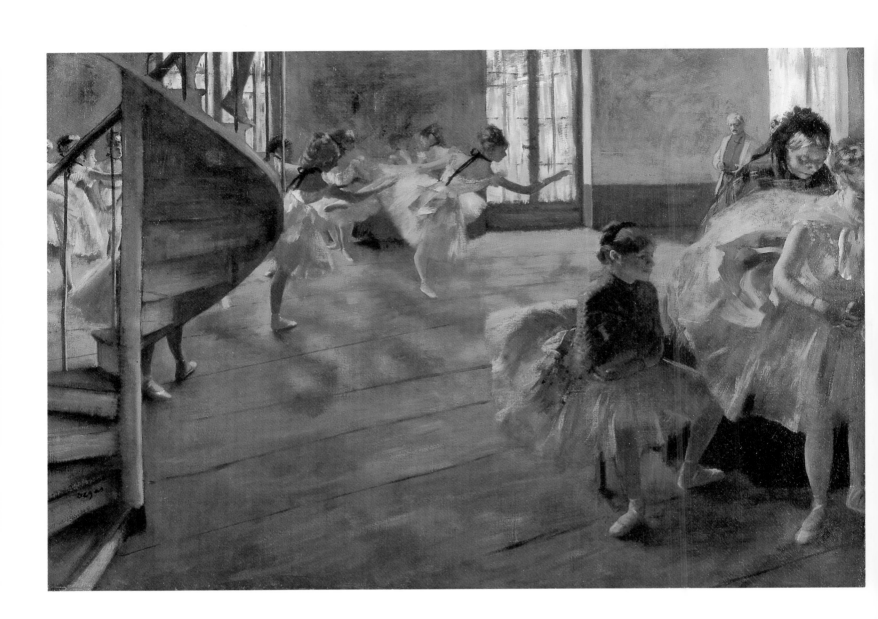

Edgar Degas, *The Rehearsal*, ca. 1874
Women on a Cafe Terrace, Evening, 1877

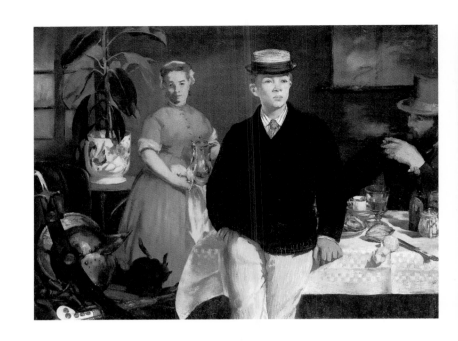

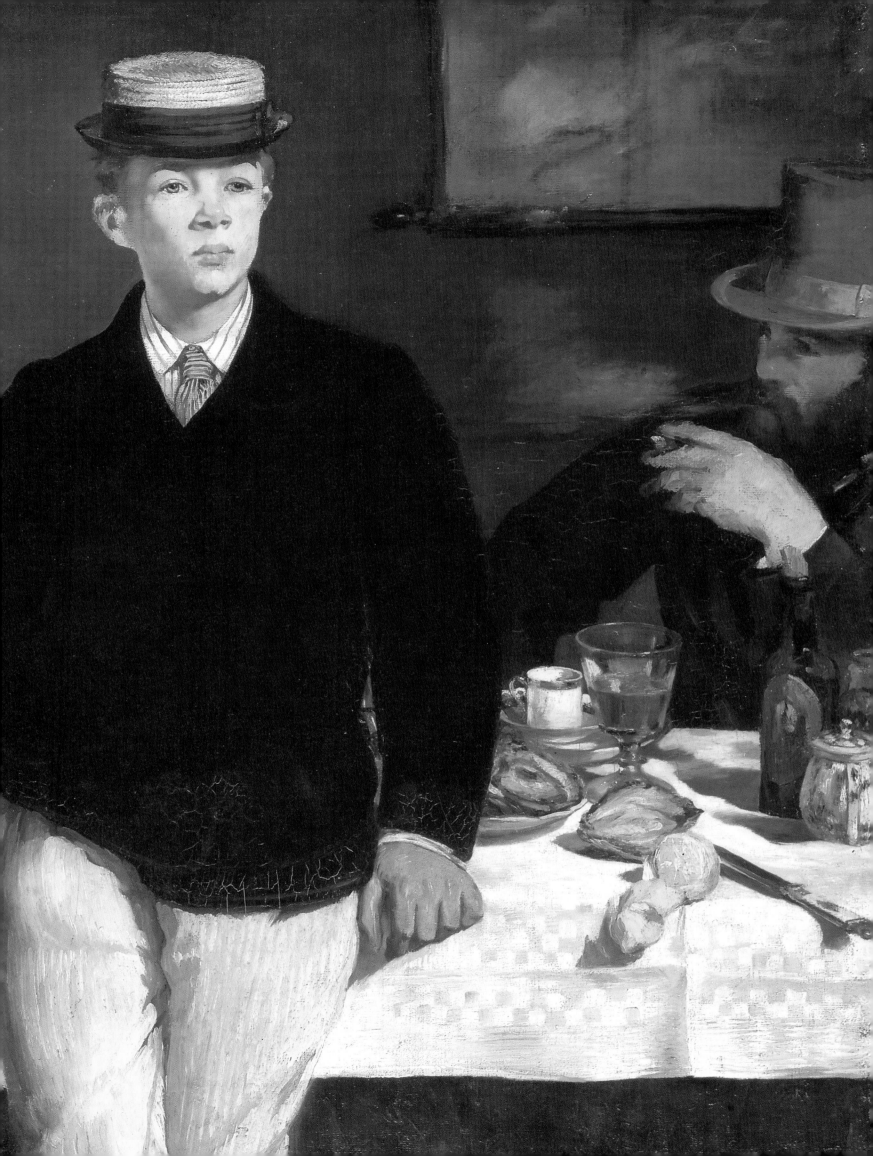

vanishing, drive it toward us. Or rather, there is no background, only a color-form, a space-matter inside which everything is played out: the mass of the chrysanthemums, which lets the woman function only as a peripheral support (1865); the dark green bulk of the wooded hillside at the foot of which the jockeys are outlined (1862); the band of empty sky filled with color alone (beach scene of 1869). Finally, the extraordinary monotype landscapes of 1890, which totally suppress any suggestion of space, leaving only smoky colors with nothing to hem them in.

Degas's natural preference, however, was not for landscapes but for interior scenes hermetically sealed by ceiling, floor, and walls. It was there he obtained new revelations from space. The light, slippery floor, below or above the image, is the trampoline projecting the image or from which the image has just leapt. Or else, a door panel near the edge seems to be the drawer from which the image has been produced. Here space is not the isotopic milieu whose center is occupied by the image, but a force, an energy that has its own values and may strike from any point. Or one may see it unfold like a screen whose panels open all at once, then are multiplied again by the play of mirrors. At any rate, the painting is no longer an immobile rectangle, a heavy spiderweb trapping the lifeless fly; it takes on the orientation of its directing force, coming toward us as if through a zoom lens. And just as the exaltation of the palette was a reaction against the discoloration of perspective, the juxtaposition of planes overcomes the perspectival confusion. Everything spreads out in distinct layers, instead of being neatly ordered in an indistinct space. Primitive painting, and Far-Eastern art in particular, offered certain analogous examples. We know that Manet, and Degas himself, became familiar with it through the cheaply printed woodcuts that were used as wrapping paper for Japanese exports to Europe, and it is clear that their style of representation was as influential as the purity of their colors. But primitive or Japanese art most often aligns successive moments of time with a narrative purpose, whereas in Degas, the true precursor of the Cubists, it is the appearances and movements of a single instant that are juxtaposed. The resulting compositions are extraordinary (and to Bonnard and Matisse unforgettable). In them, the unexpected, the impromptu of the instant is given the task of revealing to us the resources of space.

Because this liberation from perspective was more the result of an instinct than a deliberate decision, it was achieved progressively, by fits and starts. Its

Édouard Manet,
14 Juillet: Rue Mosnier Decorated with Flags, 1878, page 130
Luncheon in the Studio, 1868, page 130. Detail page 131

influence on painting grew slowly; it did not automaticlly assume the force of law.

In the *Venus of Urbino*, which Manet copied in 1856, he did not eliminate perspective, but reduced it, using spots, dabs, and hatching to transcribe the volumes. In *Bathing*, the viewers of 1863 did not see any perspective, but we find today at least the suggestion of it. Not that the ring of the principal figures, completely containing the color, recreates space as the milieu of carefully ordered objects; rather it forms a foreground behind which we perceive the sunny clearing, the trees, the woman bending over the flowers. However, the perspective appears false; the trompe-l'oeil is only an allusion to trompe-l'oeil, as if a real scene were being performed in front of a stage set. In *Races at Longchamp*, the "Impressionist" surface treatment of the two lateral masses does not exclude the vanishing point of the two fences; the jockeys stand out one behind the other. And the interlace of *Concert in the Tuileries* has at its center a sort of hollow. In *Luncheon in the Studio*, the intense velvet of the jacket places the boy wearing the boater in the foreground, while the proportions of the woman in blue-gray designate her as a figure of the middle ground. In *14 Juillet: Rue Mosnier Decorated with Flags*, the figures are placed along a diminishing scale, the farthest part being treated with the blue of the far distance. In Manet, the most decisive of painters, there is no end of similar relics, similar exceptions to the new "law."

Corot and Courbet, the two great masters immediately preceding Manet, clearly signal a liberation from traditional perspective, but not via a continuous, deliberately plotted path. In the Roman paintings, the thinnest transparency of a perpetual dawn diffuses a light that offers no hiding place. A more intense color is all that is needed to deny and reverse distance: in *The Bridge at Narni* (1826), the blue of the river in the arches' shadow seems to be nearer than the muddy yellow, to be approaching us. And the frontality of certain canvases is striking: as Jean Leymarie observes, *Civita Castellana* foreshadows Cézanne. The water painted with segmented strokes, the rocky shore, the trees, and the cliff-face form a single, seamless fabric articulated by a color that does not separate the objects, but unites them. A painting such as *Rosny-sur-Seine* (1844) seems, somewhat like a Douanier Rousseau, to predate the discovery of perspective (and there is also some of this "primitivism" in the clarity of his views of

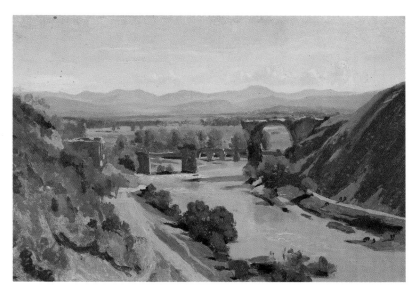

Camille Corot, *Rosny-sur-Seine, Village Church,* 1844
Civita Castellana, 1826–1827. *Detail opposite page*
Bridge at Narni, 1826

135

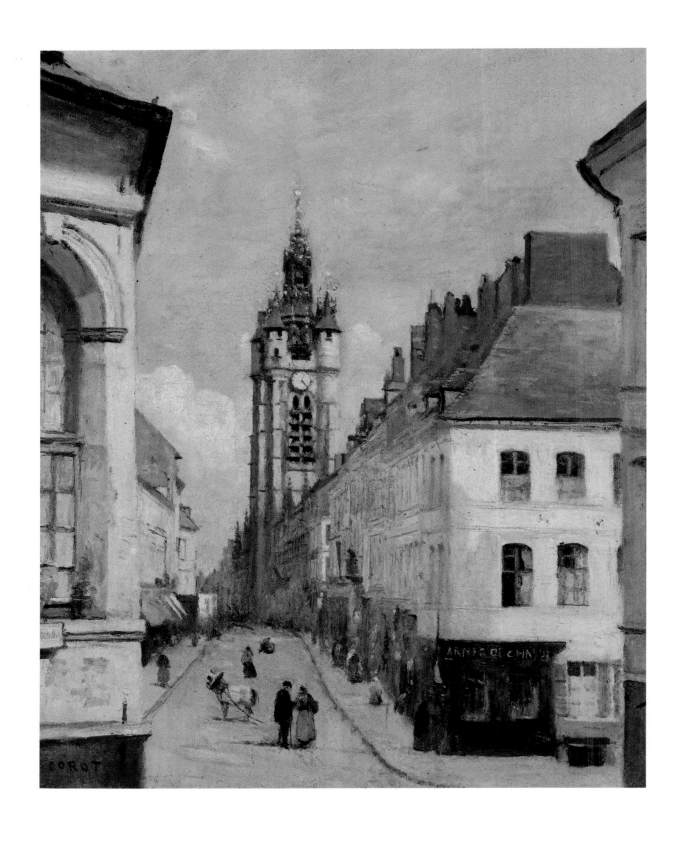

Camille Corot,
Belfry at Douai, 1871
Gustave Courbet,
The Painter's Studio: Real Allegory, 1855

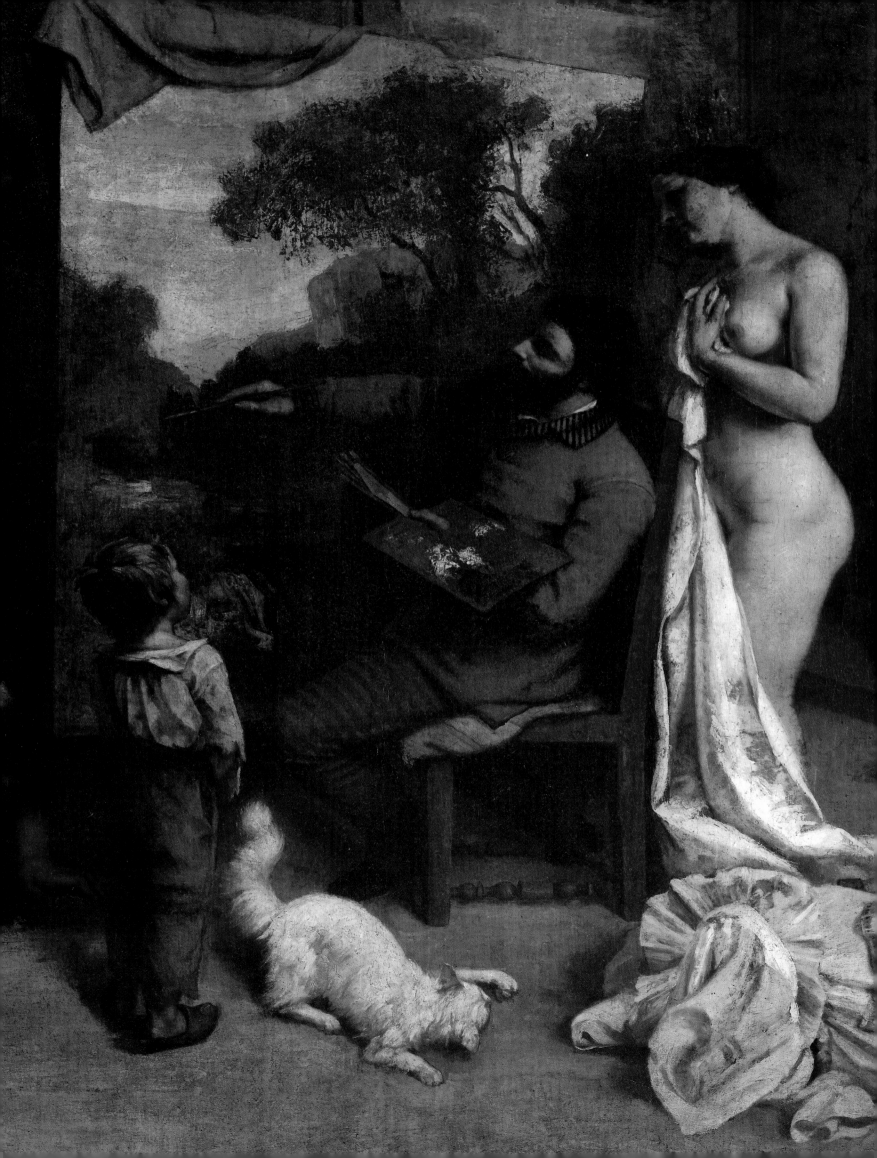

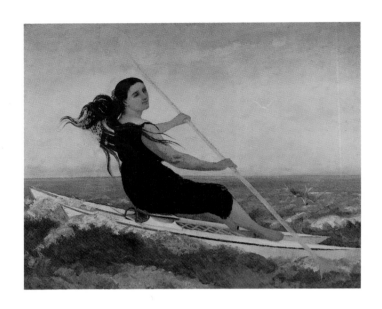

Gustave Courbet, *Woman in a Podoscaph*, 1865
The Shaded Stream or *The Stream at Puits-noir*, 1865

Gustave Courbet,
Burial at Ornans, 1849–1850.
Details pages 139, 140

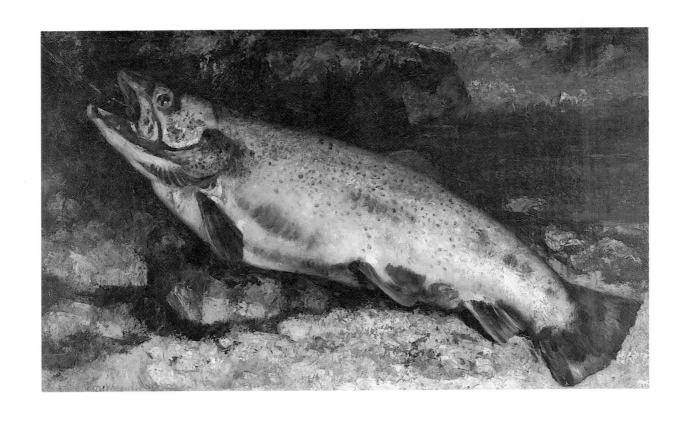

Gustave Courbet, *The Trout*, 1871
Stormy Sea or *The Wave*, 1870, *detail*

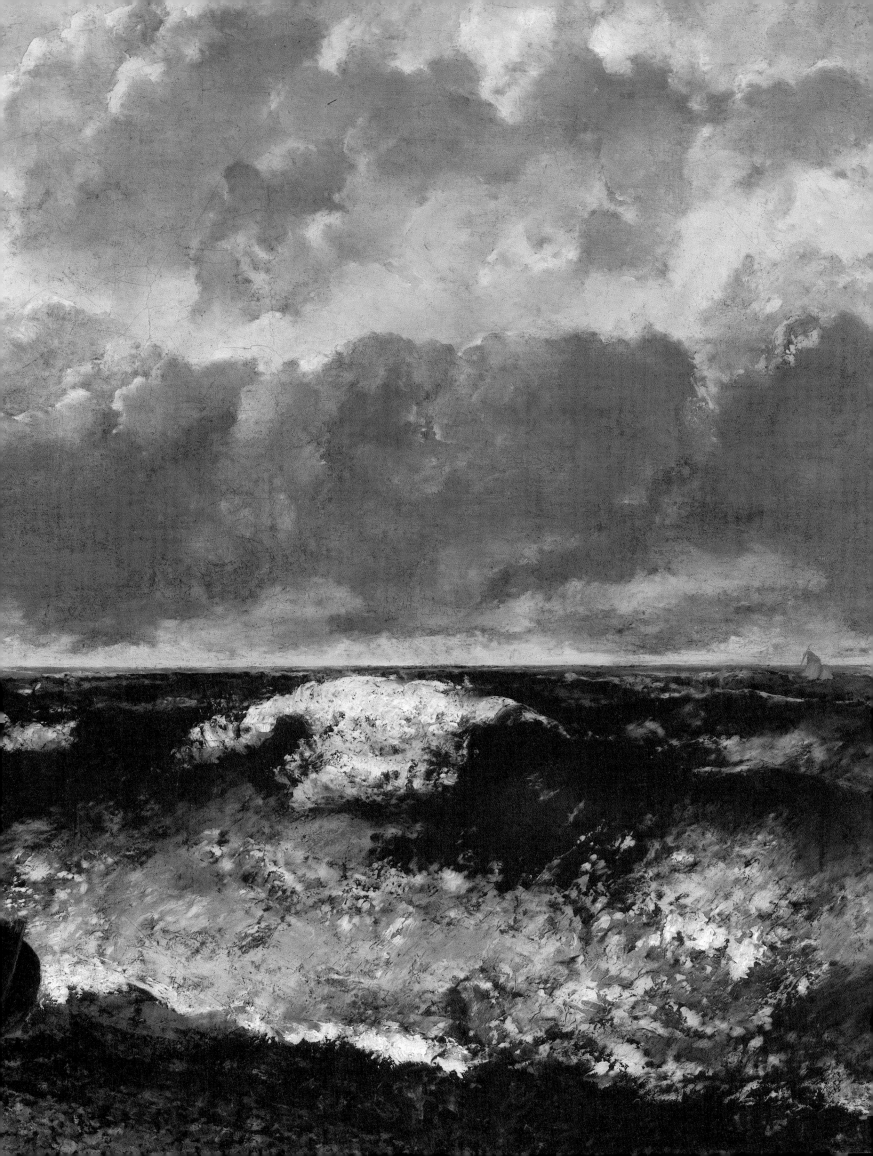

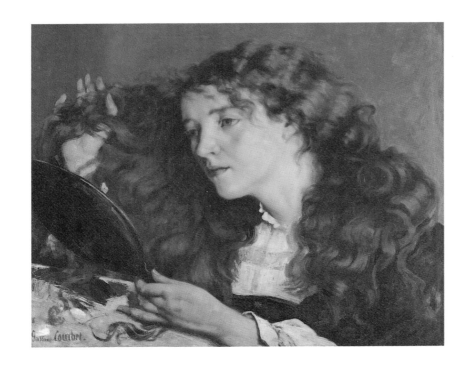

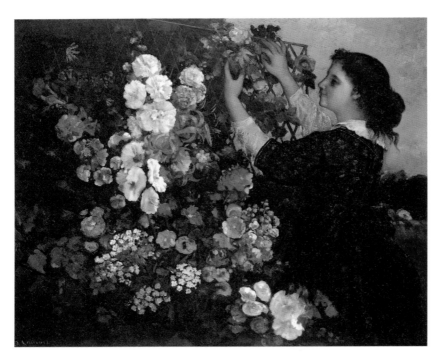

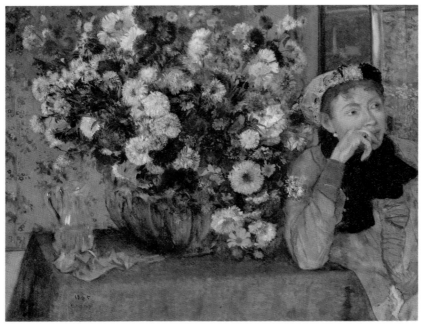

La Rochelle). But, around 1850, as Corot reintroduces shaded tonalities and replaces sharp pen strokes in his drawing with grisaille and charcoal, he rediscovers traces of the past and of distance: we have already mentioned *Recollection of Mortefontaine* (1864). However, it is not his last word on the subject. In *Bridge at Mantes* (1868–1870) or *Belfry at Douai* (1871), what matters to us much more than the vague suggestion of perspective is the unity that, as in *Bar at the Folies-Bergère*, derives from the reversibility of the planes, the reversibility of a space that no longer lodges bodies in the distance, but is a still reservoir filled with living light.

As for Courbet, he may appear to belong more to the "grand" tradition (by virtue of his Caravaggian shadows; his restrained, darker palette; the massive obtrusiveness of certain forms placed energetically in relief; and especially by this program of *real allegory*, which freights works like *The Painter's Studio* with a signification as imperious as that of the great classical composition) than to the new, were it not for the fact that the mythic, as it appears in *Woman in a Podoscaph* (1865), a "modern Amphitrite," is resolutely sought in the forms of the present day. But only rarely do Courbet's landscapes contain a centered vanishing point. In their frontal presentation, they look like friezes, presenting the visible like a wall: the long line of waves and the horizon of *Saintes* (1862) or the rocks of Franche-Comté—black, white and red forms struck on like melons—in *Burial at Ornans*. (Théophile Sylvestre has duly noted the "flaw," the composition violating all the rules, the too-pronounced heads in the background, which encroach on the foreground, etc.) And if, in *Ornans*, as later in Dubuffet's cliffs, a narrow border of sky remains, elsewhere everything is filled to overflowing. The greenery in *The Stream at Puits Noir* (1865) or a snowy landscape that has no more background than a vase of flowers or *The Trout*—these forms are themselves living, breathing space, just as, in other canvases, the seascapes, for example, the void of space becomes matter that has no need of being marked off or filled to become visible. (And certain light-filled paintings inaugurate *plein-air* Impressionism—for example, *Young Women on the Banks of the Seine*, the 1856 sketch of which exhibits a modernity that Matisse, the master of modernity, did not fail to appreciate.)

Delacroix admired Courbet, but found *The Painter's Studio* "odd." His reason was above all that the landscape the painter is working on has the effect of a "real sky" in the middle of the painting. Artlessly, Courbet had found the symbol

Gustave Courbet, *Jo, the Irish Beauty*, 1866
Detail following pages
Gustave Courbet, *The Trellis*, ca. 1862
Edgar Degas, *Woman with Chrysanthemums*, 1865

145

of modern painting: It is *painting*, and dispels any confusion with real space or "real sky." And it is upon this condition that it acts like real sky.

The gradual disappearance of perspective suggests that the image is no longer a distinct unity having its center and its boundaries. Because it no longer has a vanishing point, the image can move in any direction: it has no reason to stop. Filling the frame to the edge, it has no edge. In Courbet's *Valley of the Loue*, the enormous rock over against the left border seems to continue outside the field; in *The Trellis*, the invading flowers push the girl's face to the side of the painting; in *The Irish Beauty*, now in Stockholm, the expanse of hair seems unending. And, in Manet's *Luncheon in the Studio*, the face of the seated figure is cut off by the frame. But no one has matched Degas's inspired virtuosity at suggesting, by the obvious arbitrariness of the boundary or of the disposition of elements, by the multiplicity of different centers and by the divergence of the perspective axes, the feeling that everything is taken from a continuous space that passes by, going on its way. Far from being eliminated, the image is enhanced by the power that surrounds it and sweeps it along.

A classical painting supposes a world of objects and scenes already abstracted from their continuum, each one of them possessing a distinctive unity, center, and framing. It is the representation of pre-formed representations. Its energy is directed at reproducing illustrations that are already extracted from their texts, and not at producing something that would give the precise feeling of a reality existing prior to this abstraction (something Courbet suggests when he says that painting is the *concrete*). Classical painting obeys the prior individuation of famous scenes and prestigious objects, each of which is fully worthy of being the center of space and time. The vital importance of composition (for Ingres, a dominant element must always be reinforced by the meeting of form and light) signifies that the goal of the painting is to reproduce an object in its identity and its limits; the composition carries the same guarantee as the title. A painting that has no center and no reason to end here rather than there would be a painting with no object and no subject, a painting that embraces nothing but the void. At the same time, the image communicates with the world from which it is detached; it is thrown in relief by a sort of spotlight. But in the shadow, we sense a whole universe, complete and hierarchical, of which the image is an illustration

or a model. In contrast, the modern, limitless painting does not refer to a total system of images. It wishes to be a world in itself. That is why it is both open and shut in on itself, functioning as an absolute moment.

Framed already, the classical painting demands a frame, in the material sense of the word. Even the richness of the frame has its importance; only with the advent of modern painting does the thought arise of showing canvases without frames, or even embedding them in the wall. We also have no qualms about seeing old paintings side by side in their gilt frames, as at the Pitti Palace today and in other places happily shielded from museum thinking. They are in themselves sufficiently individuated, and, each of them being a particular plate in a text calling for infinite illustration, their coexistence compensates for their singularity.

On the other hand, a symbolic strip of wood suffices for modern works. It does not signify the distinctive abstraction of these images, but the (purely mental) frontier that separates the painted space from real space. It is outside real space that the painted work can manifest the whole, continuous energy that real space has divided up. But its potential generality, which dispenses with the frame, demands that the modern work be looked at for itself, like Oriental scrolls, each of which must be viewed separately. The distinct images form a whole. The world of objects needs every object, whereas the brilliant works that seek to be the manifestation of the same energy, of the same genesis, can only blind each other. No one canvas gives enough of an idea of the work of a great classical painter. For the work of certain modern artists, one example is all that is needed, which does not signify a lack of invention, but that each work is an *all or nothing*. It is an irony of history, one of the subtlest comedies of culture, that the mania for enormous exhibitions has arisen at the moment when allowing a representative work to have its full resonance requires that it stand out against a background of solitude.

The New Distance

At the same time as perspective, composition and centering lost their *raison d'être*, it was realized that a painting should no longer be seen from the same distance as before.

Dominating the criticisms fired at Manet's works was the charge that they

lacked finish. In place of precise line, we find only a roughly drawn mark. In place of colors blended to obtain the tone corresponding to the object, we find only dabs of paint and juxtaposed hatchings. The critics deplored distortions, inversions, and transpositions . . . that did not correspond to real contours. In 1863, Paul Mantz wrote in the *Gazette des Beaux-Arts*: "All form disappears in the large portraits of women, and notably in his *Street Singer* in which, with a disconcerting oddity, the eyebrows leave their horizontal position and place themselves vertically alongside the nose, like two commas of shadow [. . .]"

This reproach would long endure. In 1876, Émile Percheron wrote in *Le Soleil*: "M. Manet, through his own inability, does not finish what he is doing, and he must impute a healthy dose of good will to the spectator to add mentally what his painting lacks."

Now Zola, in his great study of 1867, replied to the (fairly imprecise) ensemble of these criticisms that appreciating such works required viewing them several times from varying distances:

> Olympia reclining on white sheets is a large patch on the black ground; in this black ground are to be found the head of the Negress who is carrying a bouquet, and the famous cat that has so amused the public. Thus, at first glance, one distinguishes only two colors in this painting, two strong colors, standing out against each other. Moreover, details have disappeared. Look at the girl's head; the lips are two thin pink lines, the eyes reduced to a few black marks. Now kindly examine the bouquet from up close: pink areas, blue areas, green areas. Everything is simplified, and if you wish to reconstruct reality, you must move back several paces. Then something strange happens: each object assumes its place in its own plane; Olympia's head detaches itself from the background in striking relief; the bouquet becomes marvelously bright and fresh.

Therefore, it is necessary to approach and then to stand back. Several observations from several positions are needed. And, at bottom, there is no ultimate observation since there is no privileged position. Let us move back. Then, once again, let us move closer . . . Then, once again . . .

Before that page of Zola's, there had been mention of the *new distance* from which the new painting should be seen. In 1855, Baudelaire noted that a Delacroix painting acts at a distance greater than that of traditional perception,

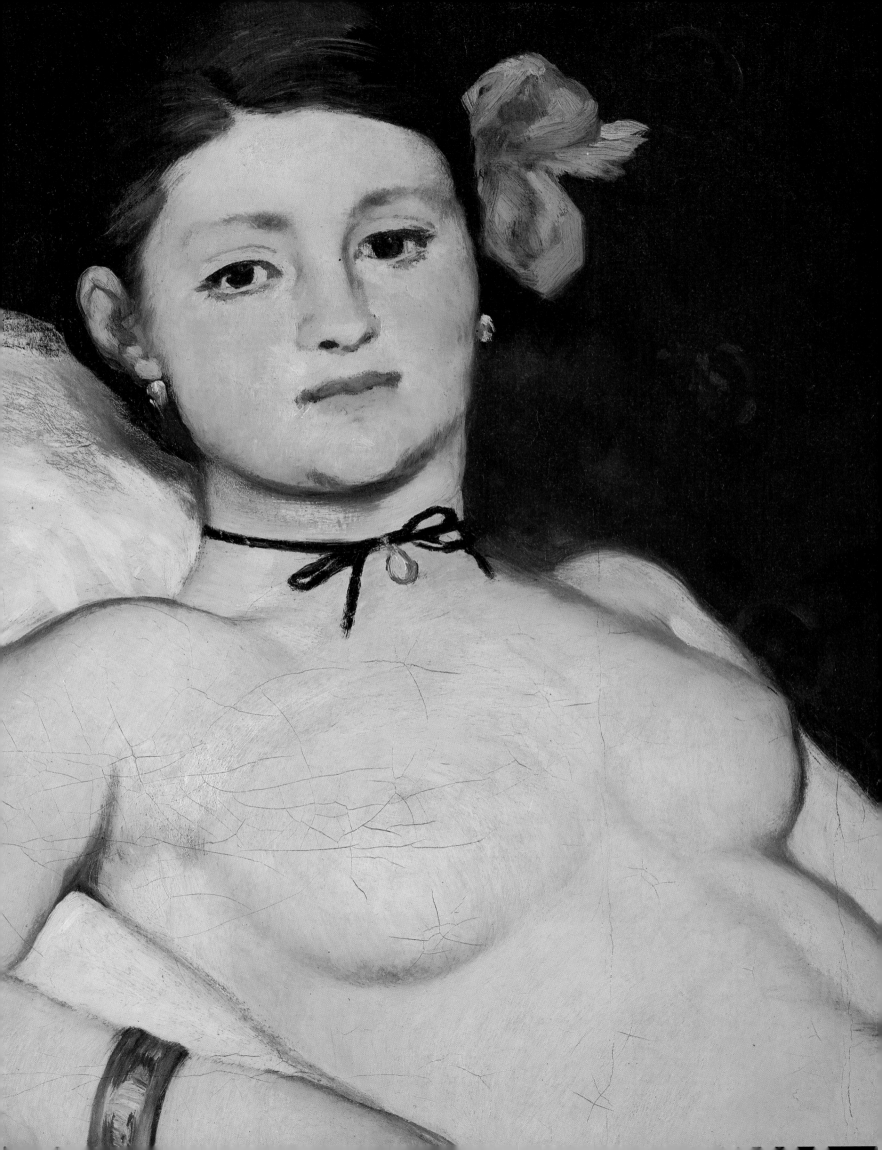

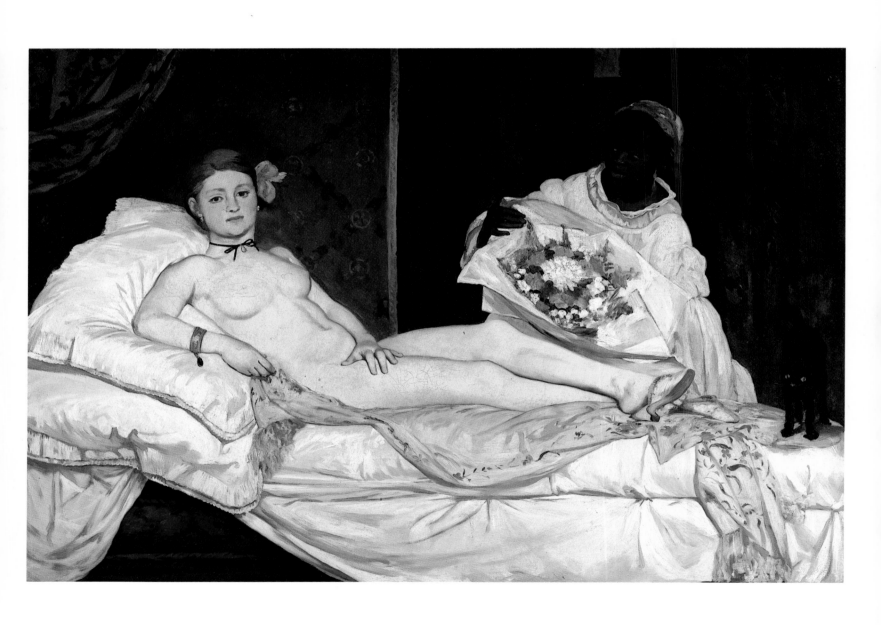

Édouard Manet, *Olympia*, 1863.
Details page 151, 153

that is to say, at a distance from which neither subject nor composition is discernible.

> In the first place, it should be noted, and this is very important, that, seen from a distance too great to analyze or even understand the subject, a Delacroix painting already produces a rich impression, whether happy or melancholy, in the soul. One would say that this painting, like a sorcerer or hypnotist, projects its thought from a distance. This singular phenomenon is due to the power of the colorist, the perfect consonance of the tones and the harmony (preestablished in the painter's brain) between color and subject. This color seems—may I be pardoned these subterfuges of language to express very subtle ideas—to think by itself, independently of the objects that it clothes.

(Might Baudelaire not have said as much about Titian or Rembrandt? No doubt. If this phenomenon is "singular," that does not mean that it is occurring for the first time, but that it takes on a meaning that is new and indeed singular . . .)

In the *Salon of 1859*, Baudelaire focuses, as he would again in 1864 and still apropos of Delacroix, on this new distance needed for the general unity, the atmosphere of the painting to manifest itself, but also for the separate dabs of color to blend optically:

> The bigger a painting, the broader the brushstroke should be, that goes without saying; but it is good that the strokes not be materially blended; they blend naturally at the desired distance thanks to the associative law that binds them. Color thus acquires more energy and freshness.

In 1846, in pages more prophetic than descriptive (*On Color*), Delacroix was writing: "The tones, as many as there are, but logically juxtaposed, blend naturally in accordance with the law that governs them."

We know of Delacroix's influence on Baudelaire's aesthetic. A cardinal page from the *Journal* (November 1857) contrasts the brilliancy of the "frank and virtual colors" employed by Titian and Rubens with the "earthy," "attenuated" colors of David and his school: pigmentary blends that aim to discover "a simplicity that is not found in nature." Delacroix does not precisely speak of the distance necessary for this action of virtuality, but he notes that it maintains its

Édouard Manet,
Street Singer, 1865

155

force even when the painting is placed in shadow and that it eclipses the muddy paintings that live only in full light.

All this suggests that we should place ourselves farther away than usual in the presence of a modern painting, because we can without risk lose sight of its subject, and even its composition. What is essential is the colored whole that springs to life at a distance, that depends on distance to realize the optical fusion of the juxtaposed brushstrokes.

This optical fusion not only adds to the brilliance of the colors, it brings out a warmth, an energy that suggests the sensation of a space resonating and breathing around us. "In searching for truth and accuracy, let us never forget to give it the envelope that has caught our attention," wrote Corot in his notebooks, in 1856. Baudelaire stresses this idea of "air-space." We see colors, he says, only through "the thick and transparent varnish of the atmosphere." If we paint the colors themselves, we achieve only false tones; they must be painted as they appear in the air-space. But "there is much less air-space between the viewer and the painting than between the viewer and nature." Since, between the eye and the painting, there will never be as much air-space as between the eye and the object perceived, the energy of the color must compensate for a proximity that risks dehydrating it, pressing it like a plant in an herbarium. The error of a painting made with "attenuated" colors, which we may look at up close without its appearance being transformed and which does not come alive at a distance, lies in the belief that it captures a space functioning the same way as real space, that we can enter into it and experience its environment. But if we do enter, it is into a space that is discolored, weakened, illusory; whereas, the painting that obliges us to move back acts like an infusion of air, giving us the equivalent of real depth. In this short distance, in this narrow air-space lying between the painting and the eye, flows all the energy of space.

Therefore, the new painting must be seen from farther away than painting with traditional perspective. At the same time, it must also be seen closer. "At first glance," says Zola . . . But he thinks that, finally, to read the painting and "reconstruct reality," it must also be seen from the distance where the image forms, the distance at which the hatching, the rough lines, the liberties taken

with the objective outlines will return to their proper order: therefore, at second glance. Some years later (November 1885), after reading Edmond de Goncourt's book on the eighteenth century, Van Gogh addressed to Theo these lines about much earlier painters, lines that he would doubtless have been unable to write if painting had not followed this path from Manet to himself:

"I liked immensely what he says about Chardin. I am more and more convinced that true painters did not finish their paintings, in the sense that has often been given to the *finished*, that is to say, so elaborate that you can stick your nose right into it.

"Seen from very close, the best paintings, and precisely those that are most complete from the technical point of view, are made with all the colors side by side; they only achieve their full effect from a distance. This is what Rembrandt defended doggedly, in spite of all that he had to go through (didn't the good burghers find Van der Helst much better, because he could be viewed from up close?)

"[. . .] I would like to tell you much more, especially concerning what Chardin makes me think about, particularly regarding colors, and not using local color. I find these words magnificent: 'How to capture, how to tell how this toothless, yet infinitely delicate mouth is done. It is done only with some streaks of "yellow" and some broad strokes of "blue."'

"When I read that, I thought of Vermeer's view of Delft, at The Hague. Seen from up close, it seems incredible, painted with colors completely different from what one would imagine from a few steps away."

Thus, handling of color, like lack of finish, is an effect of distance; the finish of the mediocre is such that looking at the painting from up close, one may recognize, unaltered, everything that could be seen from a distance. However, if one approaches the "virtual" painting, what one discovers is not equipment that only has value through its operation—the back side of a stage set. We see something else, and what we discover may be admired *in its own right*. Now, for Van Gogh, this near-sighted gaze is just as valuable as the far-sighted gaze. When he tells us that these paintings create their full effect only from a distance, he is speaking for the benefit of those who prefer Van der Helst to Rembrandt! And when Zola justifies this proximate viewing as preparation for the ultimate vision

that will "reconstruct reality" (and therefore, the image), he is either readopting the traditional point of view or speaking in that way only to reassure. Therefore, modern painting, which ought to be seen from farther away, may now be viewed from closer than classical painting. That is because it is not an image.

But what can it be, if it is not an image?

"Streaks of yellow," Van Gogh has just said, quoting Goncourt—"broad strokes of blue": *traces.*

Traces, Signs, and the Instant

But isn't Van Gogh speaking as a specialist? If he approaches the painting, is it not only *in order to learn how it is done?* Can the brushwork have any further interest, can it become, in its own right, *image?* At first this proposal seems hard to accept. Its adversaries accuse it of sacrificing the object, of which the painting should create the illusion, to the ostentation of a vain virtuosity. (Ingres: "It betrays the hand.") But if Delacroix notes the fact that the stroke is no more in nature than the cut of the engraving or the outline of the drawing, he defends it much less as a term of an autonomous language than as a means of expression: By its brilliancy, its virtuality, it is capable of creating the sensation of nature. For Baudelaire, the harmony of juxtaposed dabs of colors is like the harmony of nature seen through the magnifying glass of the colorist's eye. He affirms that the work that is *done* need not be *finished.* What is *done* manifests the *doing,* but this manifestation is not its meaning. The unfinished is justified on "realist" grounds; it guarantees the global unity of a vision that the polish of a Horace Vernet or a Delaroche is incapable of attaining. But Baudelaire thinks all the same that the sketch is justified only as preparation for the painting, that notes taken from nature—he is speaking of Boudin—are not works of art. Likewise, Corot finishes in the studio the canvases that he began outdoors, and he sees only "materials" in the Italian studies that we admire so much (twenty years later, he exhibits only one). Constable goes in search of these "breezes, dews, bloom and freshness that no painter in the world has ever properly rendered" (what he also

John Constable,
Seascape with Rainclouds, ca. 1827
detail

refers to by the word *warmth*), but he is not satisfied with his oil sketches, which today seem to capture all that better than his large-scale compositions. The sketch, which, to twentieth-century sensibilities, is often preferable to the painting *as a work of art*, is not yet the ideal of art; it is only the guarantee of its authenticity, its birth certificate. At least, before Manet. For *Déjeuner sur l'Herbe* is perhaps the first large-scale composition in which the sketch style seems deliberately chosen as the definitive style.

Dabbings, hatchings, pronounced or elusive outlines, over- or underdrawn in comparison to the objective contour, heavy impasto—is everything that "betrays" the hand, when one peers at the technique from up close, only there to make one see what one sees from a distance? Colors that blend optically are said to possess a superior brilliance. However, how satisfying is it to explain the new painting—its environment and its aesthetic, philosophical extensions—by means of a brightly colored realism? It is much too easy to contrast the earthy colors of David with the virtual colors of Titian, or Van der Helst with Rembrandt. Pigmentary blends, local colors, and *flat* tints may possess a brilliance equal to that of virtual colors. Zurbarán's colors are no less vivid than Titian's; nor Piero della Francesca's, than Delacroix's; and nothing is more vivid than the icon and the illumination. Does not the new painting, whose revolution is hardly limited to color, seek something other than this purely retinal joy? On the other hand, is what we see from a distance really the brilliancy of fused colors? For that, the colors would have to rotate, like a color wheel. In reality, what we see is less the brilliancy of a fusion, a sort of optical liquid, than a colored space in which traces of the hand are recognizable—a language as tactile as it is visible.

As early as 1850, Fromentin rationalized his "impasto" with the necessity of "rendering the impression": "I am perfectly aware that there is in my *Camp* an excess of paint [. . .] I confess that, not working for posterity at this time, I pay little attention to the material concerns of painting, provided that my impression is rendered." What the hand pursues is not its own manifestation. But the reality that the hand wishes to make visible is one that must be expressed along with the traces of the hand. Hesitating, trembling yet not blurred like something that will become diluted and fade; virtual, that is the word, as if it had not yet settled,

as if it were still forming. The world before things, its lustral freshness, its inchoative energy: the world forming, not formed. The world in its seminal unity, in the unity of its texture: its "envelope," says Corot, its "connectedness," says Delacroix.

The colorist's "magnifying glass" captured what was invisible to a distracted, distant gaze. And this painting may be defined as the exposure of a hitherto imperceptible sensory world down to its very roots. The world of roots will be given many names: the virgin, the naïve, the profound, the One. According to the painters, moreover, it has more than one aspect. What Corot or Gauguin discovers is not what Manet or Degas grasps. But the name of all names, the root of all roots, appears to be the very act that posits all the differently designated appearances. The world is felt, sighted in the act of inventing itself. It naturally accords with painting that is inventing itself. Proximate viewing is not a taste for meticulous detail and microscopic analysis, not a "critique of perception." It is the will to tap the source. The traces do not remain as the sign of a human operation upon a submissive nature; they are the meeting point between human and natural creation, between the hand and the eye.

When Van Gogh moves closer to see how it is made, he is not a technician learning about the methods of trompe-l'oeil in order to employ them himself. Admiring the way an image is obtained by means that resemble it not at all, admiring the way a broad stroke of blue becomes a mouth, he is not marveling at a human trick, but at a secret affinity. For nature itself does not resemble its effects: A mouth does not look like a mouth. It is in painting's power to act like nature, bringing forth images that are not contained in their elements. The aesthetic of the unfinished bears witness to a preestablished harmony of art and the real as acts. And the work of art exists neither as an image reconstituted from a distance nor as an element seen from up close. It exists in its trajectory, in the back and forth of the gaze. It is not representation, but transmission of an image. That is why we never enter it. We move back, away from the heat it releases. We approach to expose ourselves to its source.

To speak and think in Kantian terms, one could say: *How is it possible that the hand's "making" applies* a priori *to the world perceived by the eye?* And the reply must be: *Because the world is a "making."*

The exposure of the visible is not a reduction of the world to what may be captured on film (implying: that is all there is) with the purpose of disabusing and demystifying occasionally seen in the naturalist novel and flaunted by the contemporary novel of observation. The world is not only what can be observed. It is a manifestation, the mode through which a hidden power projects itself. At the same time as the appearances are revealed, so are their unity, continuity, and common energy. It is their source that reveals itself, a source of light. Colorless space becomes color and "illuminating medium," and the medium becomes place and connection; energy of the matter from which, before our eyes, the transformations and the work are made. The eye sees beyond sight, and, no doubt, it no longer listens, but touches, traces, breathes.

The goal is beyond the world as representation; it is the world as existence. And this is the real difference with the past. For while the critique of traditional perspective and, especially, all the opposition to academic painting make the new painting appear anti-illusionist, it would be absurd to characterize great classical painting as illusionism. Degas is right, whichever way he is taken, to say that the air that circulates in the paintings of the old masters is not "breathable air." The varnish that covers them puts them in the realm of the imaginary. It is a frost under which the objects, even untouched, and as true to perspectival illusion as they may be, are more inaccessible than autumn leaves at the bottom of a lake. Only in academic, "bourgeois" painting does the radiance of the imaginary cease to be perceived, remaining only trompe-l'oeil, the success of which justifies the price of the painting.

However, classical painting and modern painting are both *painting*. And both aim at a reality that is not given and that they do not present as reality, but rather as *truth*. Both are the acts of a desire or a thought. But classical painting aims at a world of representations, of models that haunt the real, from which they must be extracted, and in relation to which the real is only an approximate or pale imitation. Modern painting is a matter of capturing a causality, an action, an effort. In the former, the painted image presents the perfection of an imperfect, poorly reproduced world. In the latter, the painted image presents the incomplete, or rather the beginnings of a world that it would be a mistake to believe

Édouard Manet,
Madame Édouard Manet in the Conservatory, 1879

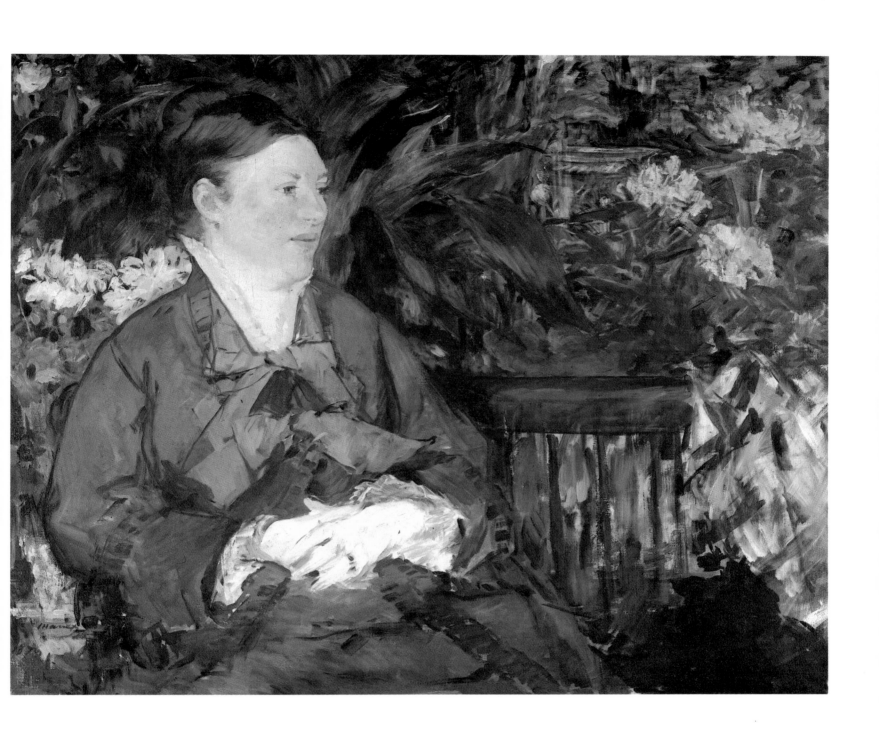

complete. Whence our very different involvement in the painting. In one case, our involvement is contemplative: Stopped on the threshold of a space into which we cannot really penetrate, we submissively receive triumphant representations. In the other, we cooperate in the work: The same time, the same instant, merges the incomplete being that looks and the incomplete being that is being made. And when Baudelaire writes: "What is pure art according to the modern conception? It is a suggestive magic, containing at the same time both object and subject, the world external to the artist and the artist himself," he is no doubt placing in the domain of the artist soul, imagination, emotional resonance, man opposed to nature. But we have the right, as well, to understand an osmosis, a tight, intense junction—the innovation in painting that asserts itself about 1863.

No doubt, the works of about the date 1863 that merit our attention do not give proof of their vintage in the same manner. Sometimes, the power of synthesis, the detail and the equilibrium in the representation of space demonstrate that it goes well beyond a single act of vision. It is the density in the transparency of certain of Corot's landscapes, their light but immutable perfection. And when I look at Théodore Rousseau's wonderful drawing on canvas, *The Source of the Lizon*, which happens to be dated precisely 1863, I can detect none of the signs of modernity that I find in Jongkind's watercolors of the same period. By its attention to detail and its patience—as if, far from capturing an aspect, a profile, the artist had waited for each thing to assume its place—by this tight network of lines that criss-crosses the whole space, by the precision with which all is said and not suggested (this form is not a sign, but really the drawing of a cloud, and that one is not only a tree, it really is a poplar . . .), it is closer to an etching by Seghers than a watercolor by Jongkind.

The reason is that drawing shows little regard for periods; it is the refuge of a certain intemporality. There are drawings by Claude Lorrain that seem unconnected to the European tradition but instead seem part of Far-Eastern art. And Poussin's drawings do not belong to the seventeenth century in the same way his paintings do. The latter show how he thinks, and the former, how he sees. Less subservient to historical styles, drawing owes its diversity and its nature to infrastructures that are personal modes of vision. But if the style of modern

Théodore Rousseau,
The Source of the Lizon, ca. 1863

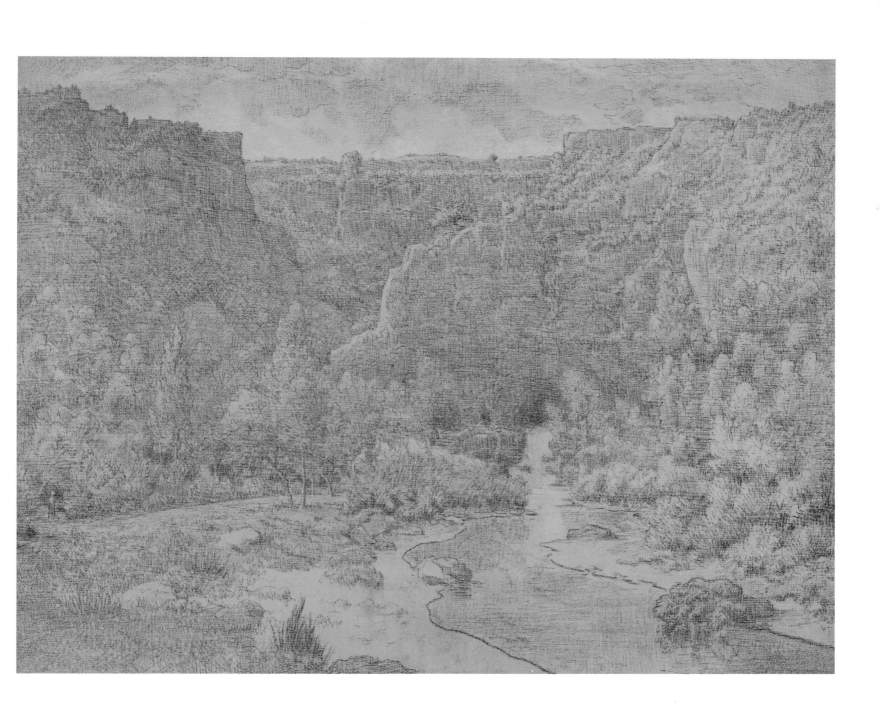

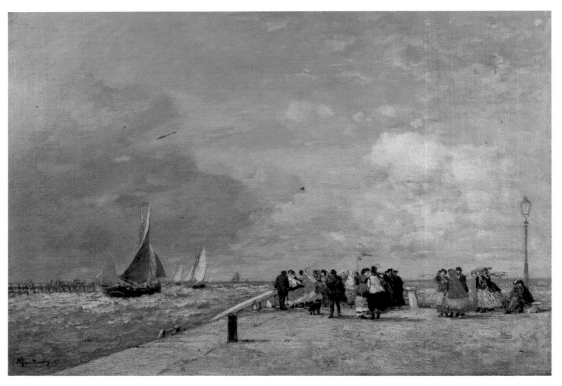

painting is that of personal modes of vision, then classical drawing may appear to anticipate modernity—modernity, after all, is the extension of the natural freedom of drawing to color and to the whole canvas. This allows us to find modernity in this Rousseau drawing, which transmits the sincerity of a vision and, if it does not appeal to the potentialities of the incomplete, is not *finished* the way a painting by Meissonier (or a Pre-Raphaelite) would have been. The foliage is seen as a mass, not leaf by leaf as in a plate from an herbarium. Also, if this fine mesh thrown over the sky and rocks, over the trees and their reflections, holds them all securely, it tends also to overflow the frame. It is the fabric of the world itself, from which the landscape is not so much detached (because of its completion, its particular success) as it is tied to it by this common texture—a mesh whose grid pattern and oblique scratches capture things but are also the lines of a hand bearing witness to itself and to things, of their common ground.

The connoisseur of paintings, like a graphologist, identifies the hand by the nature of the brushwork, light or heavy; by its direction and spacing—whether it is oblique and dense like rain or bundles of tall grass, or swirling, or again calmly horizontal—and by the heaviness of the impasto. He knows that he is before a Daumier or a Monticelli or a Cézanne. But these characteristics of the hand are characters, letters of an alphabet that had to be invented so that the text of the world might become immediately legible. They are signs that signify themselves but also signify other things besides (and sometimes so directly that they cease being signs) as in those drawings by Hugo wherein the spontaneity of a substance challenged to reveal itself according to the chance placement of a line, an ink spot, an amalgam, reduces the person we no longer dare call an artist to the state of a medium. In Manet, and particularly Jongkind, we see abbreviations, kinds of ideograms that are not in nature. For example, the rotated curves of the *Street Singer*'s eyebrows and, in Jongkind's watercolors, the wandering lines, the spots, the calligraphy, which, assuming that they can be separated from the whole, no one could read as cloud, sail, or reflection of a small boat. However, they put us in the presence of the cloud, the sail, the reflection with all the more force as they burst forth, in the reading that we make of their writing, as the signs of the reading that this writing has itself been, as a reading of the world.

Johan-Barthold Jongkind,
Merchant Ships and Fishing Boats, 1865
Eugène Boudin, *Trouville Pier*, 1869
Édouard Manet,
Le Déjeuner sur l'Herbe, 1863,
detail following pages

And the ellipsis of the sign, a deforming invention contrasting with the completed line of the object, translates not a will to invent, to distort or even to simplify, but the swiftness of a gesture—the swiftness necessary to capture what is the very ground of this painting, its new continent: the ephemeral—not the stable and complete image around which we have the time to move, but a sight contained entirely in a single act of vision. As a result, what the sign captures is not an object of another nature, the object independent of the action that is being exerted upon it. Rather the sign captures an action and makes us see a vision; it is the gesture of a gesture.

It is through the energy common to both sign and signified that this alphabet, so new, so inventive, so nimble, is defined. For, of course, this painting is that of the fleeting. It is attention paid to what will never return, to what is passing: It is the painting of time. Are we to say that it is against a background of death that the new painting seizes hold of existence, that it is hurrying so only to capture things that are doomed, that its pursuit is proof of their precariousness? In the painters of modern life, the dresses and hats of a season sometimes take on the melancholy of photographs already faded, the subtle odor of death rising from a newspaper hot off the presses; this face from *The Balcony*, with its porcelain fragility, shadowy eye sockets and spiderweb of craquelure, is that of a woman dead at an early age. Yet, this background of death exists above all for us, the more time passes. The photograph, the political caricature, the fashion plate, the newspaper editorial—all believe naïvely in the immediate; it is the romantic historian who bemoans the "irretrievable" in them. In itself, this painting rejects just this nostalgia. It responds only to the immediate, the immediate of an anger that tears the veil (in Daumier), but more often the immediate of a perception eager to possess and to enjoy. In the energy of possession, the funereal precariousness of time is dissipated. Clearly, space becomes time: Corot's skies, Boudin's beaches, Monet's cathedrals change from minute to minute like Degas's dancers. Everything they paint bears the mark of existence. And time, conversely, becomes space: the finery of the day, the carriages, the café terraces, the façades along the new boulevards, the comical expressions of a face, the attitudes of a body—all these are forms and colors. (In 1862 the Goncourts remarked aptly of

one of Millet's peasant women: "the colors seem to be only the fading of the two elements between which this body lives, blue above like the sky, brown below like the earth.") Death also disappears. Faces do not tremble at the thought of their precarious mortality; they quiver at the flash, the vividness of their appearance. Neither nostalgia nor premonition, it is the lucidity, the rush of an epiphany. And what appears is not so much what will be extinguished as what sparkles with an innocent, animal presence, unaware that it is already promised to fate.

Certainly, it is not the serenity that we will find later in Cézanne's landscapes, in which the existential connotations seem, if not excluded, at least softened, distant. Here, the image is pulled into the wave of a violent feeling of life. A somewhat feverish feeling, but it is the febrility of wonder. To cling in this way to appearance, to reject the object that is the end and sum of successive acts of seeing, is to value the moment more highly than anything else, and that because it has just been discovered. The *quality of presence* of which Baudelaire spoke, the quality possessed by every thing, whatever it may be, simply because it is present, is above all the fire of its intensity.

1863 Today

This *happy* moment, as Paul Mantz, a critic of the day, called it ("1863 will be remembered as a happy date: *Libertas artibus restituta*"), is indeed a crucial one, but to do it full justice, to grasp all its newness and the force of the breach, it must be seen as its contemporaries could not have seen it: in the light of the history that it set in motion. It was the brilliant starting point of something that, developing over many years, would form a "system" and, thus, determine the history of art. Along the way, we have considered the question whether 1863 introduced anything truly new. Indeed, is not the chain of events easy to reconstruct? Fantin-Latour paints *Studio in the Batignolles Quarter* after the *Homage to Delacroix*. Is not everything descended from Delacroix, who is in turn descended from the Spaniards, the Venetians, the Flemish? Delacroix, however, did not like Manet, and he had his reasons. Earlier examples of everything we have highlighted may always be found. What is new is not this or that sign; it is the

sum of these converging signs, the constitution of a system of affirmation and exclusion—an unconscious system, of course. Let us not set the idea of a lawless spontaneity against that of a calculated plan. The logic at work here becomes evident only at the conclusion of this operation. And precisely because this "system" is action, not thought, it does not merely fill its position but reorients it. The "modernity" that I have tried to define is mingled with relics and tangents.

But if the rupture caused by the explosion of 1863 is proven by its consequences, do these consequences still matter to us? Have I the right to title this book: *The Birth of Modern Painting*? Cézanne took Manet as his starting point: it was with good reason that in 1873 he dedicated *A Modern Olympia* to Manet. But is Cézanne still our starting point?

If we see Manet's modernity, as Malraux does, in the substitution of a personal style for the truth of the model, it is easy to see as continuous the art running from Manet to the heroes of abstract painting (who are essentially their signature styles), even if we recognize that the character initially defining this art becomes increasingly pronounced. But if it is true that the painting of Manet and the Impressionists is not at all indifferent to the real, if, on the contrary, it has a feeling for and the will to move toward the real, to make the painting function as closely as possible to the thing, then speaking of greater emphasis is not sufficient. We should speak of a rupture, a derailment. In 1863, abstraction was hardly just over the horizon!

But is abstract art abstract? There is no end to the discussion. Herbert Read defines modern art by referring to Klee's famous pronouncement—"Not to reproduce the visible, but to make visible"—which integrates abstraction into the phenomenon as a whole. Only, is it a matter of making visible what was not yet visible, but lay waiting at the bottom of the visible for our penetrating gaze, or something of another order—an invisible transformed into the visible through the mediation of painting? That remains ambiguous. Arp, along with many others, says that abstract art should be called "concrete." But he seems to intend by concrete something very different from a reference to the real, which does not help solve our problem, namely, the relationship of modern art to the real. Yet referentiality seems present in the work of a Kandinsky or Mondrian, since the

former recalls the blackness of a Florentine night, and the latter the branches of a tree, ocean waves and eventually the windows along Broadway. One seeks a nature that is freer, more abundant; the other, a nature that is simpler, more ordered. Both, starting from nature, pay homage to it in their paintings. The notion of an art without reference is hard to conceive of. Does not repetitive, accumulative painting, especially in the United States, represent modern architectural reality and the urban environment? And, as for the posterity of Duchamp's readymades, there is today a whole art that functions as trompe-l'oeil, merges with the products of technology, adopts, like an insect endowed with the power of mimicry, the appearances of the object while rejecting the appearances of art, whether it wishes to render the project of art impossible or to explode the vanity of the object. Both, perhaps. In any case, it is a long way from that inevitable reference outside of which the essence of the work is constructed, farther still from this aggressive, or at the very least critical, mimicry to the concern for the sensory that Manet, Cézanne and the Cubists have in common.

For classicism, painting is painting of the world, with the result that between the painted image and its model there is always that distance about which an obviously artificial space informs us. Later, for Manet, the Impressionists, Cézanne, and the Cubists, world and painting strive to become one, with the result that between the painting and its opposite term, it is no longer a matter of the dissonance or harmony between representation and object, but of a kind of fusion, an instantaneous conflagration that never runs out of material, always and everywhere finding new fuel, new challenges. Lastly, beginning with Kandinsky's first abstract watercolor, art has become the world without any relation of duality or reciprocity. The painting begins with the painting, the product deriving from the product—and conversely, the world (man-made or natural) becomes art without concession, without modification, without duality. If it is possible to speak in this way, it is difficult indeed to pretend that 1863 and 1974 share the same orientation! And yet, if, at a particular moment, the world had not been captured as close as possible to its *making*, the art of *making* would not have come about. The events of 1863 blazed the trail for its most recent avatars. It is understandable that an art moving nearer and nearer to the thing and

capturing it, as we have not previously perceived it, may appear *produced*, not *reproduced*, and may encourage us to produce while excluding what is originally attached to reproduction. It is understandable that it may appear as the invention of a script, whether personal or collective, the language of a language. In the final evolution of our art (and I am thinking as much of literature as of painting), it may be that this interpretation, this critical reading (impoverishing in the sense that it empties the work of its intention and separates it from its origin in order to situate it in the cultural space, among the forms of the museum and, later, among those other products that are the forms of industrial civilization) has played its part. But the creative impulse was different; its intention was objective. And if there was a derailment, an unforeseen accident, it was because the unmediated contact of the eye and the visible created a sort of bedazzlement in which the object as pretext disappeared, in which perception consumed the perceived, in which only the fire remains, its thirst for the sensory never slaked. Thus, realist objectivity contains the conditions of its own downfall. It does not discover real objects, but what were called transpositions or symbols and would come more accurately to be called traces, signs, the brilliancy of painting.

I have just written the word civilization, and indeed, 1863 gave its first significant artistic expression to the civilization that is still ours today. Therein lies the undeniable continuity. What the Salon des Refusés inaugurated has not ended. It established a social position for art that we know to be defined by a wholly new separation, an unprecedented schism. There had been in each period a style with a hierarchy of masters and disciples, the more and less gifted. After 1863, there existed two styles. One could go so far as to say that one style had no more meaning, since it referred to the context of a dead civilization, while the other gave to the new civilization its artistic meaning. The artists are distinguished less by their innate gifts (a "reactionary" painter may be more talented than another) than by the sanction they receive from their chosen course. Those who do not live the historical moment fail to give full existence to their works; they remain weak, bloodless, or when the talent, perhaps the genius, is there, eerie, wistful, alienated. Should we say that the schism that opened in about 1863 no longer exists? Certainly not. The Refusés and their successors have won the

war without achieving total surrender. A small minority has gained the upper hand or even a monopoly in museums and collections, ensuring high prices in the market. But it has not overcome a resistance that we should investigate.

Academic habit is not a sufficient explanation. With some surprise I noted that on the walls of the Metropolitan Museum, Rosa Bonheur and Carolus-Duran hung beside Manet and Degas, and in the Louvre, Gérome was next to Ingres. A desire to enlarge the market? An accord reached between narrative painting and scholarly commentary? The poorly understood influence of today's photorealists? Perhaps, to reach a deeper understanding, we should compare the recent and limited reactions in the West to the immutable position of the Soviet Union. There, painting remains traditional, only the subjects have changed. And the problem is not simply Soviet bureaucracy; the tendency of every "people's" government is the same. We must also ask why we, who like and understand the new art, remain so attached to the art of ages past, why we give museums such authority. Of course, the great tradition for which we may be nostalgic, whether it is imposed by a political regime or encouraged by some retrograde institution or other, is incapable of mustering unanimous support since it is quite simply incapable of life. In the cautiously opened vaults of museums in Leningrad and Moscow, I recall having seen canvases that in Paris I would have thought extinguished glow with all their original fire! How quickly the unauthentic gives us the taste for the accursed painters, for the daring of which we have grown weary! With what fervor we wish for a new Salon des Refusés! No matter. Without us and within us, the schism remains and will remain; what we will never see again is a crowd gathered in front of the *Altarpiece of the Mystic Lamb*.

The new art is alive because it speaks to us of a living civilization, but we do not really accept this civilization. That is why the art of the past speaks with such force; that is why the art that continues it, however feebly, still benefits from our complicity. We remain in the schism because man is not united; his consciousness and his desire are not in agreement. The year 1863 remains current so long as the civilization that it expresses (magnifies and denounces) is our own—the first civilization lacking a common spiritual ground. The painting of old belonged to those very people who did not know how to see it, because it had a meaning tied

to a shared faith. Since Manet, painting belongs only to those who are capable of grasping its intrinsic meaning, which is not painting in and of itself, but *a world seen as painting*.

To see the world in this way could never be "the commonest thing in the world." And the ingenious, marvelous, or laughable gadgets that have followed "the immediate freshness of the encounter"—the trompe-l'oeils, the ready-mades, which take on the appearance of things only to demonstrate that art no longer has a place among them—cannot become common property any more easily. To manufacture ironic or accusatory products and objects, to contest the work of art, is an even more specialized vocation than attempting to make a work based exclusively on perception come alive. Revolutionary art is an art exclusively for artists. After having belonged to civilizations that were bound together by and centered upon a shared vision of man and his relation to being, art, however grand its reputation, however high its market price, has been exiled to the periphery of a society in which it can be only a tolerated luxury or an inoffensive aggression, the portion of leisure or revolt allowed by the inadequacies of a civilization. And this fringe, dissatisfied with its status, does not even confront a center that is sure of itself! Art is peripheral only with respect to an aggregate lacking unity and value. Art is peripheral only because there is no center! There is no longer an art that speaks with one voice, because there is no longer any common value. If we feel more and more troubled and frustrated by what we possess, and isolated by what we share, the separate value of art can only assume the most extreme forms, exhausting itself without cease.

In 1863, this difficult art, which is perhaps doomed, was inaugurated. Let us remember Baudelaire's remark to Manet: "You are only the first in the decrepitude of your art." And we see that art marked from the start by a sort of absence. The great art it replaced, whose forms of imposture it so vigorously denounced, possessed something else, something more And this lack, as awareness of it grows, will wreak havoc upon the new art. But in 1863, we were far from this consciousness, far from its insights and depredations! The new art was experienced as instinctive liberation, energetic invention, wonder of youth. And, whatever the avatars of its maturity, it is this youth that still fills us with wonder.

Alain Bonfand

In 1863, the Salon des Refusés marked the disappearance of a way of painting and the appearance of another world. Yet we know these developments were neither obvious nor clear-cut. If it is legitimate to consider this moment of history in light of what its present consequences have taught us about its beginnings, we must first carefully rediscover the inaugural event as it was in itself. In 1863, that event bore Manet's stamp; but neither the gathering whims of history, which seemed to reach a head in that year, nor the scandal surrounding *Bathing* furnishes us with an explanation (one searches the painting in vain for the signs of a break with the past). But even if the break is no longer visible to us, even if it was invisible to Manet's contemporaries, such as Baudelaire or Zola, nevertheless, something that was to give a completely different sense to the tradition of painting and our perception of the world was afoot. This sense is the initial concern of Gaétan Picon's text. *1863* (the date conceals its true importance) is the locus of another historical question, which, however, slips away, as if unaware, from what obstructs its appearance. If "each sign is the now of a then, the near of a far," nevertheless, something other than the image's deictic power comes into play. "The woman in *Déjeuner sur l'Herbe* looks not at

her companions but at the flash that catches her." Thus, when we see the work, something happens that reveals her and makes us suddenly appear before her.

In the works of David, as in the last works of Ingres and Delacroix, the figures of the imaginary still appear. Each painting seems the result of a past, to have come from a space of which it is the most refined essence, like an *acme* that still communicates with the time that produced the paroxysm of its forms. With Manet, on the contrary, it is the immanence of the painting that appears to us. The image is here, in front of us; the figures are nothing more than their presence on the surface of the canvas. This immanence signals an end to the archeology of the imaginary, to the universality that each remarkable work would still reach for; what is beginning is the painting of a perception, painting that cleaves not to an elsewhere, but to a perception of the *here and now*. This rupture is not a simple transition from one fashion to another, but truly a "change of life." What was still viable for Ingres has become obsolete. A modernity is dawning, and though it is not reducible to painting, painting is its main vector. Perhaps, moreover, it is the depth of this rupture—this is what Gaétan Picon makes us realize—that created its invisibility

and authorized the Salon painters to continue exhibiting subjects that seemed to have washed up on the shores of an imaginary realm they no longer inhabited. In Delacroix there was, however, some sign of the abandonment of the image, a visibility of the brushwork that was becoming as important as the object itself. But this evolution went unnoticed, except by members of Manet's generation. The "invisible presences" that were host to classical painting vanished, leaving in Baudelaire a nostalgia, a vain wish to revive the past. What had been the present for classical painting was no longer, and there was no use returning to it, for in 1863 a new history was being created whose rapid progress abolished the univocity of the old references and signs. Painting was to be "a present simply present," Gaétan Picon says, "without a hidden text." And it is, I believe, the disappearance of this hidden text that makes the presence of a hidden world so imperative.

"The image was no longer the illustration of a text. It no longer had a text. The sole text was that of its visuality." The existent is placed in existence by the very act of the power that knows it, but if this power is knowledge, the existent must reveal itself to that power. This desire for a revelation is historical. At the very least, Gaétan Picon attempts to read it in works that sometimes turn into proper names, a form of shorthand, so that things may be said and grasped more quickly, before they flee, withdraw, slip away just like the painting we are discussing. Moreover, one of the apparent paradoxes of his work, which seeks the singular, is this use of the proper name, a use infinitely more justified than Malraux's, for it is a matter of necessity, not rhetoric. This will to relate individual works to an enterprise or a program (and Gaétan Picon is the least programmatic, least dogmatic writer imaginable), this desire that the work find its echo in a

proper name, is a temptation to fix the confines of the work. Gaétan Picon's ambition is caught between two poles (which is why 1863 stands out as a milestone); and these opposite terms recurring throughout his work must be identified. It is painting, art, that permits us to express as allusively as possible a desire that reappears throughout history (and to date those appearances). Gaétan Picon expresses elsewhere this desire that language be without terms: "The enemy at bottom is the word, the word so aptly named the term, that which defines as it concludes."[1] In 1863, a distance only secondarily metaphorical is imposed, which calls into question, besides our relationship to mimesis, the very notion of painting, or at least its foundation. From 1863 on, the presence and the legend, the figure, and the imaginary no longer communicate. History has become progressive, no longer exemplary. Production and consumption prevail, and two types of painting united under this apparent paradox will respond to the transformation: on the one hand, an art of legitimacy and grandeur, now lost, that gives the bourgeoisie, in accordance with the canons of "fine art," the quintessential image that it wishes to have of itself and that it complacently buys; and on the other hand, the new painting, which in breaking with this ossified art seems to denounce those who finance it, but nevertheless maintains closer relations with the transformed society than does the preceding artistic froth.

While the new painting may criticize social conditions, it does so with faith in the same credo as the society it denounces: the reduction of the world to what is there, to what is happening, to what is perceived and received. But this being so, painting, while it results in a product, also isolates that product by giving it a character that is not quantitative, not economic. "By its pure presence," it will

be what is lacking in the world of work, namely, "the plenitude of being." The bourgeoisie still wishes to conceal this primacy of the real; witness how its architecture tries to cover up the creations of the new industrial age with the cosmetics of Antiquity. As for painting, it throws itself head-long into the real, bringing sculpture along with it: The pure sensory now offers itself without archeo-logical excavation or artificial beautification. Reso-lutely modern, in keeping with the most profound revolution of their time, the new painters will exploit without reverie or nostalgia the gratuitous-ness and simplicity of things that the English landscapists had glimpsed. Such is the process de-scribed by Gaétan Picon, which affirms the work as *conscious experience*. Painting's subject does not disappear for all that in the new emergence of *execution*. Rather, it becomes merely the appear-ance that painting gives it; the image no longer refers to the past or a text or an idea. Signs multi-ply, but they seem to speak only of themselves. Despite some lingering glances toward the dis-tance, what Manet and Daumier establish, and what Corot had established in his Italian land-scapes, is painting's absolute self-presence: Mean-ing no longer transcends the visible. The *here and now* used to be mere anecdote, as in Constantin Guys; but in these painters it manifests the emer-gence of the visible, which meets its equal in the canvas. Time and space come out of nowhere. What Manet shows us is their interchangeability. The visible, painting's sole subject, finds its place along the continuum between world and painting, as measured by the instantaneous truth of what is perceived. Thus, the immediate is unveiled; having abandoned the artifice of natural rendering and the finish of studio work, painting discovers its proper expression by finding itself in the world and com-municating the instant, speed, the expansion

of immanence. What is implicitly suggested by Gaétan Picon, or at least by his text, is that such a receptivity is not a category of the existent; rather it is ontological insofar as it constitutes the very essence of Being.

The horizon of Being is not bound to a theme, but riveted nevertheless to the visual field, making its themes out of the existent as such that it en-counters in that field. Manet displays the desire that preoccupies Gaétan Picon, or rather he no longer displays it, but makes it appear in his paint-ing, so as to affirm that this desire is only reality and that this reality has no deeper pictorial dimen-sion than the surface. Gaétan Picon will find "what is lacking" where it is hardest to find because the work, seeking immanence, forms a barrier. Follow-ing Mallarmé, Gaétan Picon reads Manet and this self-presence of painting, interpreting it not wrongly but against the grain, in terms of his own program: that this presence should be absolute. He finds in Manet a true if unexpected ally, although the surprise is tempered once we see that Gaétan Picon retains from Manet's works what is breaking out, opening up, freeing itself, escaping from the angst that too much consciousness allows to de-velop. Following Mallarmé's lead, he interprets the immanence of Manet's works as what he cannot obtain, an absolute, which he wants no part of, *an end* of some sort. Mallarmé wrote, "'the eye, a hand . . .' let me but return" the same way Gaétan Picon says "writing is looking." With a gaze, of course, that could not be satisfied with perception alone, nor even with its immediacy, recaptured where the world was not recognized. The cultural convention of perception obscured the perception of the world. What one used to observe in a paint-ing were not painted images, but the images of things themselves. With Manet, perspective is not abolished; simply, painting "from life and in the

moment" leads to the rediscovery of the world not by the indirect illusion of an external model but by "the internal evidence of the colors" in which the world is "completely on view." Things are no longer arranged in orderly fashion; instead their presence rises to the surface. The master of this is Degas, whose unusual angles call to mind primitive and Far-Eastern art. A painting is not the imprisonment of a space that is henceforth fixed. Rather it still partakes of the force that gave it life: "just as the exaltation of the palette was a reaction against the discoloration of perspective, the juxtaposition of planes overcame the perspectival confusion." Things are no longer lost in an indefinite background. On the contrary, it is the ground that projects them, in a shift initiated by Corot and Courbet more instinctually than consciously. "The image is no longer a distinct unity." A painting filled with the visible does not return to a center or a sense; it is a world unto itself, communicating with the visible that it pursues, but also abstracting from it a sort of absolute and full instant. Thus perhaps, begins the reign of the individual work, which each time vouchsafes the absolute truth of the instant of sensation that it manifests in solitude. In solitude. Am I mistaken to think that what is written here about painting resembles a distant literary project, perhaps on the order of Hoffmansthal's proposal in his *Letter to Lord Chandos*? Gaétan Picon exceeds his work as a historian without, for all that, deconstructing it, perhaps silently taking note of the paradigm of a language—the writer's—in painting. "I write to give myself what I lack: I am therefore enclosed in my circle. But then why publish? And why not use a code language, understood by myself alone?"[2] At the same time as he grasps its historic force, Gaétan Picon sees in Manet's work what extends it and is vaguely homologous to his own program. What he cap-

tures in *1863* is the idea of this painting as victim of its *limits* but also refuter, extender of limits. What occupies him all the more is that this date is the *topos* where cracks appear in what had been cemented in word, in term, or, following Benjamin, in allegory. In opposition to the melancholy contained, held bourgeoisly prisoner, caught by its cause and not by its aim, there will be placed—at least this is how I understand it—a logic of the intemperate, of the fuzzy, of a storm of expression in which Gaétan Picon can read a beginning or think he sees a genesis.

As Jean Starobinski has written: "the critique of Genesis proposed by Gaétan Picon does not break the link between the work and its author's subjectivity."[3] *1863* is fixed on defining how the question of receiving the existent points us to a problem of an ontological order, and then, without resolving the problem of receptivity, the study poses the second problem on what is initially its own plane. This problem becomes all the more pressing, as it is in the essence of ontological receptivity that the foundation and the essence of ontic receptivity itself reside. From this there follows an attitude that I believe unites (ahistorically) the works that captivate Gaétan Picon in this and other texts. It is an attitude that is primarily a mode of vision. Just as painting requires a different way of observing, it demands that it no longer be observed from a fixed distance. As Zola says, it is necessary to engage in a back-and-forth movement that defines the new distance—a back and forth that simultaneously permits the fusion of colors that reconstitutes the object, the depth gained by standing back so that the air allows the visible to breathe, and the contemplation of the traces it leaves as painting. Thus, we perceive it as the world itself, no longer as a world that illusionistically captures the space in which we live but stops us from entering it by

keeping us at the distance that governs the illusion of the real. But how can traces become, in and of themselves, images? For Delacroix and Baudelaire, traces are at most only a means that frees them from the thrall of finish: They maintain the impression of reality that a completed work could create just as well and perhaps better. With Manet, on the contrary, the composition seems deliberately to adopt the style of a sketch, and not in order to offer a sacrifice to the taste for vivid colors, rendered more vivid still by the juxtaposition of colors and the fuzziness of the outlines, but because the traces of the hand are what allow the real to be visible, to be grasped in the act of becoming, to be born in the same instant as the painting. Because the world is experienced "in the act of inventing itself," it accords with the painting that is inventing itself. Would Gaétan Picon have us understand that what Manet asserts is what Velázquez supposed or, in painting *Las Meninas*, more than supposed? In *Las Meninas* Velázquez painted himself in that suspension of judgment, that interruption of the action—the *Augenblick*—in which the work fixes itself. He painted himself painting, unveiling the moment that constitutes the work and that will be repeated in allusive, multiple, and programmatic fashion by art after 1863. The place in which the work constitutes itself as *conscious experience* becomes *intentional object*, part of the work; not merely extending the work, it *is* the work, as its intimate, precise, but subjective condition of possibility. This logic of distance, not to say of retreat from the plane, will be replaced by a movement within the work, whose sense *I* constitute by my circular motion. This displacement—first this distance—determines the end of the space-plane, to put it simply, of the painting. *Conscious experiences* will become more complex, slowing themselves down, encumbered or not with souvenirs, citations, references; and just as a painting is named in order to be sold, the object of this complexity will be named an *installation*, a neologism born of the market and of the ever-possible positioning no longer against the wall but in the empty space of an absence. The choice of distance becomes this spacing, and the spacing ends up becoming an instrument of the work. Supposing in this last retrenchment a kenosis of the images to the advantage of the distance that constitutes what remains as a sign. Is it accurate then to propose that such a demotion of seeing indicates that the always improbable locus in which the instant of the world appears is none other than an empty silence, a silence that Gaétan Picon finds so acceptable once it is fleetingly and implicitly agreed to? The traces are not residual, they are not even the sign of a hand detached from the world, but the meeting of the two in the sensory: "The aesthetic of the unfinished bears witness to a preestablished harmony of art and the real as acts."

The work is thus not a reconstituted image, but the manifestation, the expression, the world of an image. One seeks in the work the existence of the world. "The eye sees beyond sight": the new painting is not anti-illusion; in the osmosis of the sensory, it is not reality that is apprehended as preestablished, but the truth that binds the external world and the artist in the same inchoative movement, in a common *act of creation*. It is a truth that classical art also understood, but like someone halted before the perfection of which the world was an unfaithful reproduction. It is this distance that constitutes the innovation of painting in 1863. The traces without recognizable forms haunting the works of Manet and Jongkind do not reveal a will to distort nature; they translate the ephemeral presence that endlessly renews nature into an instant of truth. This is a painting of the fleeting.

Time turns into space, becoming the landscape of a moment, but it is not so much against a background of death or destiny as under the effect of the innocent intensity of a presence. It is not a painting of the sublime, although in Turner or Hugo a purpose of that kind is discernible. "Undoubtedly the fabulous inferno, in which forms melt and are recast, was sparked by the sun of Turner's gaze refracted through the lens of the visible." Everything blurs and trembles before the gaze. This fabulous inferno is a backlight. The rupture of the noetico-noematic binomial that is achieved assumes the name of imminence, of a beginning or an end—imminence of a rupture that has been so long anticipated and whose fissures can be glimpsed opening and expanding. It is the inexpressible moment in which time vacillates, in which the equilibrium is broken and the work sets us afire, to which we cling as to a life raft. The vague thought enters my mind that these installations (if I must name names: Paolini, Anselmo, Mucha, etc.) present a natural disaster without bad weather—the flat and calm aftermath of a day of high emotion—with neither heroism nor history. As Jean-François Chevrier asked about the contemporary artist Richter: "How can one paint modern life denuded of all heroism? I am not sure whether ultimately this question made the least bit of sense before the twentieth century called painting itself into question."[4] It is no longer a matter of saving a Romantic ideal by sustaining it with the features of modern life. Turner's work, like Hugo's, would fit Gaétan Picon's implicit program. Elsewhere, he writes that Hugo's drawings constitute the formless mark, the text of what escaped, what could not be written: "He has chosen the words, but the words are the instruments of the gaze; they wish to grasp the world with the gaze, to be gaze."[5] The work (after the white square on the white ground)

can no longer make us hear anything but the dead silence of a flat calm (the day after a disaster or the day after history), a free-floating anxiety forever deprived of an object. At least when the objects do not proliferate, when they are fissured, broken, fragmented, they can no longer hold together except as cliché or useless chatter. Danger lurks in such a withdrawal, the danger of the work becoming anobjectal, atopical, and atemporal. The work becomes empty after saying too much because it has said and repeated too much, stringing together reminiscences and digressions. Perhaps 1863 forebodes the bad weather without a tempest, a shipless shipwreck, in which *conscious experiences* let us hear neither crashing thunder nor breaking mast, but only let us understand that painting, or its substitute, keeps us at a distance and has become the common ground of these perils.

The concern with the sensory, which could exist only if the world itself was "seen as painting," seems distant from contemporary abstractions. And yet, if "the world had not been grasped as close as possible to its *making*, the art of *making* would not have come about." In wishing to be and marveling at being this extension of the sensory, rid of the imaginary references that governed the becalmed world, painting in 1863 may have made possible the reversal in which this extension is no longer perceived, and the world, become too present in the work, isolates and encloses itself, creating a language fixated upon its noncommunicative forms and incapable of re-creating the universal now lost to history. In 1863 the truth of the real was that a unanimous reference, a center to lash the world to, was no longer tenable; and art, incapable of re-creating what was missing from the world that produced it, was reduced to seeking in vain, even in critical or negative fashion, what it once possessed in times past. "There is an art that

sets its sights on time and an art that seeks to exclude it," writes Gaétan Picon in *Admirable Tremblement de Temps*.[6] However, it seems to me that occasionally in *1863*, Gaétan Picon seeks out, in this art that sets its sights on time, that part of it which endeavors to exclude time.

In the work of Gaétan Picon, the question in quest of Being seems to counterbalance the question of the political (or in other words the historical); moreover, in the circular progression of his thought, it is the correlative of a question in quest of language and speech, of a means of expression that would be the precarious form of an abode challenged by the evidence of "dying." This question hesitates between a swirling of language ("Écrire c'est") and apophasis. "And if I were asked to identify the desire that speaks to the deepest core of the age, I would venture to say that it is the desire to be without desire."[7] This temptation to be silent, to withdraw when faced with the overwhelming peril that speech unseals, is a temptation of his work. The temptation that in *1863* makes it conclusively the day after is the temptation to affirm the discord between lucidity and desire: "too lucid to believe in the unknown masterpiece, the art of today places the intelligence of its maturity, its scruples and its suspicions at the service of a malignant, fatigued yet unavowed desire for demobilization."[8]

Gaétan Picon's gaze looks the way others write; the work or the word erects buttresses against this fatigue in order to ward it off; it is not against history and the political that the work struggles but against needless repetition and its own weakening. This weakening is what Gaétan Picon finds easiest to identify.[9] But in contrast, he will be unable to find that most banal name—the political—whence the fable from the last, wonderful Fribourg confer-

ence: "I call here political what separates these lovers of whom Nabokov speaks (*Speak Memory*)."[10] For Baudelaire exemplarily the political is never simply the consciousness that two instances are at odds and that this confrontation may be at the origin of a new aesthetic of misfortune, of an unfolding of the present. For Baudelaire the political makes its mark, inscribes itself only between sadness and anger ("I believe I have wandered into what those of the trade call a hors-d'oeuvre. Nevertheless, I will let these pages stand—since I wish to record my days of anger."[11]) . . . Anger; in the manuscript we find this variant: sadness. For Gaétan Picon in *1863*, and especially in the 1972 preface, it is not the modern world itself that testifies to the weightiness of the political but the works of today in this, that their manner of being political is to renounce what made the dimension of a work its ultimate and original sense. Political consciousness is situated between, or in the difference between the statement "I love the memory of these naked ages" and the text above from "Squibs." The texts of Gaétan Picon intensify this difference because they capitalize on a custodial relationship with the life entrusted to the works, a relationship he will violate only in *L'Oeil double* and *Un Champ de solitude*. At last unburdened of the anxiety that they might have been other than they are and of the weight of a hidden world whose promise is each time postponed, the words will decide to *be*. It is a last temptation to launch a work without reference to the moment when the others are halted, to write while taking into account the abstract destination that belongs to the works he has envisaged. The gaze of Gaétan Picon is imprinted (and is this not what justifies the last pages of *1863*?) with a memory that the works of the painters will never be able to give him: the anamnesis of an instant that has never taken place and

of which the works necessarily fall short. The text speaks about the works but also just as much about what they do not give and probably will not give, that which is linked neither to an eschatology nor even to a feeling of origin: the imminence of a revelation that cannot occur and that constitutes the aesthetic fact.

It is this unsatisfied desire that establishes itself as the hermeneutical principle of the works of art, reminding us, meanwhile (*1863* attests to it), that the relationship of the subject to the object is historical, that Being expresses itself historically. It is less a matter of subsuming the diverse moments of an historical process than of establishing the genealogy of a concern that manifests itself elsewhere. The text then, like the work's gaze, vanishes, slips into the margin and then fades away. One seeks to preserve it . . . no, one thinks of preserving it but can only watch as every last word is lost. An expression without word, progressive silence, paradoxical relief that nothing definitive has been said. The text, I will not say the critique, places itself then in this margin, in the border area where artists hesitate to enter for fear of having nothing left to paint. A white place that is other and more dangerous yet than the place where creation knows it is only a way of denying death: "Indeed creation is a way of denying death: but it is still necessary that death allow itself to be denied. When Tolstoy, who was always haunted by death, sees his obsession grow to the point of writing each evening in his journal, at the start of the following day's blank page, the three words 'If I live,' his work is over."[12] *Mutatis mutandis*, Pater suspects this same untenable posture in Leonardo: "Sometimes this curiosity came in conflict with the desire of beauty; it tended to make him go too far below that outside of things in which art really begins and ends."[13] Other than a mortgage of to-morrows, this place from which Gaétan Picon gazes, loves, writes is a precipice, submerged nevertheless in history, a place of vertigo and violence: "And I call literature, or rather poetics, what unites them, what will reunite them."[14]

We are, history tells us, like Orpheus and Eurydice. "Orpheus and Eurydice were not strangers to Poussin's trees as Corot's nymphs were to his."[15] Though Orpheus was forbidden to look back, today he obeys the injunction. What is left of the beloved's photo, of the World War I monument in which the warship replaced the fishing boat, but the polished rock of amnesia? Today, this life, albeit of the past, is absent from art. From the moment of possession or, more seriously, the illusion of possession, we welcome the eroding, the consciousness, the sadness, the blurring of the wrinkles. Gaétan Picon makes us understand how often love identifies itself with this art (especially today's)—bitter, bloodless and in thrall to the concept, or long-winded, noisy, ironic (recall the irony that Rilke warned Kappus against)—this art whose birth we seek, like the first sign of love, its inchoative reality, the initial breach, in sum, a wonder. Indeed, "wonder" is the last word of *1863*.

The entire Fribourg conference oscillates between these terms forever beyond our ken: the political and the poetical. There Gaétan Picon cites André Breton: "Extract gold from time." In the sand, however, the gold dust is finer, impossible to hold; we feel it slip away like brilliant seconds, at the hour when no light shines. They are shooting stars that nothing can restore to the heavens; they glow in the works of *1863*, which Gaétan Picon, with that courage Jean Starobinski has called "heart,"[16] teaches us to see anew. In *1863* he appeals particularly to the vast space that includes the contradictory and is the locus of the work of art:

For the poetical is not an autonomous activity seeking its own form, seeking to stand alone in space like the earth, to borrow Flaubert's wonderful expression, it is rather an image retrieved, the endless image of man, of being, prey to everything, haunted by the useless and the insoluble, the image of a being in which there is the yes and the no, the I and the we, the ecstasy of life and the hatred of life, a man in whom there is even history, but history under the lofty sky that Prince Andrey sees when he regains consciousness after the Battle of Austerlitz in *War and Peace*.[17]

Our gaze will, therefore, be less a gaze that looks back, even if constantly tempted to do so (we will never possess what we have not had), than a gaze that finds itself cleansed of a nightmare whose afterimage it nevertheless recognizes.

The images no longer issue from a hidden world. We do not enter the civilization of the image; on the contrary, the image finds itself empty. Images are no longer apprehended as reflections (classical perspective is obsolete), even less as references. No icon, or anything that functions as such, can be comprehended today. May we still await "the reconciliation of the primitive in our visage?"[18] The anti-art that is the subject of the 1972 preface (working at demonstrating either the insignificance of the thing represented, or the insignificance or impossibility of its being represented) is indisputably the sign of a loss that we do not know how to mourn. Contentment or flight into the synthesized image will be the sign of such an anaesthesia of the eye.

The synthesized image, modifying itself at will and at a distance in space and time (it is no longer a question of the "air-space" of *1863*, the distance of a presence), cannot be exhibited, anaesthetized, made to appear different from what it used to be. It

is the end of the death of art, not that it resuscitates it; on the contrary, it abolishes the conditions (the explicit assignment of art to metaphysics) of such a death. It makes us forget the terms by which mourning would or would not be accomplished. The image of which I speak no longer has a place to be, no longer can be taken for the *analogon* of a reality, albeit imaginary. This image without a place of origin—transmitted everywhere identically by satellite—forgets, makes us forget the hidden world that lay dormant in every image. The images cease being what they always were—a set of signifiers or, to put it simply, a language. Gaétan Picon, echoing Focillon, senses this fear that his hand may be lost, that the lines of the hand, or the desire that in its hollow stands watch, may be forgotten or lost. The greatest danger is that the anxiety over this loss may be lost. "The images should remain," Godard has attested, "the sole possibility of preserving suffering." There is little chance that the abolition of art may be other than a momentary crisis or a misinterpreted change of form. Man cannot forget that he is mortal, cannot stop seeing the world through a desire tied to consciousness of death. Even cut off from culture, history and present society, what will be said and done under this shadow will preserve the essence of what we call art.[19]

I again encounter the terms of this oscillation between history and poetics. Reconciled or not, they are at any event subordinated to a strident imperative. "The wind is salubrious." May it again carry away the mediocrities, the "avatars of maturity" of this new art. Indeed, "there is no longer an art that speaks with one voice, because there is no longer any common value." This term *value*, I can hear it in the last lines of *1863* only as the synonym of a desire tied to consciousness of death and not in a socio-historic sense. Art is peripheral only if it no

longer has a center. That is true, and Gaétan Picon never stopped seeking this sense, rediscovering it, only to lose it as a desire. We grow used to being deprived of it, and the rereading of *1863* exhorts us not to give in, not to lose our sense of revolt. May that revolt remain possible in the fallout of a word that would express the perpetually approaching space of what we have always known but still search for. It is enough, the world is there. And if language vaguely designates an abyss, could it also be the precipice? Probably the only precipice is mute and astonished at such a fear; with suspect words "saying is precisely what fragments the longed-for universal or the unity experienced however briefly."[20]

The intimate and vast exploration of the visible that Gaétan Picon accomplishes is also the experience that has lost its goal, boundary, limit upon which desire smashes itself, the better to be reborn. "And imagining a world that would leave nothing more to be desired is rather the same as believing oneself to be in the presence of a world in which there is nothing to love: the aesthetization of life soon becomes an alibi. Desire is always possible and, the limit that it encounters makes it always be reborn."[21] Of course, a dual structure of the existent—reflection, copy, image of Being—underlies such a visual way of thinking. Even so, Gaétan Picon refuses to give Being its names. The name that would complete this journey through the fog, into which we sometimes venture to hear its echo. The icon, with its original relation to the prototype, never serves as a model for this thought. From the icon there shines down the light that the believer adores and that raises him through the icon to the prototype (a word that expresses how Being renders itself visible).[22]

If Gaétan Picon reads each image according to this up-and-down movement, there is not, however, any original—a model archetype up above—only the vague, vibrant, unseen presence of a surprise or, better, an assault. "Valid response to a work is never a matter of understanding or evaluation, but admission: bowing before it as one bows before a form of nature, neither demanding an accounting, nor offering a challenge."[23] It is an assault, therefore, that forbids all challenge, since it creates the silence whose end it paradoxically seeks: "the instant of a glance, the momentary inflection of a voice." It seeks the moment when a breach opens in the work, when "something rises above the rest." In the same way that if Yvetot is the equal of Constantinople, "it is because Constantinople is worth nothing."[24] Art rejects everything only because it has the ambition to be everything, and its fear, its paralysis, its sense of abandonment, seem to derive only from the foreboding that only leftovers remain. Love subtracts itself from the image; the intentionality of love excludes itself from the power of all image since my gaze, by definition invisible, meets another gaze, by definition invisible. Is it not this invisible that was at issue in the outstretched gaze of Gaétan Picon? An invisible embedded in the visible, as strong as love (or at least of an order little different). The invisible gaze springs from the work, like the dark pupils of the beloved gaze. "Black sun of the eye that fills and eclipses it."[25]

Notes

1. G.P., *Le Travail de Jean Dubuffet* (Geneva: Albert Skira), p. 226.

2. G.P., "Écrire c'est . . . ," *Paragone*, no. 272, October 1972, p. 14.

3. Jean Starobinski, "L'Oeil double de Gaétan Picon," *Le Critique*, Centre Georges Pompidou, p. 18.

4. Jean-François Chevrier, *L'Époque, la Mode, la Morale, la Passion*, Centre Georges Pompidou, p. 64.

5. G.P., *Les Lignes de la main* (Paris: Gallimard, coll. Le Point du jour, 1969), p. 117.

6. G.P., *Admirable tremblement du temps* (Geneva: Albert Skira, coll. Les sentiers de la création, 1971), p. 95.

7. G.P., *Admirable tremblement du temps*, p. 146.

8. *Ibid.*

9. G.P., "Un Essai de mise en question," in *72/72 Douze ans d'art contemporain en France* (Paris: Musées nationaux, 1972).

10. Fribourg Conference, 1976 (unpublished).

11. Charles Baudelaire, "Squibs," in *Intimate Journals*, trans. Christopher Isherwood (New York: Howard Fettig, 1977), p. 23.

12. G.P., "L'Oeuvre et son témoin," *La Bouteille à la mer*, no. 68, 1951, p. 13.

13. Walter Pater, *The Renaissance: Studies in Art and Poetry*, edited by Donald L. Hill (Berkeley: University of California Press, 1980), p. 88.

14. Fribourg Conference, 1976 (unpublished).

15. *1863*, p. 45.

16. Jean Starobinski, "L'Oeil double de Gaétan Picon," p. 14.

17. Fribourg Conference, 1976 (unpublished).

18. G.P., "La Peinture et le Portrait," *Confluences*, no. 6, 1945.

19. G.P., "Un essai de mise en question," p. 106.

20. Christophe Carraud, "La Parole fautive," *Art et liturgie aujourd'hui* (Paris: Cerf, 1987), p. 78.

21. G.P., "Un essai de mise en question," p. 106.

22. It is unnecessary to spell out what these reflections owe to the thought of Jean-Luc Marion: *Dieu sans l'être* (Paris: Fayard, 1982).

23. G.P., *L'Écrivain et son ombre* (Paris: Gallimard, 1953), p. 17.

24. G.P., "Un essai de mise en question," p. 104.

25. G.P., *L'Oeil double* (Paris: Gallimard, 1970), p. 169.

Illustrations

19, 20–21, 23, 36, 168–169
Édouard Manet, *Le Déjeuner sur l'Herbe*, 1863
Oil on canvas 2.080 × 2.645 m
Paris, Musée d'Orsay
Ph. Gallimard-Hubert Josse

32
Jean-Auguste-Dominique Ingres, *The Turkish Bath*, 1859
Oil on canvas diameter 1.08 m
Paris, Musée du Louvre
Ph. Gallimard-Hubert Josse

35
Eugène Delacroix, *Heliodorus Driven from the Temple*, 1861
Fresco
Paris, Church of Saint-Sulpice, Chapel of the Holy Angels
Ph. Gallimard-Hubert Josse

38
Edgar Degas, *Édouard Manet with a Hat*, 1865–1870
Stumped graphite 0.33 × 0.23 m
New York, Metropolitan Museum of Art; Rogers Fund 1918
Ph. of the Museum

40
Edgar Degas, *Spartan Girls Challenging the Boys*, 1860
Oil on canvas 0.1092 × 0.1543 m
London, National Gallery
Ph. of the Museum

40
Edgar Degas, *The Bellelli Family*, ca. 1860
Oil on canvas 2.00 × 2.50 m
Paris, Musée d'Orsay
Ph. Gallimard-Hubert Josse

41
Edgar Degas, *Gentlemen's Race: Before the Start*, 1862
partially repainted by the artist in 1880
Oil on canvas 0.485 × 0.615 m
Paris, Musée d'Orsay
Ph. Gallimard-Hubert Josse

42
Charles Meryon, *Ministry of the Navy*, 1866
Etching 0.141 × 0.130 m
Paris, Bibliothèque nationale
Ph. Bibl. nat.

42
Odilon Redon, *Birth of Venus*, ca. 1910
Pastel 0.83 × 0.64 m
Paris, Musée du Petit Palais
Ph. Musées de la Ville de Paris © SPADEM, 1988

42
Gustave Moreau, *Andromeda*, undated
Oil on canvas 0.32 × 0.25 m
Paris, Musée Gustave Moreau
Ph. Gallimard-Hubert Josse

43
Pierre Puvis de Chavannes, *Girls by the Seashore*, ca. 1879
Oil on canvas 2.00 × 1.50 m
Paris, Musée d'Orsay
Ph. Gallimard-Hubert Josse

46–47
Eugène Delacroix, *Jacob Wrestling with the Angel*, 1861
Fresco
Paris, Church of Saint-Sulpice, Chapel of the Holy Angels
Ph. Gallimard-Hubert Josse

50–51
Antoine Gros, *Napoleon on the Battlefield of Eylau*, 1808
Oil on canvas 5.21 × 7.84 m
Paris, Musée du Louvre
Ph. Gallimard-Hubert Josse

51
Ernest Meissonier, *Napoleon III at the Battle of Solferino*, 1863
Oil on wood 0.435 × 0.760 m
Paris, Musée d'Orsay
(on loan to the Palais de Compiègne, Musée du Second Empire)
Ph. Gallimard-Hubert Josse

53
Jean-Auguste-Dominique Ingres, *Louis-François Bertin*, 1832
Oil on canvas 1.16 × 0.95 m
Paris, Musée du Louvre
Ph. Gallimard-Hubert Josse

54
Édouard Manet, *Georges Clemenceau*, 1879
Oil on canvas 0.945 × 0.740 m
Paris, Musée d'Orsay
Ph. Gallimard-Hubert Josse

58
Édouard Manet, *Méry Laurent in a Black Hat*, 1882
Pastel on canvas 0.54 × 0.44 m
Dijon, Musée des Beaux-Arts
Ph. Gallimard-Studio Berlin

59
Honoré Daumier, *The Burden*, ca. 1855–1856
Oil on panel 0.393 × 0.311 m
Glasgow, Museums and Art Galleries;
The Burrell Collection
Ph. of the Museum

59
Jean-François Millet, *Woodcutter*, undated
Oil on canvas 0.380 × 0.295 m
Paris, Muśe du Louvre
Ph. Gallimard-Hubert Josse

60
Auguste Renoir, *La Grenouillère*, 1869
Oil on canvas 0.66 × 0.81 m
Stockholm, Nationalmuseum
Ph. of the Museum

61
Claude Monet, *La Gare Saint-Lazare*, 1877
Oil on canvas 0.755 × 1.040 m
Paris, Musée d'Orsay
Ph. Gallimard-Hubert Josse © SPADEM, 1988

66
Auguste Rodin, *Man with a Broken Nose*, 1864
Bronze height 0.24 m
Paris, Musée Rodin
Ph. Gallimard-Hubert Josse

66
Gustave Courbet, *Young Fisherman of Franche-Comté*, 1862
Plaster height 1.20 m
Ornans, Musée Courbet
Ph. of the Museum

66
Jean-Baptiste Carpeaux, *Ugolino and His Children*, 1860
Bronze height 1.94 m
Paris, Musée d'Orsay
Ph. Bulloz

67
Honoré Daumier, *Ratapoil*, ca. 1850
Bronze height 0.435 m
Paris, Musée d'Orsay
Ph. Gallimard-Hubert Josse

68
Edgar Degas, *Dancer, Fourth Position in Front on Left Leg, Second Study*, 1882–1890
Bronze height 0.603 m
Paris, Musée d'Orsay
Ph. Gallimard-Hubert Josse

71
Hector Lefuel, Cour du Manège
at the Louvre
Ph. Giraudon

71
Charles Garnier, Grand Staircase
of the Paris Opera
Ph. Jacques Moatti

72–73
Jacques-Ignace Hittorff,
Gare du Nord, Paris: Perspective View of the Hall, 1862–1863
Graphite on reinforced tracing paper 0.330 × 0.775 m
Cologne, Wallraf-Richartz Museum
Ph. Rheinisches Bildarchiv, Cologne

74–75
John Constable, *The Hay Wagon*, 1821
Oil on canvas 1.302 × 1.854 m
Ph. of the Museum

76
Richard Parkes Bonington, *View of the Coast of Normandy*, ca. 1823–1824
Oil on canvas 0.465 × 0.385 m
Paris, Musée du Louvre
Ph. Gallimard-Hubert Josse

78–79
Joseph Mallord William Turner, *The "Fighting Téméraire,"* 1838
Oil on canvas 0.908 × 1.21 m
London, National Gallery
Ph. of the Museum

81
Giovanni Fattori, *Ox-Drawn Cart*, undated
Oil on wood 0.19 × 0.33 m
Florence, Museum of Modern Art
Ph. Giovanni Dagli Orti

82
Sir John Everett Millais, *Autumn Leaves*, 1856
Oil on canvas 1.04 × 0.74 m
Manchester, City Art Galleries
Ph. of the Museum

84, 120
Édouard Manet, *Bar at the Folies-Bergère*, 1881–1882
Oil on canvas 0.96 × 1.30 m
London, Courtauld Institute Galleries
Ph. Hubert Josse

85, 121
Édouard Manet, *The Balcony*, 1868
Oil on canvas 1.700 × 1.245 m
Paris, Musée d'Orsay
Ph. Gallimard-Hubert Josse

87
Édouard Manet, *Stéphane Mallarmé*, 1876
Oil on canvas 0.275 × 0.360 m
Paris, Musée d'Orsay
Ph. Gallimard-Hubert Josse

90
Francisco de Goya, *Shootings of the Third of May*, 1814
Oil on canvas 2.66 × 3.45 m
Madrid, Prado Museum
Ph. Oronoz-Artephot

90
Édouard Manet, *The Execution of the Emperor Maximilian*, 1867
Oil on canvas 2.52 × 3.05 m
Mannheim, Städtische Kunsthalle
Ph. of the Museum

90
Gustave Courbet, *Pierre-Joseph Proudhon and His Children*, 1865
Oil on canvas 1.47 × 1.98 m
Paris, Musée du Petit Palais
Ph. Hubert Josse

91
Honoré Daumier, *Massacre in the rue Transnonain*, 1834
Lithograph 0.445 × 0.29 m
Paris, Bibliothèque nationale
Ph. Bibl. nat.

93
Camille Corot, *Ischia, View from the Slopes of Mount Epomeo*, 1828
Oil on paper mounted on canvas 0.26 × 0.40 m
Paris, Musée du Louvre
Ph. Gallimard-Hubert Josse

93
Camille Corot, *Recollection of Mortefontaine*, 1864
Oil on paper mounted 0.65 × 0.89 m
Paris, Musée du Louvre
Ph. Gallimard-Hubert Josse

94, 96–97
Honoré Daumier, *The Emigrants*, 1868–1870
Oil on canvas 0.3874 × 0.6858 m
Minneapolis, Institute of Art;
Ethel Morrison van Derlip Fund
Ph. of the Museum

95
Honoré Daumier, *The Painter at His Easel*,
ca. 1870
Oil on wood panel 0.333 × 0.257 m
Washington, The Phillips Collection;
Gift of Marjorie Phillips
Ph. of the Museum

98
Jacques-Louis David, *View of the Luxembourg
Gardens*, 1794
Oil on canvas 0.55 × 0.65 m
Paris, Musée du Louvre
Ph. Gallimard-Hubert Josse

98
Eugène Delacroix, *The Sea from the Heights
above Dieppe*, ca. 1852
Oil on cardboard on wood 0.36 × 0.52 m
Paris, Musée du Louvre
Ph. Gallimard-Hubert Josse

98
Jean-Auguste-Dominique Ingres, *Raphael's House
in Rome*, ca. 1807
Oil on wood diameter 0.15 m
Paris, Musée des Arts décoratifs
Ph. Gallimard-Hubert Josse

98
Georges Michel, *The Environs of Montmartre*,
undated
Oil on canvas 0.645 × 0.800 m
Paris, Musée du Louvre
Ph. Gallimard-Hubert Josse

98, 99
Paul Huet, *Breakers on the Promontory at
Granville*, 1853
Oil on canvas 0.68 × 1.03 m
Paris, Musée du Louvre
Ph. Gallimard-Hubert Josse

100, 101
Théodore Rousseau, *Landscape with a Stormy
Sky*, undated
Oil on canvas 0.25 × 0.35 m
London, Victoria and Albert Museum
Ph. of the Museum

101, 102
Charles-François Daubigny, *Sunset on the Oise*,
1865
Oil on wood 0.39 × 0.67 m
Paris, Musée d'Orsay
Ph. Gallimard-Hubert Josse

105
François-Auguste Ravier, *Pool of the Levaz,
Morestel*, undated
Oil on canvas 0.250 × 0.335 m
Paris, Musée d'Orsay
Ph. Gallimard-Hubert Josse

106
Édouard Manet, *Vase of Peonies on a Stand*, 1864
Oil on canvas 0.93 × 0.70 m
Paris, Musée d'Orsay
Ph. Gallimard-Hubert Josse

108–109
Édouard Manet, *Concert in the Tuileries*, 1862
Oil on canvas 0.76 × 1.18 m
London, National Gallery
Ph. of the Museum

110
Jean-François Millet, *Spring*, 1868–1873
Oil on canvas 0.86 × 1.11 m
Paris, Musée d'Orsay
Ph. Gallimard-Hubert Josse

111
Jean-François Millet, *Man with a Hoe*, 1860–1862
Oil on canvas 0.80 × 0.99 m
Santa Monica (California), J. Paul Getty Museum
Ph. of the Museum

113
Hippolyte Jouvin, *Snapshot of the Holiday of
August 15, 1862.
Bridge and Place de la Concorde on the Emperor's
Birthday.*
Stereoscopic photo
© Bibliothèque nationale, Paris

113
Hippolyte Jouvin, *Snapshot of the Industrial
Holiday of January 25, 1863.
Return to the Tuileries, Emperor's Carriage,
the Cent-Gardes.*
Stereoscopic photo
© Bibliothèque nationale, Paris

114
Fair at Montmartre, ca. 1862
Anonymous stereoscopic photo
Ivan Christ Collection

115
Auguste Renoir, *Le Moulin de la Galette,
Montmartre*, 1876
Oil on canvas 1.31 × 1.75 m
Paris, Musée d'Orsay
Ph. Gallimard-Hubert Josse

118–119
Édouard Manet, *Races at Longchamp*, 1864
Oil on canvas 0.439 × 0.845 m
Chicago, Art Institute; Potter Palmer Collection
Ph. of the Museum

122
Édouard Manet, *The Fifer*, 1866
Oil on canvas 1.61 × 0.97 m
Paris, Musée d'Orsay
Ph. Gallimard-Hubert Josse

123
Édouard Manet, *The Dead Toreador*, 1864
Oil on canvas 0.759 × 0.153 m
Washington, National Gallery; Widener Collection
Ph. of the Museum

125
Édouard Manet, *Asparagus*, 1880
Oil on canvas 0.165 × 0.215 m
Paris, Musée d'Orsay
Ph. Gallimard-Hubert Josse

126–127
Edgar Degas, *Landscape*, 1890–1893
Pastel on monotype 0.30 × 0.40 m
Boston, Museum of Fine Arts; Ross Collection,
gift of Denman Waldo Ross
Ph. of the Museum

128
Edgar Degas, *The Rehearsal*, ca. 1874
Oil on canvas 0.584 × 0.838 m
Glasgow, Museums and Art Galleries;
The Burrell Collection
Ph. of the Museum

129
Edgar Degas, *Women on a Cafe Terrace, Evening*,
1877
Pastel on monotype 0.41 × 0.60 m
Paris, Musée d'Orsay
Ph. Musées nationaux

130, 131
Édouard Manet, *Luncheon in the Studio*, 1868
Oil on canvas 1.18 × 1.54 m
Munich, Neue Pinakothek
Ph. Joachim Blauel-Artothek

130
Édouard Manet, *14 Juillet: Rue Mosnier
Decorated with Flags*, 1878
Oil on canvas 0.65 × 0.81 m
Private collection
Ph. Gallimard-Walter Dräyer

134, 135
Camille Corot, *Civita Castellana*, 1826–1827
Oil on canvas 0.36 × 0.51 m
Stockholm, Nationalmuseum
Ph. of the Museum

135
Camille Corot, *Rosny-sur-Seine, Village Church*,
1844
Oil on canvas 0.54 × 0.80 m
Private collection
Ph. Priv. coll.

135
Camille Corot, *Bridge at Narni*, 1826
Oil on paper mounted on canvas 0.34 × 0.48 m
Paris, Musée du Louvre
Ph. Gallimard-Hubert Josse

136
Camille Corot, *Belfry at Douai*, 1871
Oil on canvas 0.465 × 0.385 m
Paris, Musée du Louvre
Ph. Gallimard-Hubert Josse

137
Gustave Courbet, *The Painter's Studio:
Real Allegory*, 1855
Oil on canvas 3.61 × 5.98 m
Paris, Musée d'Orsay
Ph. Gallimard-Hubert Josse

138
Gustave Courbet, *Woman in a Podoscaph*, 1865
Oil on canvas 1.73 × 2.10 m
Tokyo, Muraucshi Hachiôji Museum
Ph. M. Babey-Artephot

138
Gustave Courbet, *The Shaded Stream* or *The
Stream at Puits-noir*, 1865
Oil on canvas 0.94 × 1.35 m
Paris, Musée d'Orsay
Ph. Gallimard-Hubert Josse

139, 140, 141
Gustave Courbet, *Burial at Ornans*, 1849–1850
Oil on canvas 3.15 × 6.68 m
Paris, Musée d'Orsay
Ph. Gallimard-Hubert Josse

142
Gustave Courbet, *The Trout*, 1871
Oil on canvas 0.525 × 0.87 m
Zurich, Kunsthaus
Ph. of the Museum

143
Gustave Courbet, *Stormy Sea* or *The Wave*, 1870
Oil on canvas 1.170 × 1.605 m
Paris, Musée d'Orsay
Ph. Gallimard-Hubert Josse

144, 146–147
Gustave Courbet, *Jo, the Irish Beauty*, 1866
Oil on canvas 0.54 × 0.65 m
Stockholm, Nationalmuseum
Ph. of the Museum

144
Gustave Courbet, *The Trellis*, ca. 1862
Oil on canvas 1.098 × 1.325 m
Toledo (Ohio), Museum of Art;
gift of Edward Drummond Libbey
Ph. of the Museum

144
Edgar Degas, *Woman with Chrysanthemums*,
1865
Oil on canvas 0.74 × 0.92 m
New York, Metropolitan Museum of Art;
bequest of Mrs. H. O. Havemeyer, 1929,
H. O. Havemeyer Collection
Ph. of the Museum

151, 152, 153
Édouard Manet, *Olympia*, 1863
Oil on canvas 1.305 × 1.900 m
Paris, Musée d'Orsay
Ph. Gallimard-Hubert Josse

154
Édouard Manet, *Street Singer*, 1865
Oil on canvas 1.713 × 1.058 m
Boston, Museum of Fine Arts;
bequest of Sarah Choate Sears
Ph. of the Museum

159
John Constable, *Seascape with Rainclouds*,
ca. 1827
Oil on paper mounted on canvas 0.22 × 0.31 m
London, Royal Academy of Arts
Ph. of the Museum

163
Édouard Manet, *Madame Édouard Manet in the
Conservatory*, 1879
Oil on canvas 0.815 × 1.00 m
Oslo, Nasjonalgalleriet
Ph. Hubert Josse

165
Théodore Rousseau, *The Source of the Lizon*,
ca. 1863
Charcoal and pastel on canvas 0.895 × 1.165 m
Paris, Musée du Louvre
Ph. Gallimard-Hubert Josse

166
Johan-Barthold Jongkind, *Merchant Ships and
Fishing Boats*, 1865
Watercolor 0.13 × 0.22 m
Paris, Musée du Petit Palais
Ph. Musées de la Ville de Paris © SPADEM, 1988

166
Eugène Boudin, *Trouville Pier*, 1869
Oil on canvas 0.648 × 0.928 m
Glasgow, Museums and Art Galleries;
The Burrell Collection
Ph. of the Museum